Marc Chagall

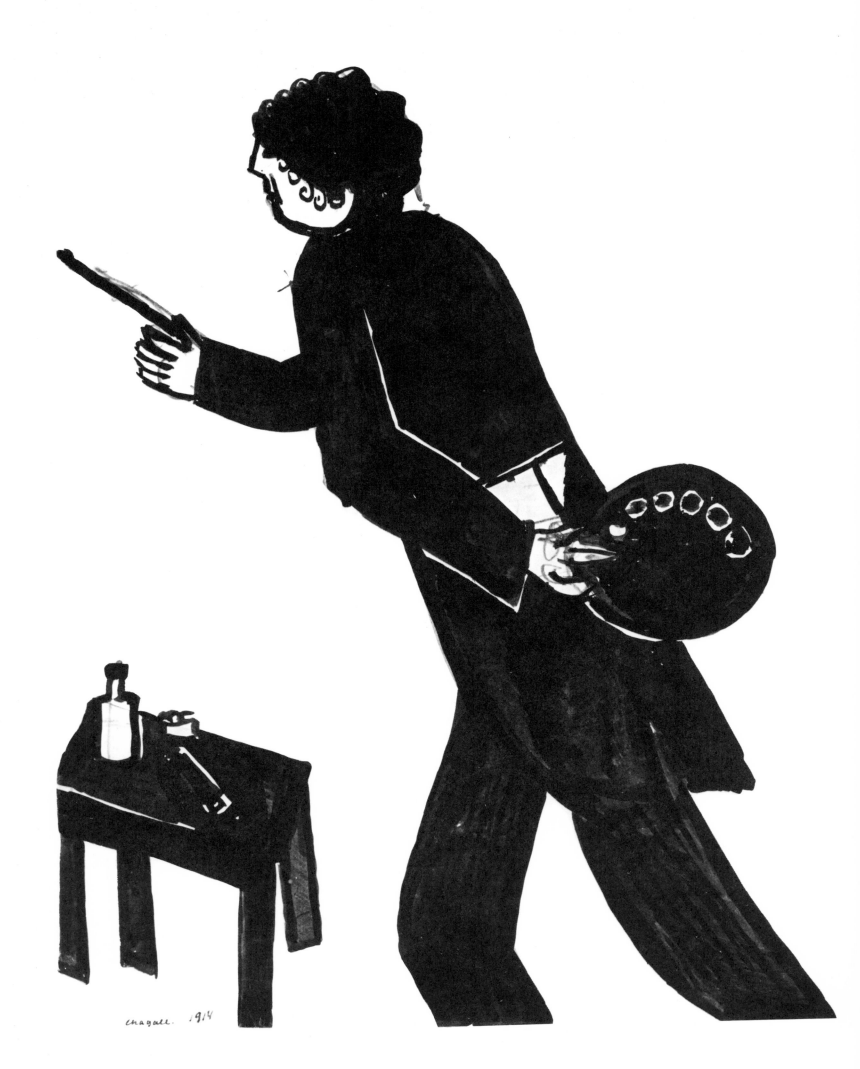

WERNER HAFTMANN

MARC CHAGALL
GOUACHES · DRAWINGS · WATERCOLORS

TRANSLATED FROM THE GERMAN BY ROBERT ERICH WOLF

HARRY N. ABRAMS, INC. · PUBLISHERS · NEW YORK

Frontispiece: *The Painter*, 1914

Published in 1984 by Harry N. Abrams, Incorporated, New York

LIBRARY OF CONGRESS CATALOGING IN PUBLICATION DATA

Chagall, Marc, 1887–
 Gouaches, drawings, watercolors.

 Translation of: Gouachen, Zeichnungen, Aquarelle.
 1. Chagall, Marc, 1887– . I. Haftmann, Werner.
II. Title.
ND1978.C5A4 1984 759.7 83-15806
ISBN 0-8109-0768-2

Printed and bound in West Germany

LIST OF PLATES *(asterisk indicates colorplate)*

I

With the 1950s Marc Chagall's work began to take on a monumental character. He not only took to working in larger formats but also began to think in terms of wide-ranging cycles or series of paintings. With this new interest in decorating walls, rooms, and even entire buildings, he used mediums unprecedented in his work and scarcely to be expected from him: ceramic plaques, sculpture, stained glass, wall tapestries, mosaics.[1]

While there were signs of this development as far back as the mid-1930s, it was only after returning to France from his years in America, after 1950 or so, that Chagall's inner forces had matured to the point where they could cope with the monumental format and the imposing scale his poetic vision was now calling for. In 1950 he began his first biblical pictures, pictures that sought out the legendary core of biblical history or chronicle. At the same time he began to feel that such pictures could be grouped in cycles and conceived from the start for a specific architectural setting. It was in Vence, in the little church on the hill reached by seven chapels with the Stations of the Cross, that Chagall first dreamed of an interior he could illuminate with the splendor of the biblical message. Two decades later he was able to realize this dream in a hall built and furnished on his own directions in the cultural center of the city of Nice, which he himself sponsored and which was inaugurated in 1973 as the Musée National Message Biblique Marc Chagall, which houses his major biblical cycle.[2] Early on, however, in 1953, he was commissioned to decorate the baptismal chapel of the church at Plateau-d'Assy (Savoie), his first public undertaking for a specific architectural setting. Here he was able to use his newly acquired techniques in wall ceramics, sculpture, and stained-glass windows. Though the setting was modest—a small baptismal chapel in an out-of-the-way small church—this first combination of means specifically adapted to decorating walls and three-dimensional spaces can be considered, in hindsight, the nucleus from which grew his later monumental conceptions.

In 1958 there were the preliminary studies and sketches for a stained-glass window in the Metz cathedral. In 1959 came the wonderful commission for twelve eleven-foot-high windows for the lantern of the synagogue in the Hadassah University Clinic in Jerusalem, a huge undertaking he acquitted in a mere three years. Out of the rare austere, archaic images of animals and plants handed down in the Old Testament as symbols of the twelve tribes of Israel, Chagall created walls of light, the walls of a virtually abstract cathedral of luminous color. In a broad symbolism he united the distinctive signs of the tribes into the encompassing circle of God's chosen people whose rallying point is light itself—the enlightenment and illumination that streams forth from God's word. In this holy place of colored light, all of Chagall's familiar images of growing and living things were brought into play to surround and intertwine the great texts of the Bible, interpreting them in an entirely personal litany. Color in these windows takes on the fullest spirituality. In Chagall's assertion that the light of heaven itself was his companion-painter on these translucent walls of color, it truly takes on the legendary glow of the numinous. Color is raised to a pictorial autonomy in which composition and decoration are identical with the spiritual content expressed. On the practical creative level these were the preconditions for transcending the problems inherent in a large-scale work of art and the demands of its architectural setting. The Hadassah Synagogue project represented a stylistic high point from which all the stained-glass windows Chagall would do afterwards would derive.

In those years, there were other undertakings of the most varied character and technique, often in enormous dimensions. In 1964 Chagall produced the gigantic round ceiling painting for the Paris Opéra; in the following year, the huge wall decorations for the Metropolitan Opera House at New York's Lincoln Center. For the new parliament building in Jerusalem, in 1966 he worked on three tapestries, each over nineteen feet wide, and produced a wall in mosaic, the latter a technique new to him but one that he would exploit repeatedly in the following years for the color that glows from the glass pastes and stones. He would return to that technique in 1967–68 for the thirty-six-foot-wide Ulysses mosaic for the university in Nice, his first and only venture in a Classical humanistic theme

[1] For biographical details and further bibliography, see Franz Meyer, *Marc Chagall, Leben und Werk*, Cologne, 1961; and Werner Haftmann, *Marc Chagall*, New York: Harry N. Abrams, 1972.
[2] Catalogue of the *Musée National Message Biblique Marc Chagall*, Nice and Paris, 1973.

which, however, in its quality and inherent grandeur set the measure for everything done afterward in that medium. In his eighties and even beyond, the painter has continued to receive large-scale commissions, and his pleasure in mastering large surfaces and in reshaping architectural settings through his art has remained as fresh as ever.

Numerous as these large-scale undertakings have been, they have neither stifled nor altered Chagall's personal relationship with the world around him nor affected his inner life, aspects which, ever since he came to public attention, have always appeared bound up with an approach compounded of poetic introspection and a keen fantasy that turned everything it touched into fable. The quiet center of his existence continues to be a house hidden away in a small pine wood a good way outside St.-Paul-de-Vence. On the narrow road that leads to it, nothing reminds one of city noise and bustle. A cricket's chirp, a bird call suffice to make the silence audible. The two-storey house is roomy but not really big. From a vestibule one enters a bright, sparsely furnished parlor whose finest adornment is a few of the owner's own most famous pictures. Books, pottery, terracottas by Laurens, a small painting by Braque rest on fireplace ledges and shelves and lend their touch of friendly intimacy to the quiet room. Here the visitor is usually received first by Madame Chagall, mistress of the domestic domain, who ensures that the innumerable demands of the outside world do not ruffle the industrious quiet one senses in the house itself. Conversation with her is always to the point and has to do with the matter in hand, although she by no means shuns the pleasantry or odd joke that may crop up in the course of more serious talk. A good-humored cheerfulness makes discussion easy, and when decisions are called for they are talked over with Madame Chagall but left for final say-so to the *patron*. Everything in this house, one feels, centers on the painter at work in the adjoining atelier.

And he himself is never far off. Drawn by his native curiosity, he slips through the door and, before you realize it, has joined in the conversation. Lively, alert, as ever, he excuses himself with quite unnecessary affability for the "intrusion," yet is eager and interested to see what the newcomer has to show him and to hear what he may have to say. His concentration is nonetheless intense. When, as for instance in choosing the illustrations for this book, one shows him examples of his work done decades earlier and

long forgotten, he falls into a kind of reverie, then suddenly recaptures the euphoria of the hour in which this or that picture was produced, and can often come up with entirely unsuspected information about how it came to be. Rarely, however, in either fact or thought does he allow himself more than twenty minutes or so away from his worktable. Then his working world claims him again and, fearful of losing the inspiration of a moment, he hurries back to his studio. The door shuts behind him as if snapped to on a slingshot. He may pop in and out again once or twice if something in connection with the subject comes to mind, but only briefly and as if in flight; then work draws him irresistibly back to the studio. Working and living are one for him. Just as the quiet house is the center of his existence, so his working place is at the heart of his life as artist.

The atelier is reached through a narrow, fairly long corridor lined by all sorts of storerooms for pictures and supplies. It lies in the east wing of the house, well shielded from the living quarters and inevitable hustle and bustle. It is easy to imagine how Chagall's comings and goings through this narrow passageway set the tone for his working fantasy. The atelier itself is a very high, spacious, yet not overlarge room. It gets its light from a window in the south wall shaded by trees and is crammed with tables standing every which way, through which only a single passage between them has been left open. The tables are piled high with books, magazines, papers, drawings, gouaches. Every possible utensil for drawing lies at hand, so that even the most fleeting improvisation can be caught and set down at once. To an onlooker, there is no discernible order to it all. It is as if all this paraphernalia were simply shoved from one place to another in the improvisation of a work spot for a moment. Only the east wall offers an uncluttered surface on which a large-scale composition could be worked out. An easel is pushed back, holding a picture awaiting its finishing touches. Strictly one man's workshop, this studio has nothing in common with the fabulous salons-for-painting where artists of the generation of Makart, Lenbach, and Stuck did their public turns. For all its spaciousness it is more like a cell. It has in fact an extraordinary resemblance to the anything but orderly chamber in which the Old Masters used to depict the scholarly Saint Jerome meditating within the thicket of his books.

It is, in fact, something of just that sort. This is where

pictures are born. In this stillness Chagall aligns himself with that "point from which creation arises" of which Paul Klee spoke so often, the point where out of the scattered and diffuse details of the way one senses and reacts to reality, an

this combination of spontaneity and thought, come about? By its nature one would think it apt only for formats small enough to be mastered in a turn of the hand, where the artist's inner impulses can be matched by the slight and

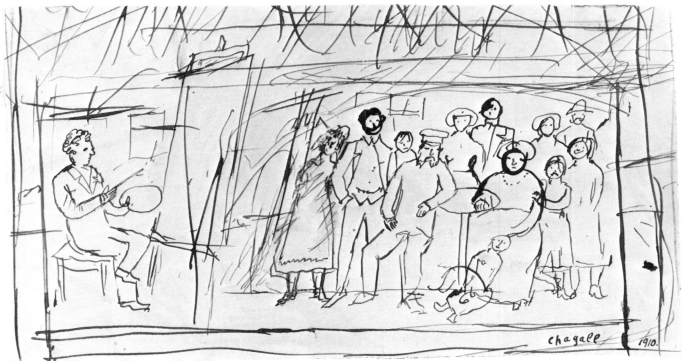

The Painter and His Family. 1910

image shapes itself into a single unified pictorial metaphor. Even the least imaginative among us can imagine Chagall, quickened with a still scarcely defined inner image, suddenly extemporising a corner in which to work and there, on some table edge, bending over his sheet of paper, exploring—although still open to the hints of passing chance—how to bring shape to the image stirring within him. What results is a product of contemplation and meditation. It owes its final form to the spontaneity of an imagination which is incessantly seeking and inventing, yet works with a control which determines and shapes a form.

But when it comes to the large formats and monumental forms practiced by Chagall, just how does this procedure,

easy movements of his brush or pen, where there are no problems of construction on large surfaces that demand to be worked out in full and that might suppress the free play of the inventive fantasy.

The answer has to do with practical matters. The large works Chagall creates are then produced in workshops staffed by skilled craftsmen working under his constant supervision: stained-glass windows in his favorite work-shop in Rheims, mosaics in one of the workshops on the Côte d'Azur, tapestries in the Manufacture des Gobelins in Paris, and the large mural paintings, like the separate portions of the gigantic ceiling decoration for the Paris Opéra, in specialized ateliers and, finally, on the spot.

Chagall has the faculty of being the guiding, productive, and inspiring force in charge of a group of skilled artisans. If anyone doubts that in the artistic hierarchy of the group the true *patron* is Chagall, a brief chat with one of the workers familiar with every finesse of his métier is enough to dispel it: everyone works for Chagall, but Chagall works side by side with all of them.

Thanks to this, there is no difference between what is done in the final stage in the workshop and the familiar procedures in the quiet house outside St.-Paul-de-Vence. In his home studio Chagall does not need to worry about how to carry out a major commission that may be in the works, but can arrive at and develop the core and essence of large-scale compositions while working in the smallest of formats, sacrificing nothing of sudden inspiration. Whatever this gift of the creative hour or even moment, it can then serve as point of departure for a more conscious development in which he can work out and control the relations between colors and forms and the communicative capacity of his figurative signs and symbols. Without leaving his atelier he can pin down the definitive design in a larger format, and this will serve as a model to be translated into the full-scale work. Once that model leaves his studio, the problem shifts decisively from meditation to construction. What matters then is no longer imaginative invention as such but, rather, the way to make the construction of the picture so clear and effective that it can fill and still communicate once on the large-scale surfaces involved. If Chagall is able to direct his complete attention in this final phase to matters of construction, it is precisely because the vision conceived in the studio survives intact.

Chagall appears to be aware of this reciprocal relationship between intuition and construction. It governs, if I see it rightly, the very rhythm of his work. He spends days in the workshops turning out the full-scale works where he takes an active part in whatever is being done, but then, after even such relatively brief excursions away from his own worktable, he returns to his home ground—his own studio. Like an Antaeus in need of contact with earth to preserve his strength, Chagall requires the uninterrupted meditative contact with his own inner world that only his private studio can assure him.

Still, it would be gross oversimplification to claim that Chagall's concern with construction is confined to the final stage in the working procedure, to the point where the personal world of the picture is made to fit the requirements of its eventual architectural setting. The constructive element is something he always aims at more or less consciously. If Surrealism's chief spokesman, André Breton, could speak in 1945 of Chagall's hallucinatory pictorial inventions of the years 1911 to 1914 as a "total lyrical explosion," this striking formulation is unquestionably correct within Breton's own context yet remains too one-sided.[3] This is because it was precisely in this most "explosive" phase of his work that a regulating mechanism came into play, the encounter with the French Cubists. From them Chagall first learned that, to convey to others by way of images all the poetry behind one's real-life experiences, a new organization of the body of the picture may be indispensable. Only thus could that "hinterground"—something that can only be evoked, never stated—be made visible. And an "evocative" picture is one which does not merely reproduce what anyone can see but, instead, from within the artist's own being conjures up a counterimage which is his personal answer to experience and feeling.

Chagall's overflowing fantasy and the ecstatic and euphoric element in his personality admittedly underplay the constructive side of the creative process. And this means that the viewer himself is likely to overlook it in his astonishment at the fantasy world opened up before him, or simply thinks of it as the not very important work any artist has to do when putting a picture together. Chagall himself is not of that opinion. The more his pictorial thinking became clarified in the natural course of maturity and old age, the more clearly he saw the function of the constructive element in communicating the images welling up from within him. Today Chagall thinks of the ecstatic pictures of his early years less in terms of Breton's total lyrical explosions (though the expression pleases him) than, in his own term, *constructions psychiques*, constructions of the mind. In a conversation of 1957 that Franz Meyer refers to only as a passing note in his fundamental book on Chagall's work, Chagall singled out the "will to construction" as a major element in his art, and this in

[3] André Breton, *Le Surréalisme et la Peinture*, 2nd ed., New York and Paris, 1945.

accord with his belief that as an artist he belongs to an "epoch of construction."[4] The latter is certainly true. It was precisely the generation of artists to which Chagall belongs that in the culminating years between 1910 and 1912, following Cézanne, Van Gogh, Gauguin, and Seurat, focused on the formal framework of a new kind of picture, attributed a new evocative function to that factor, and prepared the way for it to become the vehicle for making visible the invisible images drawn from within the artist's own unconscious mind or memory.

But then again, in the same conversation, Chagall named as further indispensable components of his art the "mysticism of the icon" and the "mysticism of Hasidism." In doing so, he definitely detached the notion of constructivism from its long-standing historical association with Classicism. For Chagall, the constructive element in no way excludes the ecstatic. It is, on the contrary, the frame-work that for him channels the ecstatic and makes it possible to articulate it in an image. The ecstatic element that imbues all of Chagall's art with fire, rapture, joy, and a dancing exuberance simply cannot be given the humanistic designation of "Dionysiac" for the simple reason that it has no relationship whatsoever with anything "Classical" or "Apollonian." But taking up what Chagall himself has suggested, it *could* be called "Hasidic" because of its deep bond with the human existential factors that underlie the mystical religiosity of that group of Eastern European Jews. To remain in that metaphorical context, constructivism in Chagall's sense can be compared with the frequently recurring Old Testament image of the ladder by which man can communicate—commune—with divinity. For Chagall this means the ladder on whose rungs the vague inner images can make their way upward into the clarity of real, not just subjective, vision. Construction and intuition are in a highly subtle equilibrium, like a pendulum whose swings center on an ideal midpoint, one more conceptual than real. Because of the nature of creative activity, in the initial creative impulse the balance is more to the side of spontaneous intuition, and this is especially so with Chagall. It is only in the active, formal development of the initial vision that new impulses bring awareness and guide the constructive element.

Chagall, we have mentioned, feels himself part of an

[4] Meyer, p. 603, note 2.

"epoch of construction." In point of fact, the intimate involvement of Chagall's creative thought with this only apparently contradictory element can be dated to precisely those years when he was becoming an artist. Furthermore, it was especially strong in the region of Europe that Gottfried Benn called the "northeastern world of expression" and to which Chagall belonged. During the same years between 1911 and 1913 in which Chagall, having come in contact with the Orphic Cubism of the French (Delaunay, Léger), was attempting to fit his unbridled mystical fantasy into a two-dimensional yet crystalline order—and thereby for the first time transmuting his poetic metaphor into something truly pictorial—Franz Marc in his *Tower of Blue Horses* and *Animal Destinies* was painting a new mystical legend of the animal and its inherent place in the scheme of Creation. Through an inward *feeling into* reality he, like Chagall, was striving to penetrate more deeply into the visible, to make others see the harmonious and poetic "hinterground" of reality behind the readily visible surfaces of nature. In a formulation involving the double-meanings so characteristic of him, Marc called it the "mystical inner construction behind the visible world," an expression which, had Chagall known it then, would have been very much to his liking. Like Chagall, Franz Marc also held the definition of this "mystical inner construction" to be "the great problem" for his generation. Paul Klee likewise in those years was already concerned with understanding the constructive pictorial aspect as the ladder, the climbing mechanism, by which to bring up to the plane of the visible the store of images held in the unconscious and the buried-over realm of memory—those hidden domains that Klee called his "primordial field of psychic improvisation."

Had he known it, we can be sure that the term "psychic improvisation" would have had Chagall's full approval. The fact is, all these ideas developed entirely independently. Chagall met Franz Marc only once—in 1914—and only in passing; he never met Klee. In his decisive years he knew nothing of either of them. Yet today Franz Marc is the only German painter to interest him, and he willingly acknowledges his deep sympathy for Klee.

Modernism was by no means as monolithic in France as we sometimes think. There too a kind of unauthorized Sezession wing grew up on the fringe of strict Cubism,

though in less Romantic guise than the Austrian movement of that name. Where the orthodox Cubists were concerned with processes of transforming an immediate objective reality, these dissidents placed greater emphasis on poetic content and took over from Symbolism a number of concepts based on arcane proportional systems. For the orthodox wing the rigorous constructional framework was understood to be the guiding formula and basic structure of the new evocative image, whereas the unorthodox aim was to charge that same structure with far-reaching poetic significance. For the Cubist dissident faction, which had numerous adherents in Paris at the time, Guillaume Apollinaire, the product of a humanistic education, found the somewhat hermetic but appropriate name of Orphism. The reference was of course to the mythical singer Orpheus who, still within the primeval magical unity of nature and man, raised that concept through his verse and song to an artistically shaped spiritual expression. Himself a poet, Apollinaire knew that the power of a poem welled up out of the primal mythical sense of reality in man, yet needed to work its way up the ladder of rhythm and shaped verse-forms into the consciousness and to the level where its form could be seen and grasped. Whence arises "Orphic" as a felicitous term to designate the reciprocal action of intuition and construction.

It is not improbable that Apollinaire lighted on his word with Chagall's work in mind. He knew him, visited him in his chaotic atelier in "La Ruche" (the famous "beehive" of artists' studios in Paris), dedicated a famous poem to him, and in 1913 called him to the attention of Herwarth Walden who, enthusiastic about the young Russian, in the following year organized the Berlin exhibition that launched his career. In Chagall, Apollinaire saw an unrestrained hallucinatory fantasy at work, one which called forth its images from the most primal sources and was rooted in a folklore steeped in a mystical religious faith almost beyond the ken of the Parisian intellectuals. Apollinaire saw how the young artist from the provincial Russian town of Vitebsk, with all the hunger for humanity in his youthful blood, alone and homesick, plunged himself with astonishment into the new light of France and into a human freedom which, as a Jew in Tsarist Russia, he had never known. And how, as painter, without intellectual fuss he simply assimilated the great change in painting that

the Fauves and Cubists had brought about, and this with the enraptured assent of a man opening up a path new to him yet somehow sensed in advance.

The Parisian painters were rooted in a rational tradition that they could themselves carry further: the Cubists in Cézanne; the Fauves in Van Gogh, Gauguin, and Neo-Impressionism. Not so Chagall. He was naive, was swept off his feet. What for others was a comparatively logical transformation of the usual picture, the kind which merely reproduced and idealized its subject, into an *evocative* picture—one evoking an image and a content far less easy to define—for him represented a total revolution on the artistic plane. True, in St. Petersburg, at Bakst's school, he had heard something about "the painter with his ear cut off" and about "the painter with cubes." But in 1908–09 they could scarcely be more than legends from a far-off land for him. Then, in the autumn of 1910, when he finally stood before their pictures, the encounter for this restless, searching painter from provincial Russia was overwhelming. Almost in an instant these that were to him revolutionary processes of transformation made him understand what he was himself doing unwittingly. Indeed, once that became clear, he was enraptured with his own finally liberated fantasy and wished to push the revolutionary break even further. Cubism struck him as still too "realistic," too much taken up with things of real substance and their surfaces; Fauvism he found too formalistic, too involved with the physical laws of color and with color as decoration. The Orphists, however, were something else. Instead of the restrained gradations of color for which the classical Cubists were willing to settle, the Orphists were putting into play again the entire color spectrum and all its possibilities of contrast. This was something, though not yet enough for Chagall. Using as his basis the formal and coloristic structure of the Orphic approach to a picture, he sought to intensify its capacity to communicate on the poetic level. The carefully laid out stratifications of the Cubist picture were invaded by something unheard of in cosmopolitan Paris: the irrational perception that came with the dream, vision, and legend that Marc Chagall had brought out of his very different Russian Jewish human sphere.

The Cubist crystalline structure now became filled with the hallucinatory images that surfaced in Chagall's home-

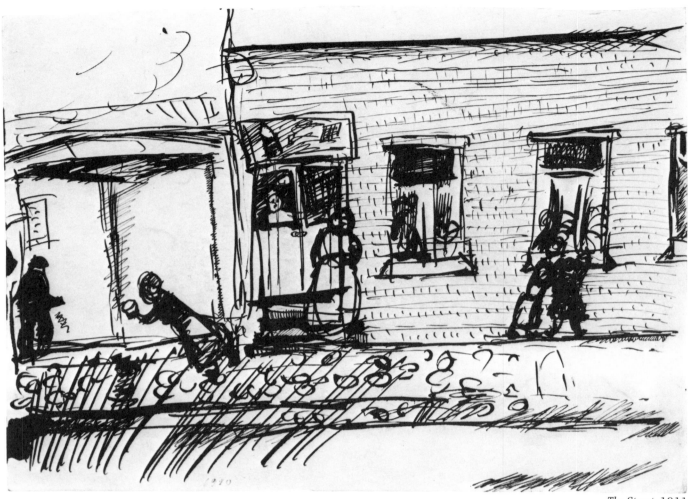

The Street. 1911

sick recollections of his native Vitebsk. The cubistically facetted planes and spatial stratifications that made up the architecture of a Cubist picture served him not only as a framework for his spontaneous pictorial fancies but also as pictorial equivalents to the layer upon layer of memory unfolding within him. They became, in fact, the "ladder" on whose rungs the whole vocabulary of images stored away in his unconscious could come to light, and it was they that made it possible to incorporate the overlying layers of memory into the interlocking strata of the pictorial planes—the Cubists' *plans superposés*. Further, grasping that the planes of the Cubists' surface constructions could also be pictorial equivalents for the psychological planes in the kaleidoscope of memory, he found he could deal with distances in both time and space simultaneously and thereby bring out his remembered images more fully than in any sort of realistic depiction that took for granted that space and time were separate and distinct.

When Chagall, speaking as a painter, referred to *constructions psychiques*, he was trying to describe this process in which spontaneous images are intimately inter-woven with those manipulations of form that enter into the construction of a picture. For Apollinaire, who was both

poet and critic, the term "Orphic" seemed more to the point and was perfectly exemplified by what Chagall painted in his first years in Paris. With considerable justification, in fact, because in those works a surge of inner visions broke through the ancient layers of memory, were given visual form through the rhythm of Cubistic construction, and resulted in pictures which were both visual poems and formal constructions. They were primal and eruptive in their origin, and rhythmically constructive in their final realizations, therefore 'Orphic.'

After this long prelude it may be easier to grasp the interplay between inventive intuition and formal construction in Chagall's creative process. In the masterly late works the two poles—initial conception and monumental execution—are separately distinguishable, yet because they originated entirely spontaneously they continue to be fraught with productive tension. The first move toward production occurs right at the start. The intuition of the creative moment is released through the drive to make a tangible, visible object, a painting, and it sets into motion the inner mechanism that produces a work of art. Because that can come about only in a state of utter concentration on the inner dialogue, Chagall's focus of

13

activity must inevitably be his very private atelier.

An artist's manner of thinking is not logical or one-track. It originates and develops in action, in *making*. It requires an appropriate technique, since a painter is nothing without the means and medium that constitute his expression. One such medium best adapted for catching the spontaneous images of such a restlessly active fantasy as Chagall's is gouache. With gouache the artist can be forever at work, and Chagall is an inexhaustible worker. In the quiet of his workplace, and in thoughtful dialogue with the world of images that spring up on the paper under his hand, in the hours of reflection (night hours often) when the capacity to dream up images grows stronger, he produces gouaches in a constant flow while oil paintings wait their turn on easels and monumental undertakings bide their time in the workshops.

Gouache—opaque colors dissolved in water and applied to paper—occupies a special place in Chagall's working system.[5] His full-scale works, right up to the monumental creations of these recent years, are based on—not merely accompanied by—an unceasing stream of spontaneous pictorial intuitions which he quite literally uncovers more than invents, often to his own amazement. For such poetic transformations and such inventive discoveries that surface in the reflective imagination, gouache is the ideal medium. The small format easily filled with minimum movement of the brush, the freedom to improvise that a full-sized oil painting can never afford, the nature of the opaque paint itself which makes for easy correcting—all these open the freest possibilities for what takes shape so unself-consciously on the paper. Gouache is the perfect vehicle for giving visible shape to the store of imagery buried in repressed fantasy and memory or concealed under the banalities of everyday happenings. Chagall nonetheless uses it in an unorthodox manner, casually mixing it with pastel, colored pencils, and chalk, and this is his key to opening up spontaneously the inner domain of the mind to giving rein to the "automatic writing" which makes those pictures meaningful to us though they may lack logic and be alien to our usual way of seeing.

There are many thousands of those gouaches. They far exceed in number not only oil paintings but also the drawings. Thus they are by no means casual marginalia to the main body of his work. Rather they are the very source of it. Almost all of Chagall's definitive large paintings go back to these spontaneous inventions. Even for the extensive etching cycles in black and white illustrating the La Fontaine *Fables* or the Bible, hundreds of colored gouaches were done beforehand or at the same time. Gouaches set the basis likewise for Chagall's first colored lithographs, a technique he first tried in New York in 1947 in illustrating *The Arabian Nights*. Using gouache, Chagall has in hand the one evocative element that is truly his own—color.

This involvement with color explains why for Chagall drawing, the usual means of most artists for working out ideas, takes a decidedly second place to gouache. As Jacques Lassaigne has pointedly remarked, drawing for Chagall is no *discipline étudiée* but *le geste initial*, a memorandum made at the start.[6] Apart from a few drawings done for line-etchings in Herwarth Walden's periodical *Der Sturm*, relatively few drawings by Chagall were intended to stand on their own. In number they lag far behind the gouaches. This can be taken as sure evidence that Chagall thinks essentially in color and, as a true colorist, responds to the suggestions of color in whatever shapes and forms he invents, whatever their content may be.

Even watercolor, which he used often in his early days, became relatively rare later. The flow of watercolor could not offer him the dense, sumptuous solid stuff of gouache which, like a magic carpet, transported his imagination into worlds no one else saw. After working with gouache in Paris in 1910, he only seldom resorted to watercolor, and then only when an ethereal conception or the delicacy of the sentiment seemed to call for so sensitive a medium. Even then, especially since 1950, for such ideas he prefers *lavis*, the India-ink wash technique which can be considered monochrome gray watercolor. His coloristic sense calls for the kind of dense intermingling of complementary colors he admires in the French, in Delacroix, Monet, and Bonnard. With gouache, which is opaque, he can intertangle skeins of color or even build them one above the other. Easier to prepare and use than other mediums, it is flexible enough to capture every psychological improvisation that color may suggest.

[5] Compare also the introduction by Georg Schmidt to *Zehn Farblichtdrucke nach Gouachen von Marc Chagall*, Basel, 1964.

[6] Jacques Lassaigne, *Chagall, dessins inédits*, Geneva, 1968.

14

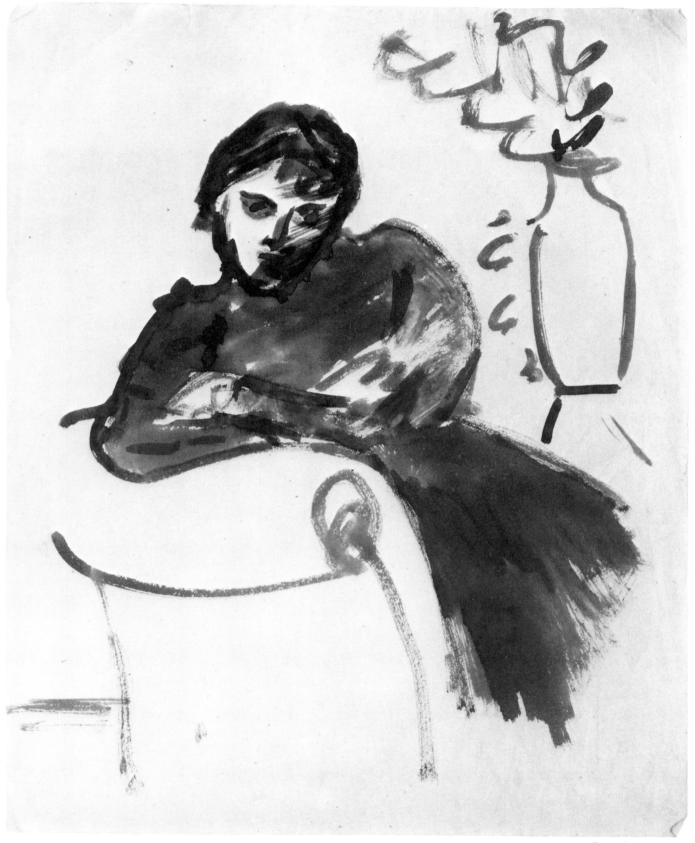

Bella on the Sofa. 1911

Precisely because of that function, gouache has had prominent use in his work at those specific stages when dream, recollection, memory, and fantasy have taken over. Where the observation of reality came to the fore, as in the Russian years after 1914 or at certain specific moments in Paris in the twenties when he followed a general trend of the time and tended to a certain objectivity, he resorted to gouache very much less often.

Once he discovered this medium in his early Parisian years, in 1910–11, he used it without stint. The list of works shown at his exhibition at the Berlin Der Sturm gallery in 1914 shows 150 gouaches to 40 oils. Since we know that Chagall showed everything he had fully finished to date, it is safe to assume that the number of gouaches was even greater.

The first Parisian years: the time when Chagall took over his new expressive means from Orphic Cubism, when, an alien in the real world of a great capital, he compressed his homesick recollections of his Vitebsk childhood into pictures that at one and the same time preserved the imprecise diversity of layer upon layer of meaning and the completeness of a past experience recalled. It was the time of that "total lyrical explosion" that Breton wrote about in 1945 (though later he would deplore it as "a grievous omission" that "at the beginning of the movement of Dada and Surrealism, which brought about the fusion between poetry and the visual arts, Chagall was not given due credit"). It was in that situation that the young painter discovered gouache to be the right means for setting down the flood of recollections welling up out of his unconscious. He turned out hundreds of gouache drawings, and some of these impromptu inventions were at the origin of the full-scale compositions of those years—*Dedicated to my Bride; Russia, the Donkeys, and the Others; I and the Village*—which belong among the most significant incunabula of the art of our century.

In 1925 gouache returned to the fore. Chagall had returned to Paris two years earlier and had begun to discover the French countryside. He accepted with enthusiasm Vollard's proposal that he illustrate the amusing moralistic fables of La Fontaine with their population of city and country animals. A scintillating, almost pointillistic, flickering way of painting, where the spontaneous play of the brush and the suggestions of color itself suffice to bring figures into being on paper almost as if without premeditation, gouache was just right for Chagall's exhilarating translation of La Fontaine's droll but sober-minded fables into unstintingly lavish, truly fabulous, Oriental settings. Once launched on that track, Chagall also seized on a new suggestion of Vollard's. The dealer, delighted by the surge of pictures his first proposal had elicited, had no trouble in turning the artist's attention to the world of the circus, which in any case had been one of Chagall's passions since childhood. The year 1927 saw a flood of gouaches on that theme. Although Chagall still refers to them as his *Cirque Vollard*, they have scarcely anything to do with the entertainments he enjoyed in Vollard's company in the latter's regular box at the Cirque d'Hiver. They are pure *Cirque Chagall*, pictorial paraphrases of the circus and its denizens which Chagall's fantasy delightedly exaggerated to the point of absurdity. Fantastic through and through, they exalt that magical world of fun and spectacle to the purest artistic unreality, to the unlikely and the impossible: a riotous satyr-play whose absurd scenes erupted into the bucolic arcadian world of the moralist's *Fables*.

After that new explosion Chagall somewhat neglected the medium until around 1932, when he began his Bible illustrations. In a constant, serene flow of invention, small gouaches accompanied his work on the biblical cycle and, thereafter, the gouache has permeated all of his painting activity. Wherever his pictorial fantasy seeks spontaneous expression, the gouache comes to his aid. With that technique he makes almost daily entries into the pictorial diary which is the record of things seen and things felt in his everyday life: it was his faithful companion through the difficult times of his flight to the United States, through the apocalyptic visions of the war, through the return to France, and in the wise serenity of an old age spent mostly along the Mediterranean coast of France. If one thumbs through the great lot of them, they seem to tell as much as the rings of a tree. We find we can read from them the inner biography of a great poet, who thinks in pictures.

I

t is not particularly difficult to set the pages of Chagall's
personal journal into chronological order. As Franz
Meyer has shown, his art has developed in broad rings
which often do not coincide with the specific years but are
nonetheless easily recognizable as possessing their own
inner consistency and chronology. The dates Chagall
himself has assigned to his sheets of drawings and gouaches
should be understood as having to do with his own inner
chronology rather than the inexorable sequence of every-
one else's calendar. He neither signed nor dated the mass of
his drawings and gouaches when he did them, and when
they bear dates, these were often assigned much later and
are at best approximate. When upon occasion he had to put
some of those on show, as in the Berlin exhibition of 1914,
he appended signatures and dates that were often not even
good guesses in the case of works done some time before. In
later years, pressed by friends or by his own not very well
developed sense of order to put the innumerable sheets in
his portfolio into some sort of rational arrangement and to
assign proper dates to them, he ends up in rapt
contemplation of forgotten treasures and, after a modest
effort to remember the when and where of them, delivers
himself of a deep sigh, shuts the portfolio, and goes back to
whatever new work he has in hand. Like many artists,
fussing over exact dates strikes him as time wasted. His
personal calendar is marked off in the separate phases of his
life and work, more than in any mechanical succession of
days, and mostly, within that context, he does hit on the
appropriate date. If ours sometimes differ by ever so little
from those Chagall himself has proposed, it is because he
thinks in "phases," not years, and we should not like to
have to answer for our own pedantry if challenged by
Chagall's subjective chronology. Whatever else, his dates
do match the inner consistency of the sequence of his own
phases of life and work. The first group of works among
those surviving that still testify to a personal experience and
approach comprises drawings and watercolors done before
1910. They go back to his learning years in St. Petersburg
and reflect his emotions and excitement at a time when he
was learning how painting really is done. At nineteen he
had left behind the friendly little world of Vitebsk and the
protecting warmth of a family poor in wealth but rich of
heart and of a Jewish community whose faith and
ceremonies had impregnated every aspect of his family life.

He moved to St. Petersburg in the winter of 1906–07.
There his living conditions were of the worst, he was full of
misgivings about the art school, and was inwardly resisting
what it had to teach him. Not until the autumn of 1908,
when he could enter Léon Bakst's school, did the youth
from the provinces finally, if slowly, become aware of the
exciting prospect of modern painting. Although Bakst, that
clever, widely traveled, cosmopolitan painter, clung to the
international Symbolist style in his own painting, he was
well acquainted with the new developments in Paris, and
these were all the talk in his circle. In his school the young
Chagall heard about the extraordinary saint of Aix, about
the painter who cut off his ear, about Gauguin and his
invectives against European civilization from which only
the primitive could rescue art. And he had already heard
about Matisse and his explosive colors and the expressive
ornamentalism of his highly colored decoration. From those
years there are nude drawings by Chagall which in their
summary ornamental use of line recall Matisse's broad way
of drawing with its concentrated abbreviations. Even if he
still had no direct acquaintance with those names and
terms and approaches, the ideas they opened up to a young
painter in quest of himself were highly stimulating. In them
he felt he could recognize pictorial approaches that already
stirred within himself and in which he could get a clearer
glimpse of what so far had been largely unconscious with
him. Yet, whatever the primal source reflected by those
names and words, his own experience remained steady and
sure within him, his deep roots in the simple life of Vitebsk,
in Russian folklore, and in a naive hallucinatory religious
faith. As often as possible, during holidays or whenever he
could arrange it, he returned to his native town and steeped
his imagination in the sights of that simple, unsophisticated
life. Somehow, too, the new ideas from abroad seemed of
great help in forming those images into pictures.

Two small works, a pencil drawing and a watercolor
(plates 1 and 2), let us glimpse that rather particular state
of uncertainty in which the young Chagall found himself at
that time, caught between a naive delight in story-telling
and a concept of style that was already taking shape. It is
precisely that hint of a style that speaks for a date in the
winter of 1908, thus after enrolling in Bakst's school. The
drawing (plate 1) shows a peasant dance in a country
tavern. Two couples, the one to the fore rather grossly

peasantlike, the other already a little citified, heavy-footedly circle the deep room where the tables have been pushed back to the sides to make space for dancing. The newlyweds too, rather dwarfish and gauche, get up to join the dance. All of it is observed with a keen eye for what is comic in the way people move and gesture. But there is also an ornamental movement in the graphic signs—the arabesqued curve of the dancers turning from the empty foreground to the midground, the ornamental fermatas made by the chairbacks, the fleetingly sketched flat wallpaper pattern across all the walls—and this suggests a specifically "modern" approach. Yet the line is still coarse, summary, rather awkward, and in the newlywed couple is even naive or "primitive." But then too, the way objects are drawn—bottles, plates, chairs, the hanging lamp—has the demonstrative character of "naive" art in which the simplest things are simply set down as things in themselves.

This very personal mélange of a naively direct manner of observation—one which is virtually hallucinatory in its poetical aspect—with a recognizable intention to make a "modern" picture gives us an insight into the young painter's frame of mind at the time. On one side there was the familiar reality of Vitebsk which already, through a slight shift in the way of looking at it, was beginning to take on something fantastic. On the other side, the exciting notion of a new kind of painting scarcely known beyond the "names and words" picked up from Bakst. Chagall knew something about Symbolism, its expressively ornamental repertory of forms on a flat surface, its idea of real objects as poetic metaphors. This readily linked itself with his personal animistic rapport with things, which went back to a child-hood so poor that his only playthings were everyday house-hold objects: "To handle them [those things], to reflect on them, and to dream, that was how I played," he recalled later.[7] But also he heard about something called "nature lyricism" which, rooted in Millet and the Barbizon School, elevated the expressive elements of nature into heightened color and expressively simplified contours, and whose expressive means had been exaggerated to the point of ecstasy by "the painter with his ear cut off." And Gauguin! The stirring tale of a painter who slammed the door on everything civilized and hid away first in a lost village in distant Brittany, then as far off as Tahiti, and did so in order

[7] Meyer, p. 24.

to find his way back to a totally original way of painting outside the stylistic conventions of his own culture so as to express the mythic element in nature and life. What a fantastic legend for a highly imaginative young painter from a small Russian town! In Gauguin's circle, among his pupils in Pont-Aven in Brittany, the catchword was the unusual term *gaucherie*. It meant crude and rough, "unrefined"—a kind of drawing simplified to the point of "primitivism," one that shunned all virtuosity and bravura.

If we apply the historian's tools to this drawing by Chagall, the impact of these new notions is plain to read in the undulating ornamental way of harmonizing the figures, the expressively simplified definition of everyday objects, the theme of a simple unspoiled world, the *gaucherie* of the line. Nor is it difficult to cite something comparable. A similar style of drawing is found in certain schools of late Nature Lyricism when that approach had already become international and was transforming itself into Expressionism in the school of Pont-Aven, for one, and in its offshoots in Belgium and Holland or the German group at Worpswede. There are striking parallels, for instance, in the late drawings by Paula Modersohn-Becker from 1905–06, with their reflections of Gauguin.

We see, then, how the "modernism" that glimmers through in Chagall's drawing of a country wedding derives from the Nature Lyricism of the turn of the century, which was so indebted to Gauguin but owes something also to the syncretistic vocabulary of a Symbolist art of expression such as permeated Bakst's teaching. Not that there could be any direct connection with the former of these influences. Even the name of Paula Modersohn-Becker would have been unknown to Chagall. The influence was only of the most generalized character, that of Modernism that was spreading through all of Europe in those years. But even after we have consigned all these vague suggestions and associations to a general style of the time, Chagall's drawing still shows the authentic visual approach of a naive, direct observer caught up in his theme and his milieu, with something hallucinatory or hallucinated about it, and in which the new ideas of form were present but still mostly below the surface of awareness.

Much the same is true of the watercolor *The Musicians* in the same format (plate 2). Again a Russian village scene, this time with itinerant musicians begging from the

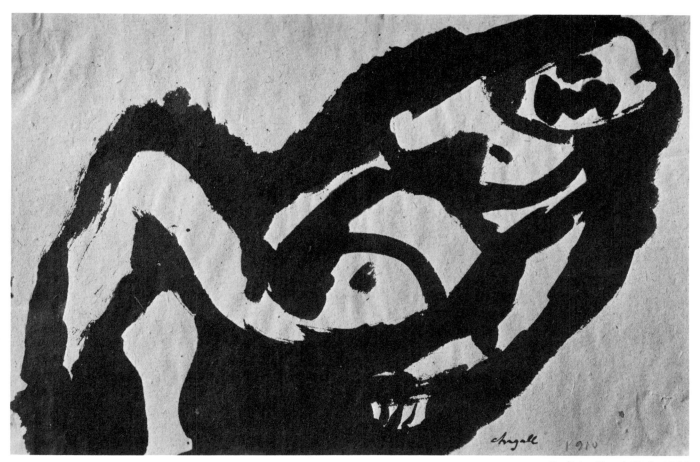

Reclining Female Nude. 1910

listeners and passersby on a snow-covered village square. Contours and color are both markedly simplified. The color is dark, tonal, restrained, tuned to the harmony of grayish violet with damped-down accents of blue and red, grayish white and ochre, something not unlike the colors used by the Nature Lyricists. All sudden bright notes are avoided, the scene is permeated with a warm honey-yellow light which contrasts with the cold grayish white, and conveys the mood of a simple legend recounted in a folk song.

Be that as it may, behind the simplicity of the village scene and the *gaucherie* of its representation there lies a conscious concern with form. The odd position of the feet on which the figures rest has its significance for the spatial organization of the surface as a whole. Each of these seemingly crudely delineated resting points for the eye serves in fact in outlining a spatial plan. Their ground plan establishes the vertical elevation of the spatial planes. In this way the four figures to the rear in the midground constitute something like a surveyor's bench marks for the picture and, in combination with the house fronts parallel to the plane of the picture, help establish the various strata. This rigorous arrangement of the spatial strata binds the perspective space into a latticework of flat planes in which

each one maintains its relationship to the surface. The result is in fact a unique crystalline structure which does away with any illusionistic feeling of space.

Thus, if we were to think of this watercolor as a spontaneous expression, it would be only half the truth. The fact is, it already contains a conscious and, in a sense, even provocative rejection of the impressionistically inclined realism in vogue in Russia at the time. Chagall, after all, was twenty-one, not a boy. Even in Vitebsk he had belonged to a circle of intellectually enthusiastic young people among whom he played the role of "artist," and that he found that role congenial is obvious from the numerous self-portraits of those early years.[8] On the evidence of his first pictures it would have been easy for him to settle down into a conventional realism. But that was not for him. He was already taking up the cudgels against that sort of stylish style, already suspecting that in the "names and words" bandied about in Bakst's school in Petersburg lay the way to escape it. Returning to Vitebsk on school vacation, he found himself before a pristine reality permeated with memories which, within his poetic character, took on a fantastic quality that he wanted to

[8] Haftmann, commentary to plate 1.

19

express in a strikingly different manner: simply, naturally, ornamentally. In this the "modern" ideas were a boon. The *gaucherie* and the surface organization of the pictorial space that we have remarked on were the sort of "modern" means that could help him shape pictures out of his personal vision.

But they were means he knew little about and had never seen put to use by others. What he had, though, was a subject matter entirely his own and an approximate concept of a direct personal style appropriate to his own direct vision of things. That concept was bound up with news of revolutionary developments in Paris. From this came an overwhelming desire to go to that Mecca of modern painting, so as to implement what were so far only "ideas" with sight of the real thing. In the spring of 1910 his teacher, Bakst, was enticed to Paris, and this may have been the decisive incentive. Equipped with a small stipend from a St. Petersburg patron, Marc Chagall of Vitebsk moved to Paris in the same year.

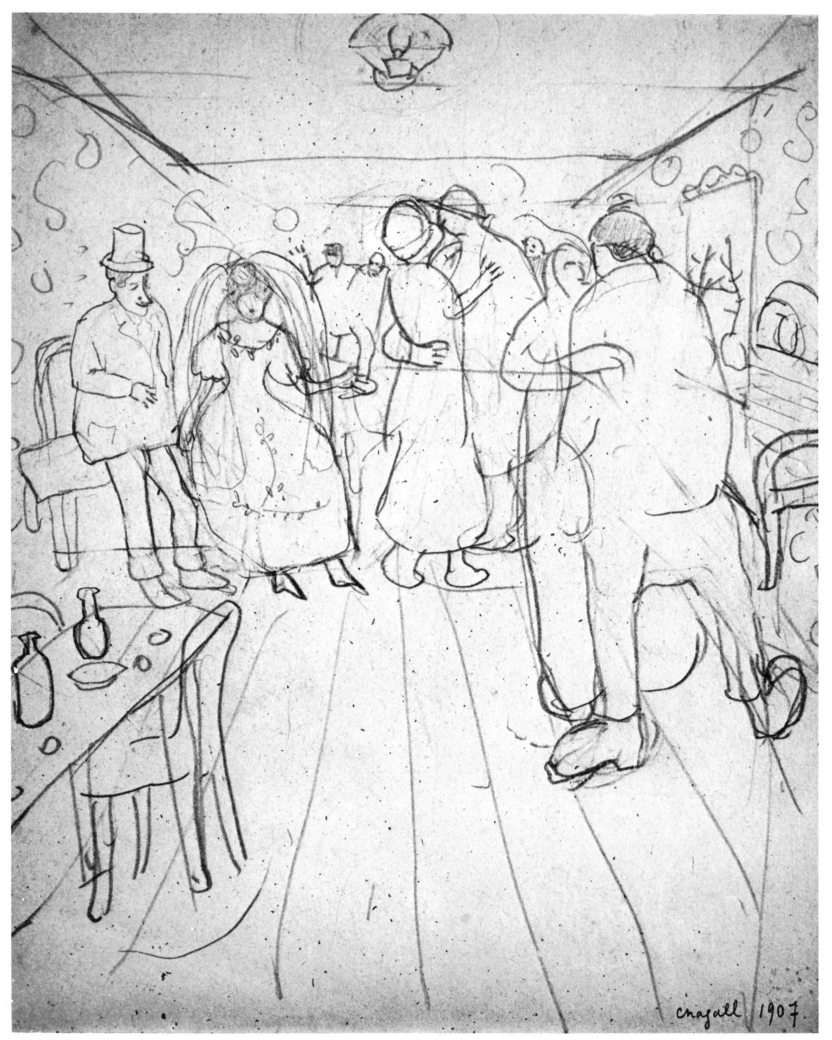

chagall 1907.

Plate 1

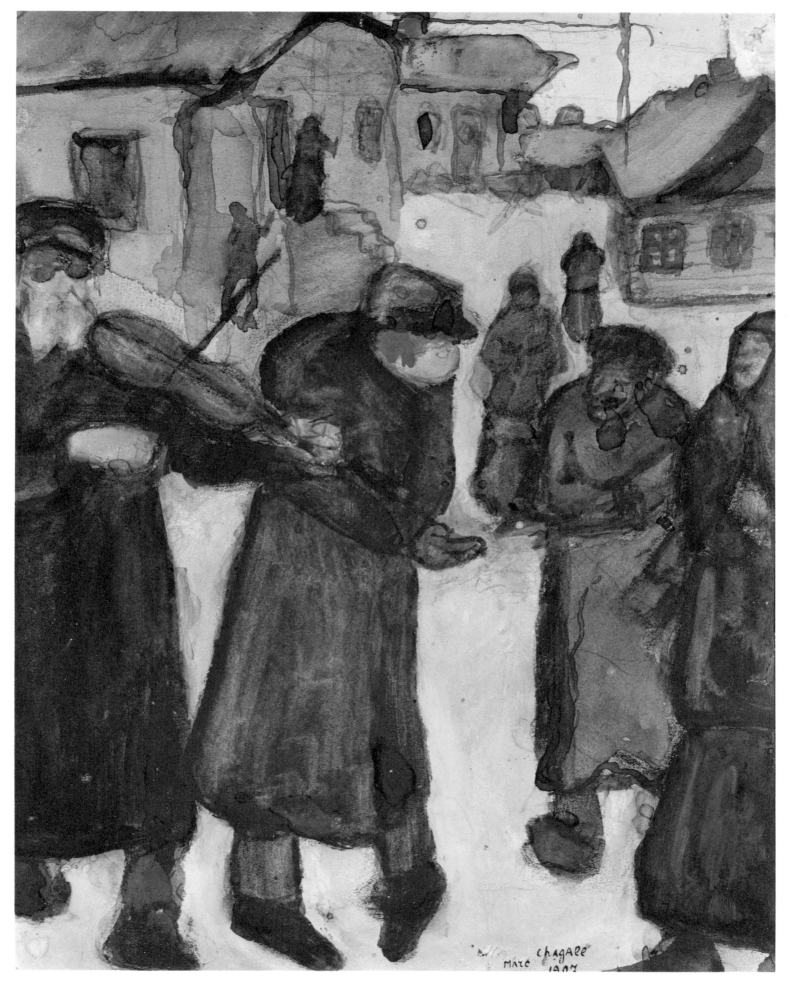

Plate 2

Chagall arrived in Paris in August, 1910. Only in the winter of 1911–12 was he able to find quarters of his own in "La Ruche," a run-down studio building on Rue Vaugirard near the slaughter-houses. There he found himself in the midst of the international bohemian life of Paris, and in that milieu of painters and poets he was quickly dubbed *le poète*.

The Parisian experience was overwhelming. He was enthralled by the clarity of the light that had won Paris the name of the City of Light. He was enthralled too by what, for this Jew from Tsarist Russia, was an entirely new experience in human freedom. On his daily excursions through the teeming life of Paris, he was unfailingly astounded by the easy relations in a population that took for granted their own and others' freedom to act as individuals and to let others do what they themselves might not care to do. Chagall's own world of painters and poets gave him an immediate example of this: individualists of anything but conventional comportment, they were marginal to society yet regarded with sympathetic tolerance by their fellow Parisians.

This same casual freedom to do as one liked surprised him also in his own professional domain. As soon as he had oriented himself in his new environment he took himself to the Salon des Indépendants and, as he tells it in his memoirs, "plunged into the heart of French painting of 1910." There at last he could see for himself the explosive color of the Fauves, the studied simplicity of the Naive painters, and the constructive approach of the Cubists which, for all its basis in objective reality, struck him as virtually abstract. He was almost literally bowled over by the extent of this liberating revolution. "Here I entered it fully," he recalled, and "no academy could have given me everything I discovered when I got my teeth into the Parisian exhibitions, the gallery windows, the museums."[9] Gauguins and Van Goghs were to be seen at Bernheim's gallery, and he recalls one-man shows by Bonnard and Matisse. Dazzled by the éclat of color set free and by form that shied from no deformation and cared only for expressing a subjective concept, at first he could see only the unlimited freedom for his spontaneous creative impulse and could turn his back on logic and rationality. Alogical, irrational, heeding only his inner voices, this seemed to him

then the one true way to create, and he welcomed every folly and foolishness: *Que notre folie soit la bienvenue!*[10]

In his first Parisian years, consequently, what he produced carried further his impressions of Van Gogh, Matisse, and the Fauves. He recognized immediately Van Gogh's hallucinated vision as something familiar to himself. Not quite so immediate, though, was his appreciation of Matisse's ingenious use of color aimed at a carefully worked-out overall harmony of the colored surfaces. In Matisse he admired above all the autonomous brilliance of the colors and the spontaneous and ornamental way they were disposed. He found himself in full agreement with the Fauves, young men more or less his own age who based their work on Van Gogh and Matisse but, entirely to Chagall's own liking, thought of the "tubes of color as charges of dynamite," as the young Derain liked to proclaim. It was the paroxysmal intensity of their color that encouraged the young Russian to give full sway to his own explosive fantasy.

At that time Chagall worked for and by himself. Days were spent visiting galleries and museums and in losing himself in the life of a great metropolis. A foreigner and alone, as he walked about the city it took on fantastic aspects strangely jumbled together with reminiscences of Vitebsk. Back in his studio, before his easel, replete with the experiences of the day, he gave unbridled rein to his super-heated fantasy.

His use of drawing line and of color changed radically. A surviving *Self-Portrait* (plate 3) from 1911 shows us the Chagall of the time in a concise summary: young, sensitive, with an alert gaze. But psychology and narrative were no longer the chief thing, and his drawing was reduced to an economical, pure line. In this likeness a few broad strokes of French chalk mark out, underneath the drawing, a firm and almost abstract graphic framework. Over them the drawing itself, with its broadly swinging flow of lines, delineates the pure contours of the face against the white ground without modeling them or giving them any physical weight. The outlines play across the surface, coil ornamentally in the hair, come to a firm end in the lineaments of neck and shoulders. Their course fills the surface right into the corners with a highly mobile ornament. At the same time, by making the line denser or

[9] Marc Chagall, *Ma vie*, rev. ed., Paris, 1970, p. 144.

[10] *Ibid.*, p. 155.

thinning it out to give a feeling of distance, the surface is made to appear to catch and hold light. The flat, uniform light of the paper itself is transformed by the lines inscribed on it, becomes bright in the broader parts of the left half of the face, dimmer in the right where the lines lie more closely, then becomes a brighter plateau in the flat forehead. This is an entirely autonomous pictorial light, however, which streams out of the surface itself under the impact of the drawing. It has nothing to do with natural illumination. Matisse's approach to drawing is much in evidence here: spontaneous, ornamental, filled with an autonomous inner light which the line, in response to the expressive content, modifies. Yet in its impetus the linear drawing here goes beyond the cool serenity of that painter and moves toward a stronger charge of expression.

As mentioned earlier, Chagall's expressive urge found its natural field in color. In Paris he became acquainted with the use of opaque pigment dissolved in water and brushed in on paper—gouache—and immediately made it his own. It was to remain his favorite expressive medium because it permitted spontaneous improvisation. The material was cheap, any paper would do. In his straitened circumstances the young painter could seldom afford canvas, and then only when the results promised to be worthwhile. Gouache facilitated the preparatory work, proved very useful in inventing and clarifying themes, readied his creative faculties to move on to larger formats. In his four years in Paris he turned out hundreds of gouaches which prepared the way and culminated in scarcely more than forty full-size canvases.

Naturally enough in that city, Chagall's work in Paris seems to have begun with nude studies. True, the doctrinaire Cubists had elected the still life and the landscape as the ideal motifs for their geometrical disciplining of form. But with Matisse's *Dance*, large-size figurative composition made its way again, though on the wholly transformed plane of modernism. It was there that Chagall, who was and remains essentially a figure painter, found his incentive. His nudes, though, were something else again. The *Red Nude* of 1911 (plate 4) shows what he could do with that familiar theme. The figure is freely invented, something spontaneous out of a dream. Any resemblance to nature is incidental. The vividness of the

color makes this work claim one's attention as forcefully as a flag in the wind. A blood red body flashes in silhouette across a golden yellow ground. Green as complement to red, blue to yellow, make the contrasts. A warm reddish brown modulates the ochre tint of the brownish paper which here and there shows through and sets the basic chord for the other colors. Spurts of light and opaque white lines reinforce the contour and, by their blankness, firmly establish the foreground plane. Then, staggered in very shallow planes, come the principal colors, from red to golden yellow to blue, and they repeat that play in the dense ornamentation of the foliage. Everything is flat, on the surface. The feeling of light and spatial gradation emanate only from the disposition of the colors. They are purely autonomous pictorial equivalents to natural illumination and natural space. Across this spatially agitated surface is inscribed the arabesque of the body which fills it with its ornamental shape. It is impossible to say whether the figure is lying or kneeling, and indeed the swing of the body is so strong as to make it seem to spring up or even fly: an acrobatic dancing figure in the fulsomeness of delight in living. If one senses a distant echo of the dithyrambic dancers in Matisse's oversized canvas, it is quickly forgotten in the expressive spirit of the color and in the ecstatic gesture. This gouache is no descriptive depiction of a nude figure but, instead, a kind of poetical "figuration" which spun itself almost trancelike out of the theme when Chagall, bent over his sheet of paper and spurred on by the suggestions of his colors, created a counterimage, so to speak, that responded to his mood.

On occasion Chagall attended evening life classes in private academies where "modernists" like Le Fauconnier and Ségonzac taught. A nude drawing from 1911 (plate 5) was obviously done in the artificial light of such an evening class. Its medium is *lavis*—wash drawing—which he had never used before. The nude is very carefully observed, yet the approach to form is deliberately ornamental, with the arm movement transposed into a dynamic pattern and the displaced, swaying contrapposto of the legs deformed in exaggerated fashion.

This concern with form is clearly legible in the "invented" drawings which do not seem to have been done from life. In the *Girl with Fan* (plate 6), an India-ink pen-and-brush drawing belonging to a group of nudes done

in 1911–12, the half-figure makes a whirling ornament across the surface. The sharp contrast of black on white makes the white body stand out almost luridly and outlines it with a stormy contour that clearly grew out of the rapid sweep of the hand across the paper. Two large S-shaped curves delineate the body. Heedless of deformations, the artist's sole concern was to capture this driving movement within a graphic pattern. The turbulence of the graphic movement in the glistering contrast of light and dark gives an effect almost of terror, as if the girl were in flight and looked back an instant with head in profile. Unexpected, curiously soft ornamental details—the fan, the highly refined foliage-like patterning of the hair—contrast with the motif of fright and flight. A feeling of startled fear is transformed into an evocative ornament to make a drawing utterly original in vision, rhythmical and ornamental in realization.

In the gouache *Nude with Flowers*, also of 1911–12 (plate 7), the same formal characteristics are in evidence but the color has become more sonorous, tuned to an overall reddish brown. Likewise the organization of planes is more decisive. Although every detail is spread out on the surface like a carpet pattern, a strong impression of depth is conveyed by the markedly projecting flower pots and by the way the light yellow sets up an impression of distance from the red, which therefore tends to recede into the background. There is good reason to interpret this spatial organization as an initial influence from the Cubists' *plans superposés*. The geometrizing way of treating the nude and developing it across the surface is further evidence. If these elements taken over from French Cubism are relatively rational, they are tempered poetically by a strong dash of naivete. What began as *gaucherie* had taken on naive folkloristic elements, and it is these that give the picture an unmistakably Russian tone. The small gouache in fact recalls Russian *Hinterglasmalerei*, the painting done on the back of a sheet of glass in which peasant piety found a homely substitute for the costly icon. As for the color, it has little in common with the well-harmonized equilibrium of French coloring. It likewise is "Russian," highly expressive and mystical in sonority. For anything comparable in painting of the time, one must look to what Jawlensky was doing in his early years in Munich. And Jawlensky, it should be remembered, likewise was a Russian spurred to

an intense concern with color under the influence of Matisse and the Fauves and he too transformed the French lesson into a Russian expression. In Chagall's gouache, what strikes one most is precisely this Russian reinterpretation of the Fauves' use of color from something decorative to something mystical. Chagall, however, was alien to the rather gloomy mysticism of the Russian nobleman Jawlensky. Whenever mysticism, however we interpret the term, came too close to Chagall—and he has himself said how susceptible he was to "the mysticism of the icon and Hasidism"—he tended to play it down with elements of the burlesque so that, as Klee wrote under his own etching of Perseus, "wit may conquer woe."

This Russian tinge was by no means fortuitous. Chagall was homesick. The old Vitebsk with its familiar wooden houses and inhabitants shimmered like a gold ground through the young man's new existence. When of an evening he sat down at his work table, his fantasy dwelt on scenes of home. Familiar figures out of the past who had left their mark on his dreaming childhood came forward and claimed their place on the paper in front of him. In the remoteness of memory those familiars took on the remoter character of legends. The old fiddler of his childhood playing his songs in the snowy village streets was one of them, and in a swift script the artist put down the look of him (plate 8). But he let him grow large as a saint on an icon and surrounded him with the attributes of a world a thousand miles away, like so many captions of commentary: houses and churches, a tree, a horse, the tiny listeners, and over it all the angels taking the simple melody up into the spheres of heaven. And because those individual pictorial comments were meant only as evocative allusions, it did not matter if, like the horse here, they stood on their heads. Their emblematic content remained the same, indeed was strengthened through such unexpected illogical contrasts. It was out of such hasty hallucinatory notations that, like an unavoidable obsession, there grew a solid pictorial concept which finally, in 1912, matured into the full-scale oil painting, *The Fiddler in the Snow*.

In Paris Chagall remembered the hackney coachman, comic and frightening at once, whom as a child he had seen waiting for fares on the squares of Vitebsk and who, like gendarmes and soldiers, incorporated all the fearful authority of the grownup world. So, dreaming back, he

built himself such a giant in a long padded coat, stood him in an artless pose as in an old-fashioned photograph, and to make the lout look even mightier reduced his droshky and horse to unlikely dimensions (plate 9). As format he chose the oval that the village photographer and his clientele found so elegant. Because of the naive *gaucherie* of the depiction, the theme is displaced into the fairytale sphere of a childish dream. In this the unrealistic color also does its part. It is laid over the surface in a broad series of bands that make one think of the empty distances of the steppe traversed by a swarm of birds. The red-haired head looks like a mask in front of the cold green of the dome of sky: unexpectedly the bold coloring of the French Fauves has been given a symbolic mystic quality. "My subject matter I brought with me from Russia," Chagall has written, and then added, "Paris cast its light on it."

This was meant metaphorically of course. Yet the most important discovery Chagall made in his early years in Paris was in fact color in its entire spectrum and the light that can emanate from color and from paint itself. "Light" here however means also another, intellectual, illumination—the crystalline facetting of pictorial construction which the Cubists were working to achieve. It was sometime around the end of 1911 and, even more, in 1912 that their ideas began to overlay Chagall's natural enthusiasm for the Fauves' strong colors. And just as he made that colorfulness serve his personal poetics, what interested him in the Cubists' prismatic diffractions of the picture plane was not so much the formal structuring as the possibility of enhancing the poetic capacity of the body of the picture. Essentially he understood the formal structuring of Cubism as metrical and thought of the gridlike structuring as a kind of magic crystal through whose kaleidoscopic diffractions the image of reality still shines, though transformed into something entirely poetic.

There is a drawing of Russian peasants in a religious procession (plate 10) which, very much later, Chagall dated 1909, though I, and Franz Meyer also, place it around 1911–12. It shows his new concern with how a latticework of light can break up the entire picture surface. The figures are packed densely into a box of space, all facing the officiating *diakon*, who chants from his book. Each figure is rendered in angular abstraction and reduced to simple forms laid out on the surface. The three women making up

the main group and the figure of the *diakon* solidly establish the surface stratification. Above them, a circle of heads sets up a rhythmic spatial barrier which is more fine-detailed and ornamental. Throughout the drawing the objective form is abstracted into a geometrical ground pattern with circles, triangles, rectangles, rhomboids. The empty space below becomes an entirely abstract configuration of geometrically interlinked *plans superposés*. The crystalline diffraction of the form follows the illumination of the flat spatial planes in a manner quite independent of reality. The candle carried by the foremost peasant woman serves only as an evocative sign and has nothing to do with the lighting. The result is a mirror field broken up into prismatic forms, a magical kaleidoscope in which the simple reality of the pictorial subject is answered by and transfigured into its counterimage.

Chagall found that fantastic tales could be invented using these apparently merely formalistic manipulations. In memory, numerous uncontemporaneous images overlie each other and create *plans superposés* out of separate psychological layers of recollection. It finds its pictorial equivalent in geometrically facetted and folded planes. For the visual record of such dreamlike improvisation, gouache was the means of choice. From a great output of gouaches there then filtered out large compositions requiring more effort. Before it appeared in oil, Chagall's famous theme of the *Cattle Dealer* existed as a gouache (plate 11). It goes back to the memory of an excursion he made as a small boy with his uncle, who was a cattle dealer and whom he describes so vividly in his memoirs. The personages in the story are aligned as in a frieze, and objects take on the same narrative force as figures. The Russian peasant wagon, with its lopsided wheels creaking and groaning over the uneven ground, is the vehicle for the story as well. It carries a peaceful blue cow and is pulled by a little red horse with an unborn foal in her belly. The uncle perches on the edge of the wagon, throwing himself around and gesticulating, cursing, kicking, brandishing his whip as he goads on his pretty little horse. Behind him walks—floats?—a peasant woman carrying a calf over her shoulder. At the lower right a peasant couple—only their heads are in the picture field—comment on the odd conveyance. The drawing possesses that simple strength of definition that successful pictures by Sunday painters or children can sometimes

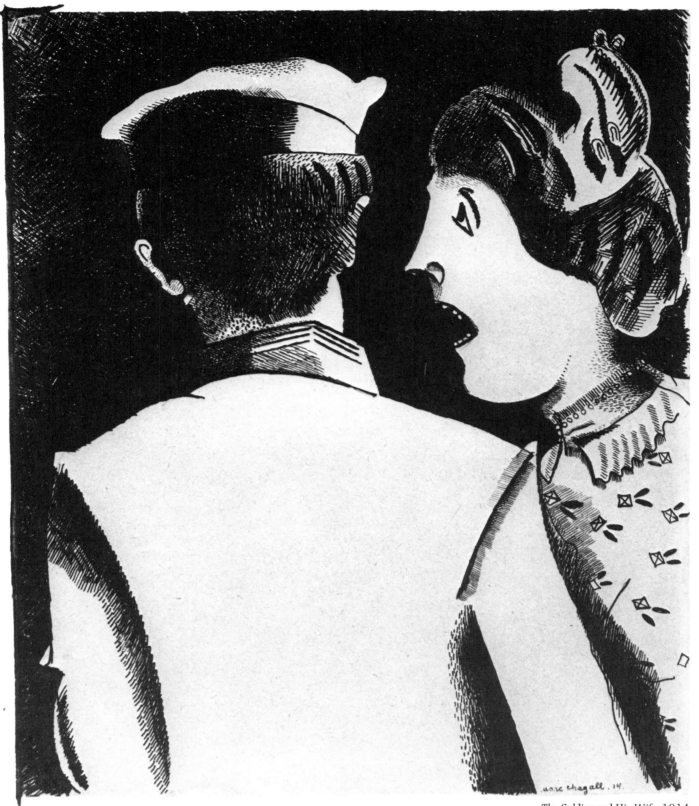

The Soldier and His Wife. 1914

attain. Yet, in its ornamental incorporation of the parts of the bodies and their movements into the picture surface, it rises to an astonishing artistic quality. The color, for all its striking exclamation points in the blue cow and red horse, remains restrained. From the brownish red of the ground in the left half of the picture it develops into the dusky grayish blue on the right where the patient little horse quits the warm solid earth to try its first confident steps through the air. Blossoming branches tell us that the fairytale world through which the wagon rides is in fact a dreamer's paradise. Yet more than the color as such, it is the prismatic fractionings that the opaque paint spreads across the surface that contribute to the mood of something far-off and unreal. They transform the surface into a non-perspective space that is itself unreal and yet makes the scene we see a real part of it. When we look closer into this prismatically facetted flat surface shot through and through with colored light, the scenery shifts into a different dimension and is transformed into the pictorial equivalent of the remoteness of things remembered. The formal suggestions that Chagall took from the Cubists are transformed here into the means of a visual poetry. Color, to which the orthodox Cubists conceded only a minimal place in their rigorous constructional schemes, irradiates Chagall's composition with fairytale light.

In Chagall's interpretation, the Cubist devices served to give poetic relief to the reality depicted. An interpretation in accord with his own human character, it represented a specific choice within the Cubist stylistic currents, that of the splinter-group of the Orphists. Their particular appeal to the young Chagall must have been that for them color played a decisive role in the construction of the picture. In the rigorous Cubism of Picasso, Braque, and Gris, color was restricted to the earth colors used almost mono-chromatically in order to bring out more effectively the harmonic background underlying the assemblage of objects. The Orphists, on the contrary, retained the entire color scale for its poetic as well as constructive qualities. Their leaders were Delaunay and Léger, and the latter's *Les Noces* of 1911 was of great significance for Chagall. With Delaunay, whose "window-pictures" of 1910–11 showed how poetically colored light can irradiate a crystalline construction rooted in natural scenery, Chagall enjoyed a close friendship. Through the writer and critic Canudo, who published an avant-garde art review, Chagall met the

other members of the group as well: Gleizes, De La Fresnaye, Le Fauconnier, Metzinger, Marcoussis, and Lhôte. Invited by Delaunay and Le Fauconnier, it was under their aegis that he showed his first pictures in the Salon d'Automne of 1912.

For all his affinity to that circle and to the many lessons he took from them, Chagall nonetheless remained critical of them. Cubism as a whole he found still too "realistic," too much taken up with images of real things and too little with the fantastic lurking behind reality everywhere. "I had the impression," he wrote in his memoirs, "that we were still remaining on the surface of material subject matter, that we were fearful of plunging into chaos and breaking through the customary surface and treading it under-foot.... All those questions—volumes, perspectives, Cézanne, African sculpture—lay in ruins around us...." What was needed, he felt, was "a revolution from the ground up, not merely a revolt on the surface."[11] This inner anarchy was fostered by the hallucinatory power of the poetic visions to which he, as a painter untroubled by theories, wished to give spontaneous expression. It was only with Delaunay, who at that time was pursuing an entire cosmological metaphysics in his color principles, that he found himself in accord, although the French intelligence of his friend did seem to him remote indeed from the primal sources of his own pictorial fantasy.

Since his imaginative bent found only slight satisfaction in the company of the painters, Chagall—nicknamed *le poète* by his friends—turned to the poets. He revered Max Jacob, knew André Salmon, was closest to Blaise Cendrars, who supplied him with a number of titles for his pictures and whose manipulations of isolated words having multiple significances matched his own manipulations of polyvalent images. But it was Guillaume Apollinaire above all who, as art critic, made Chagall see the poetic possibilities of Orphic Cubism and, as poet, subjected association-laden nouns and fragmentary sentences to constructional processes that brought out poetic meanings transcending the words themselves. Chagall admired this approach of the "young Zeus," his name for Apollinaire, and found in it a literary parallel to the way he himself was working with images. "In verse, figures, and rhythmically set syllables Apollinaire showed us a way," he would say later.[12]

[11] *Ibid.*, pp. 143, 155.
[12] *Ibid.*, p. 158.

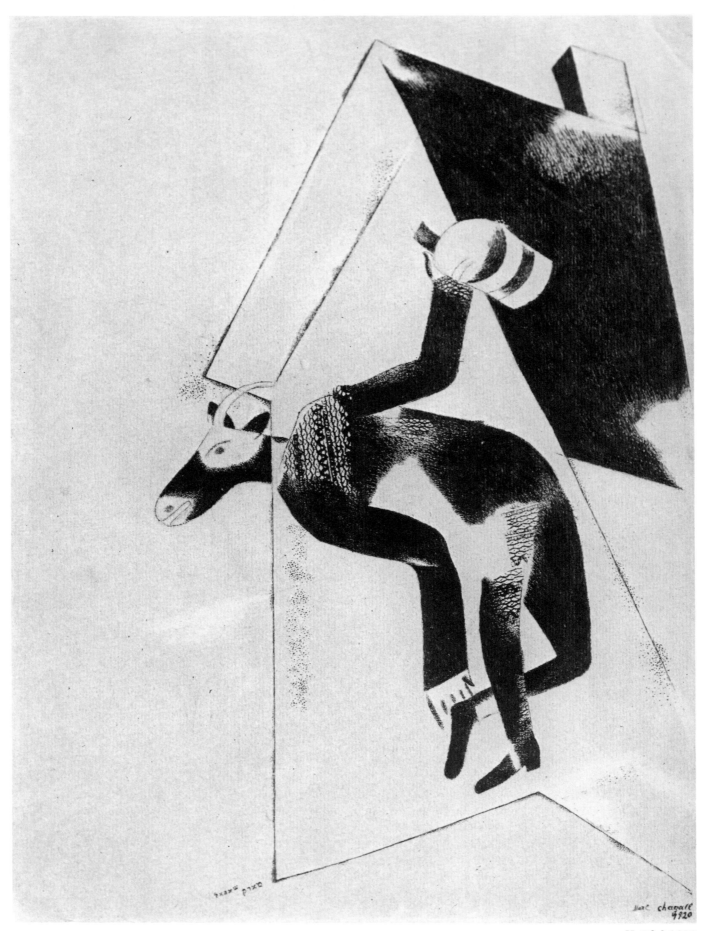

Untitled. 1920

There is a drawing which is a true *Hommage à Apollinaire* (plate 12). It was dashed off on a sheet of paper that already had on it a number of sketches for pictures: a vase of flowers, a wooded landscape, and, not least, in the lower left a man at a table with bottle and glass. Since the latter element is closely related in composition to the paintings of *The Drinker* and the *Portrait of the Poet Mazin*, the drawing can be dated to 1911–12. The poet is pictured half-length, with the attribute of his profession, a pencil, in his hand. True to Cubist doctrine the figure remains on the surface, and only the full, moonlike face is treated with greater delicacy as a soaring form. An abstract half-circle, segments of arcs, a full circle at the upper left, but also the oval of the hat carry on the motif of the soaring sphere, as if they were all helping to bear the planet-like face aloft. Evocative signs—tersely indicated frontage of Paris houses, the Eiffel Tower, which seems bent as if by the sheer radiating force of the round face—suggest the poet's milieu. A tiny hot-air balloon soars skyward like a spark of inspiration. With these swiftly sketched signs the portrait is transformed into a poetic metaphor spontaneously conjured up out of what Apollinaire would call an Orphic ground.

Weary of all the theoretical experiments, sure of his own inspiration, Chagall went ahead interweaving the bits and pieces of memory into his own poetic primal terrain. In hundreds of gouaches that followed one another between 1912 and 1914 he was passing in review his recollections of the remote dreamland of childhood. What he recalled was almost exclusively country life in Russia and the great days of the Jewish calendar which had marked the phases of his young life into solemn segments. Fauve color, Cubist constructivism were of use to him only as means for giving a legendary cast to the images he was rescuing from time past.

He remembered peasants returning home preceded by a woman carrying water across the span of fields (plate 13), and he turned it into a rainbow-colored circular prospect under the heavy infinite blue of the sky across which, as if on tracks laid down in advance, the figures pass in the rhythm of a long day's work, going up and going down as if the *sens giratoire* were moving them on a slowly rotating disk across the picture stage. It was Delaunay's word, that *sens giratoire*, the sense and feel of rotation, meaning the innate capacity of color to rotate across the spectrum into

another color, and which he said paralleled the movement of the cosmic bodies, of the sun and moon. It was this that Delaunay strove to convey as equivalent to the abstract movement of color in itself. In fact, in Chagall's forcefully colored gouache and its emphasis on simultaneous contrasts (another Delaunay term), we can sense more than a nod to his Parisian friend. Yet in the moonstruck grasp of Chagall, Delaunay's clever theory of simultaneous contrasts and of the potential of light and color for movement is transformed into a purely expressive means. Out of the simultaneous contrasts Chagall builds his own rainbow-bridge. For the rotation of cosmic time he prefers to recall not the ever-mobile color wheel but a much more primitive naive image: the rotating targets with their brightly colored figures that challenged the expert marksman at every country fair in those days. This is the same motif he adopted for his *Hommage à Apollinaire* with the world's clock rotating behind the central motif of Adam and Eve—nothing less than a pictorial metaphor for the awareness of time which was inflicted on man at the Fall and has, ever since, inexorably struck man's hour.[13] Once again all the formal considerations of contemporary art theory were transformed under Chagall's hands into means for strengthening the legendary aspect of what he found in his remembrance of things past.

From this same time there is a pen-and-ink drawing (plate 14) connected with the well-known painting of 1912 titled *The Poet*, to which Chagall has also sometimes given the deliberately absurd subtitle *A Quarter of Five, Half-past Three*. Both titles, of which the longer was intended to evoke the poetic hallucinations that come with the early morning hours, can apply to the drawing. It seems rather like a self-portrait which shows, metaphorically, the state in which the painter was finding himself. The poet—himself—sits on a stool in a vast empty space, his hands beating out the meter of his verses. In the alienated state of early morning hours his head has come off his neck and faces upward, as if literally acting out the poet's vision of rejecting normal contact with man's physical nature. But high up, in childishly drawn clouds, there *is* a vision: a Russian village, Chagall's naive abbreviation for Vitebsk.

Turning from this drawing to the gouache of *The Water Carrier on the Hill* (plate 15), this latter strikes us as a denser

[13]Haftmann, commentary to plate 7.

Bella's Window. 1914

materialization of the abbreviated vision floating on the cloud of inspiration in the former. One could easily incorporate the image shown in this gouache into that small cloud as a further quirky fancy spun in the poet's upside-down head. The ring of green earth is surrounded by a red sky traversed by birds, and the house is mirrored in the sky as a transparent medium. The visual poem turns on three nouns: the warm and flower-circled house; the sturdy woman carrying her buckets across the green meadow and looking back at her house; the little domed church which crowns the circle of her life. To these are joined the decorative adjectives of the blossoming branch lightly painted in the zone of the house, the nostalgic curve of birds in flight in the sky. The meter is set by the contrast between the crystallinely facetted, ornamentally patterned house and appurtenances and the large bare oval of the meadow. This contrast in forms is orchestrated also by the colors laid over the fundamental chord which unites the warm red of the house zone with the cold green of the grassy meadow, where ascending white patches mark a spiritual ascent culminating in the little church. Interior and exterior, inner and outer life, earthly and heavenly, all find their correspondences in purely pictorial terms. Over and beyond its formal significance, each element takes on its own—in

the broadest sense—"symbolic" communicative weight. "One must not begin with the symbol but come to it," Chagall says. "One should make no pictures *with* symbols. If a work of art is entirely authentic, it becomes itself symbolic" as, he adds, is so "with Klee, Grünewald, Mozart."[14]

Among Chagall's recollections are the Jewish holidays so much a part of his childhood. A gouache shows a peasant scene of *The Eve of the Day of Atonement* (plate 16) with the father of the house, who within the intimate circle of the Jewish family takes over the function of the rabbi, sacrificing a cock. The scene of sacrifice, with the peasant chanting from his book as he holds the birds, is bathed in a spiritual blue. A gleaming yellow breaks in, which may be objectively explained by the hanging oil lamp but does seem to stream in from the Beyond. It fills the top of the rough-hewn peasant table with golden light and transforms the everyday furnishings into an altar. The spiritual metaphor emerges from the disposition of the colors, although it clothes itself in the quotidian in which, as all Hasidim know, the spark of God exists in even the most insignificant of things.

[14] Meyer, p. 14.

33

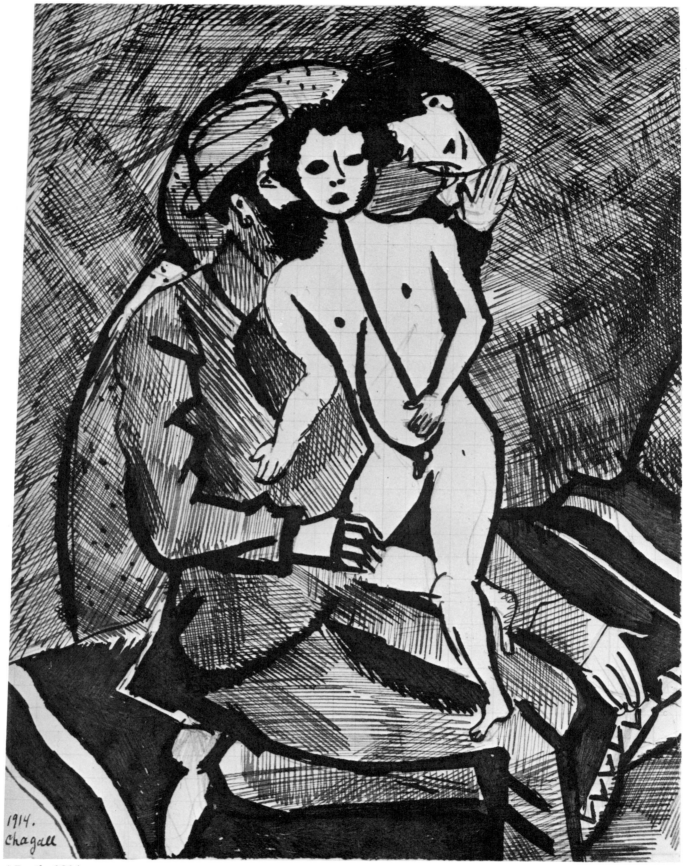

A Family. 1914

In the gouaches of Chagall's early years in Paris, he achieved the precise sort of link between poetry and painting which would later become the chief concern of the Surrealists. The significance of that link in Chagall's work was not recognized at the time. The French critics dismissed his pictures as "literary." André Breton, however, later judged that Chagall had been treated unjustly since he was the first who, out of the hallucinated force of his fantasy, established the link between the two forms of expression. "With him," Breton said, "with him alone did metaphor make its triumphal entry into painting." In 1943, in a public lecture, Chagall recalled the "thoughts that were stirring me in Paris in 1910," and said that

perhaps at that time I spoke of a specific "vision of the world," of a conception beyond object and observation.... I was enchanted by the eye of the French painter, by his sense of measure; and yet one thought would not leave me: that perhaps there is another capacity of the vision, another gaze, an eye of another sort, disposed otherwise, so to speak, not there where it is familiar to us.... Perhaps, it seemed to me, there are broader dimensions that cannot be grasped by the eye and that, as I would like to emphasize, I certainly did not consider as "literature" or Symbolism. Perhaps it was something more abstract, something liberated, something more ornamental, decorative....
A something, perhaps, that intuitively brought into being a series of pictorial and at the same time psychological contrasts and permeated the picture but also the eye of the observer with a new conception and entirely unfamiliar elements.[15]

When the gouaches and oils exemplifying such ideas were shown at Der Sturm in Berlin in 1914, they were received with enthusiasm by the German Expressionist circles. One easily imagines Paul Klee and Franz Marc standing awestruck and full of thought in front of those pictures which cast light on the direction in which they themselves were heading and whose traces are recognizable in the work of both men.

[15] Marc Chagall, "Quelques impressions sur la peinture française. Lecture held at Mount Holyoke College, August, 1943." *Renaissance* II-III (1944–45), pp. 45–57.

Plate 3

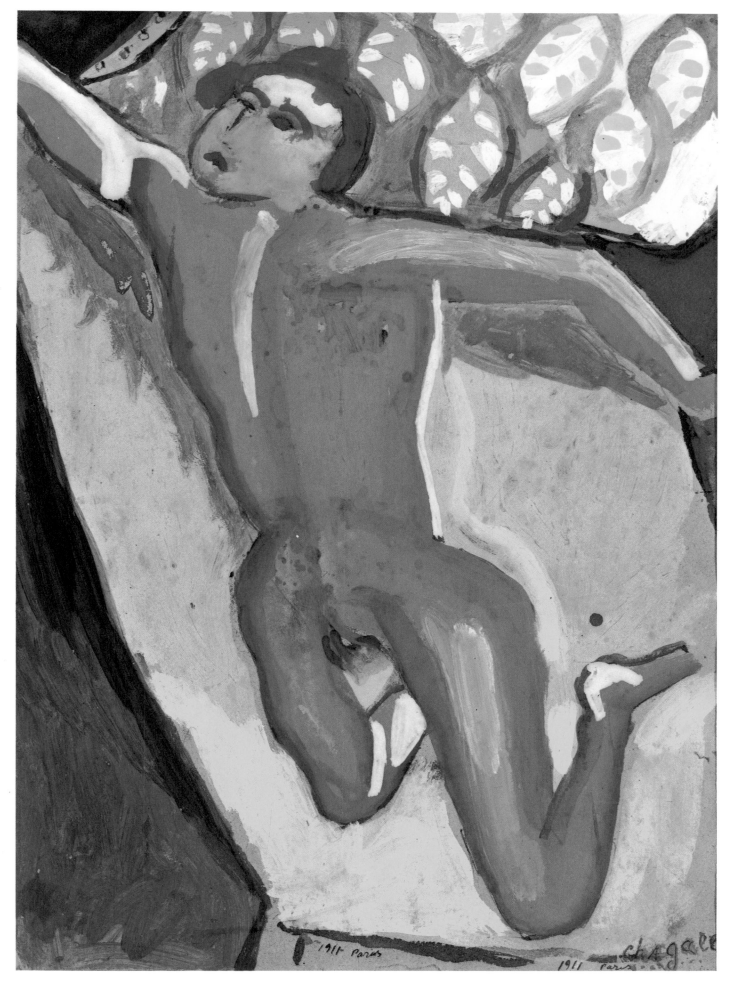

Plate 4

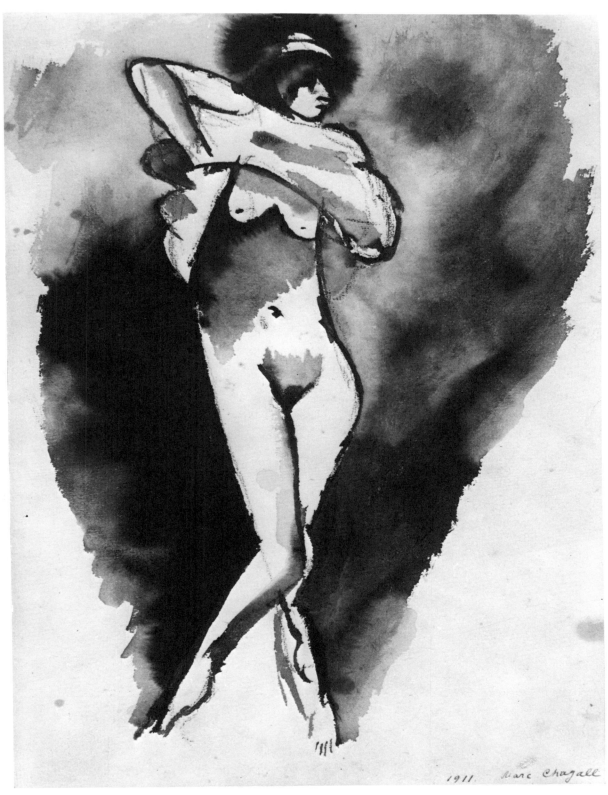

1911 Marc Chagall

Plate 5

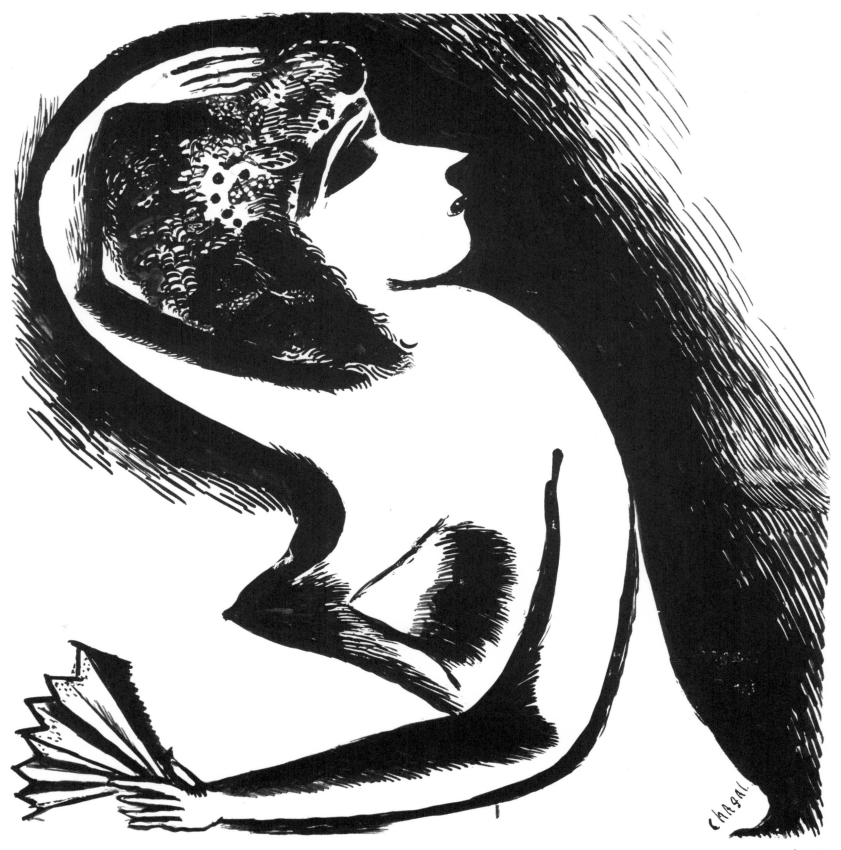

Plate 6

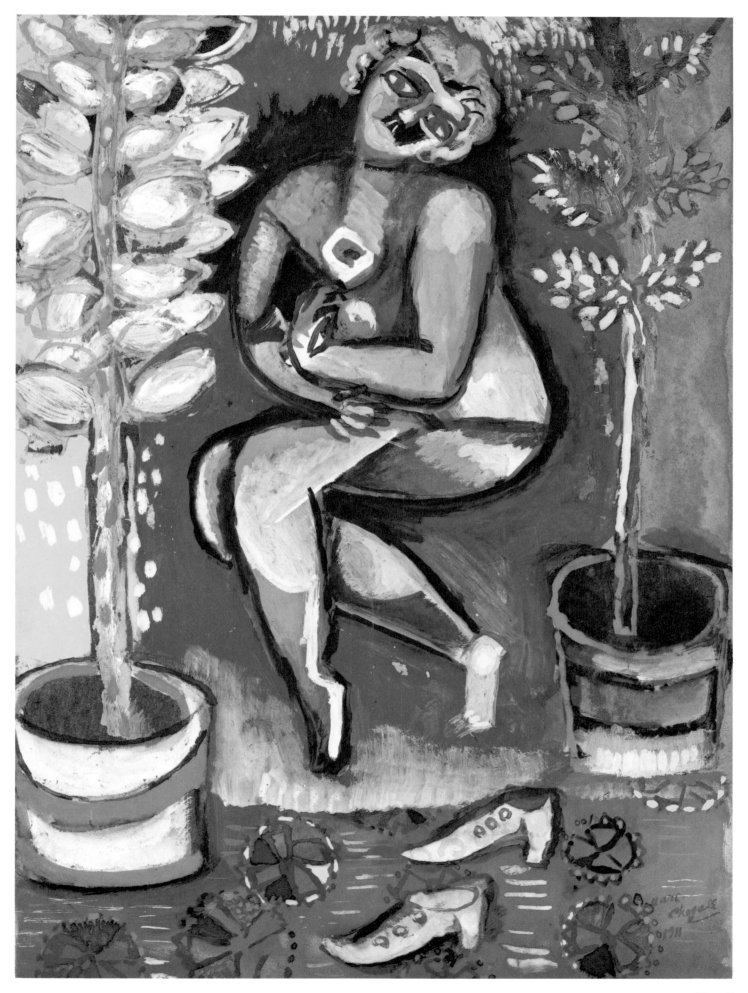

Plate 7

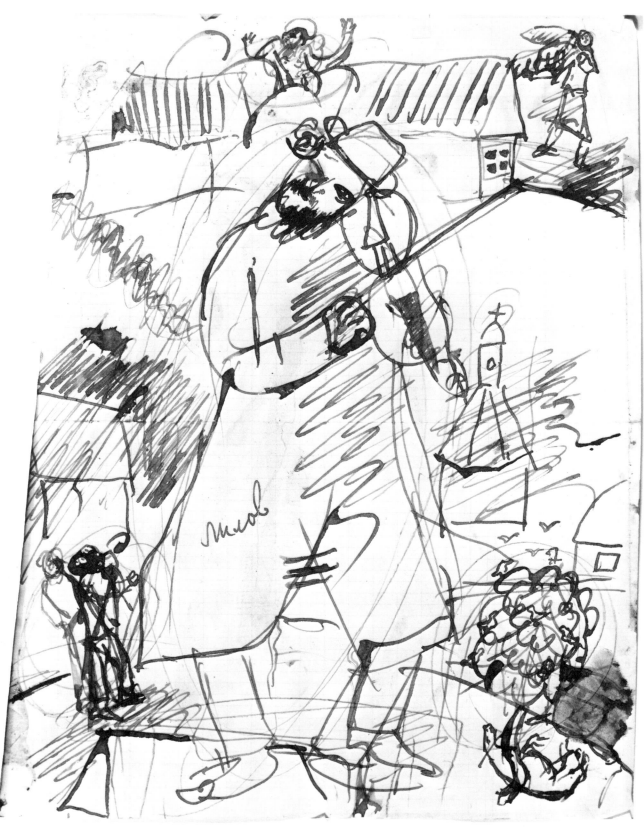

Plate 8

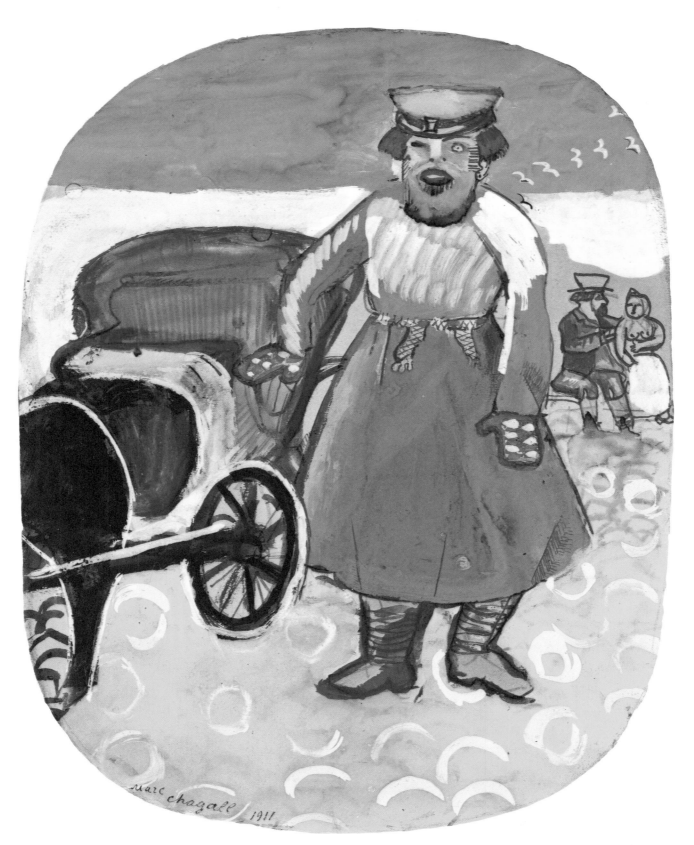

Plate 9

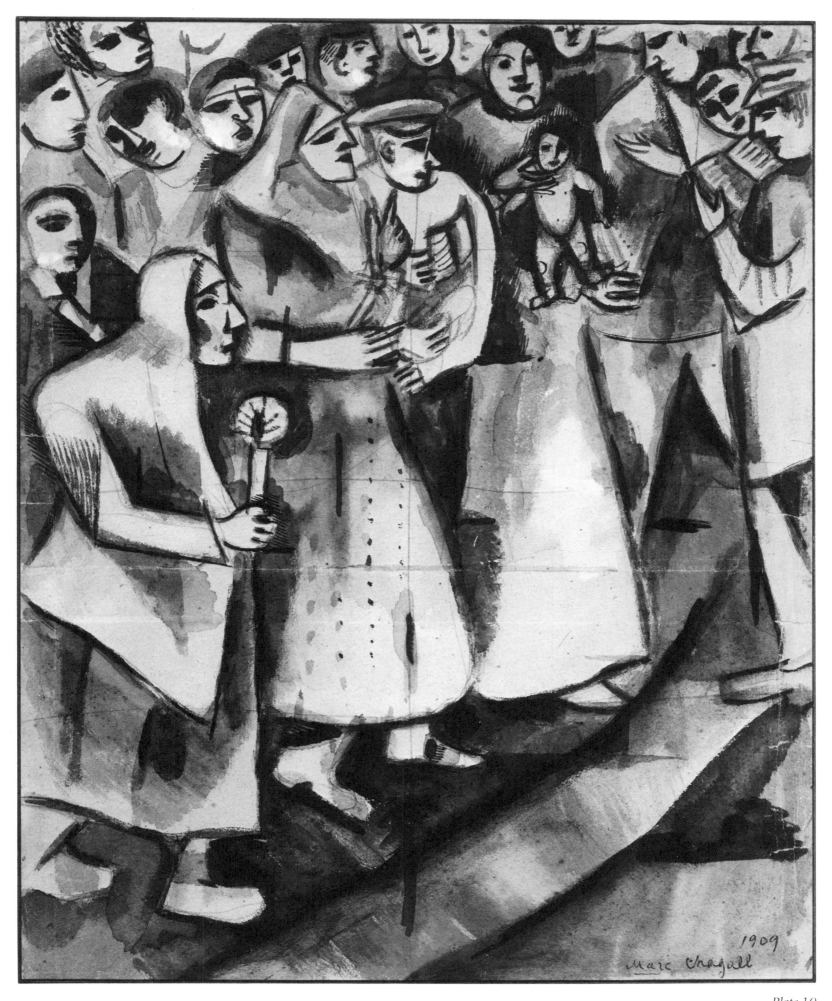

1909

Marc Chagall

Plate 10

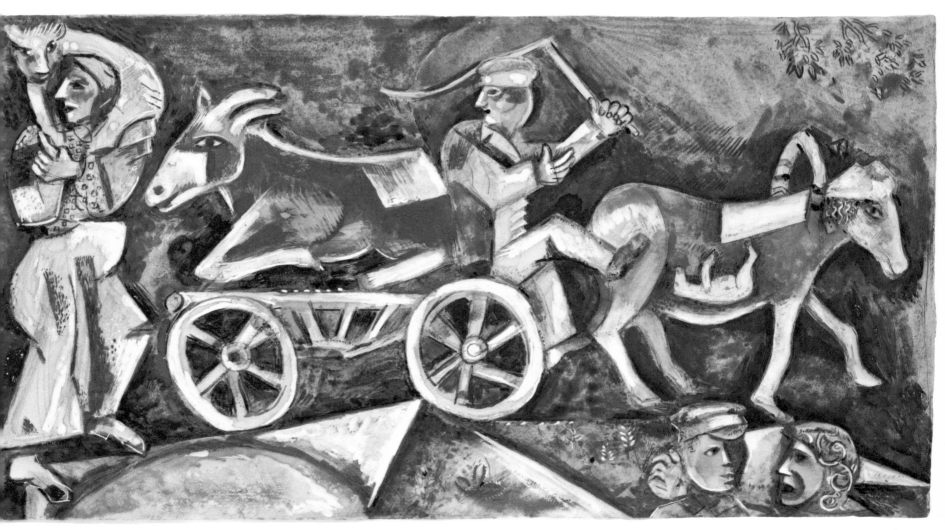

Plate 11

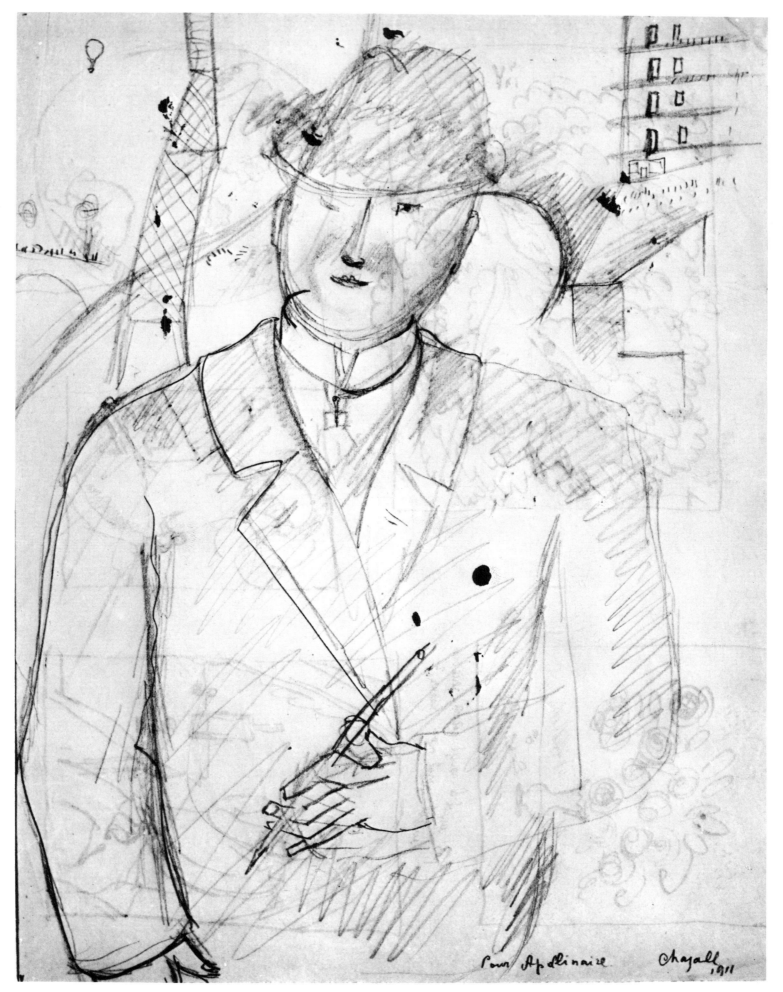

Plate 12

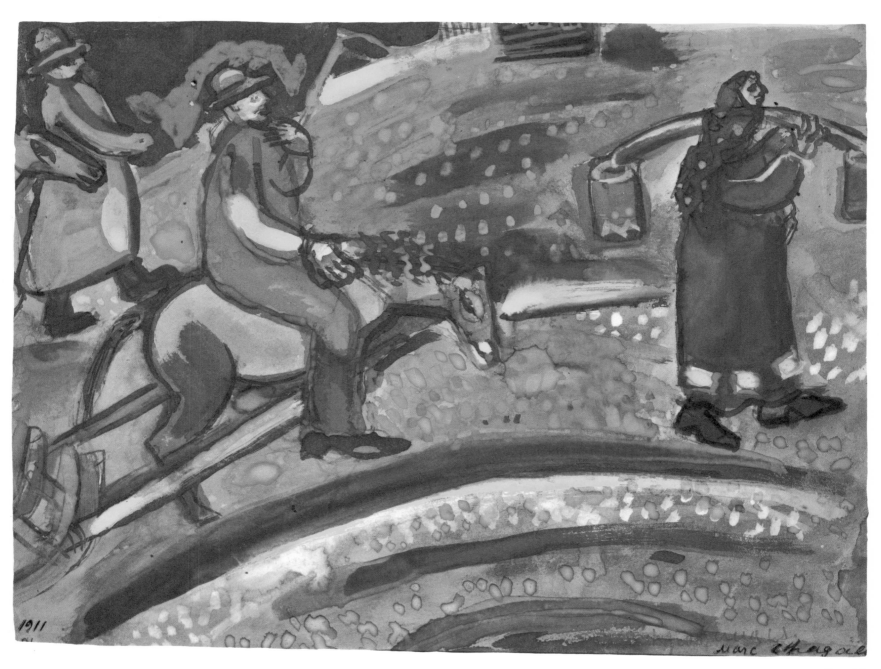

Plate 13

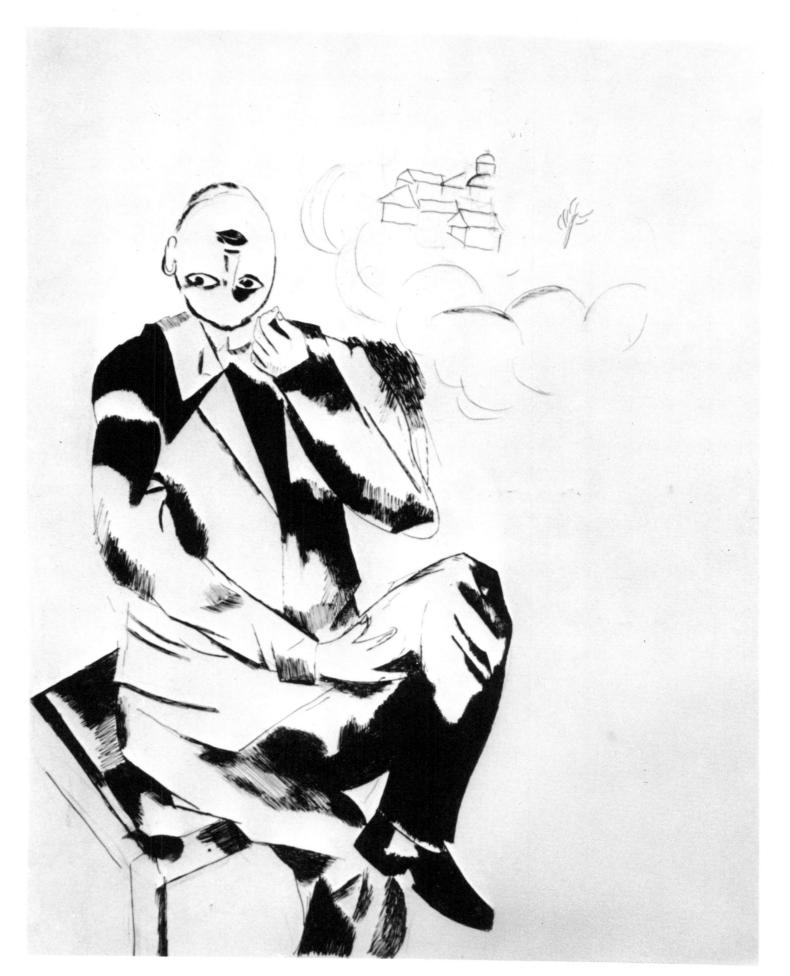

Plate 14

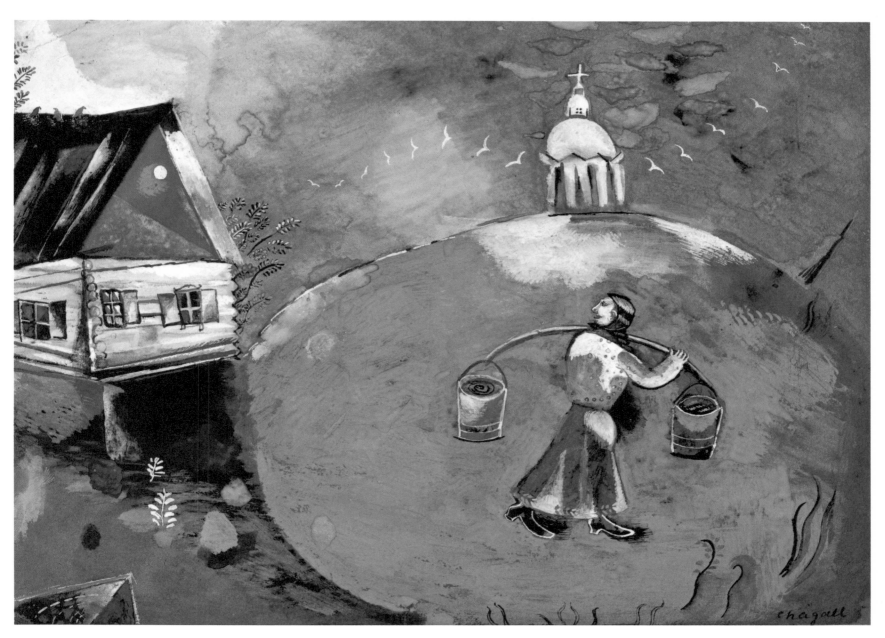

Plate 15

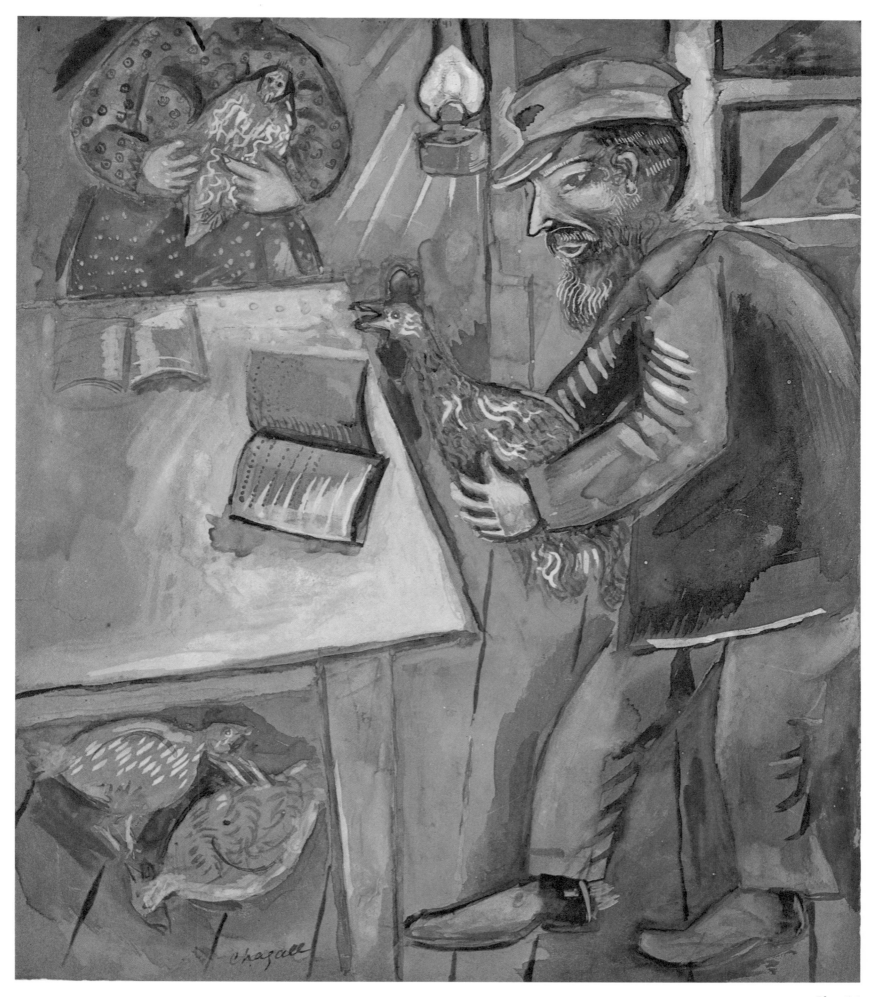

Plate 16

IV

Chagall went to Berlin for the opening of the exhibition. Having gone that far, he felt he wanted to visit his family in Vitebsk as well and to see his fiancée, Bella, again. In mid-June he left Berlin for Russia, planning to stay no more than a few weeks. War however broke out, and he was obliged to remain there for what finally became eight years, until the summer of 1922. In the summer of 1915 he married Bella Rosenfeld but soon, in autumn, had to leave for St. Petersburg— Petrograd by then—to take up a post in war production which his brother-in-law claimed, more wrongly than rightly, would satisfy the requirements for active service. Wherever he went, though, he was inevitably drawn back to his Vitebsk.

What struck him first in Vitebsk, on his return, was that what had become a legendary dream world for him in Paris was in fact a living, vivid, resilient reality. Before the force of real life, the fantasy faded into the background; first-hand re-acquaintance cut off the inventive power of memory. It was only natural, then, that he should turn much less often to gouache, the medium associated with his fantasy-pictures, and limit it to merely descriptive scenes. His present subjects came from his immediate environment: many family portraits; glimpses of intimate domestic life with his parents, brothers, and sisters; the many uncles and the itinerant pious Jews who came to the house to ask for alms; street scenes; soldiers; the landscape around Vitebsk.

A few drawings from early in that period, from 1914–15, illustrate that repertory. One, which must have been done in early winter of 1914 (plate 17), still has ties to the fantastic visions of his Paris days. It shows the painter with brush and with palette raised aloft like a shield. He is a giant in half-length, rising from amidst the places of his native town that were his poetic points of reference, the many-domed church and his family's house. For all the heraldic touch of the distinctive symbol, the depiction is strikingly realistic. The drawing of the back yard is done in firm, unhesitating strokes that faithfully capture its look. Likewise the church of St. Ilya, which was always before his eyes through the window of his workroom, despite its gleaming apparition before the dark wintry sky, is quite precisely drawn. Cubistic construction is still to be found in the facetted unfolding of the surface and in the ornamental disposition of contrasts between black and white. Yet the documentary reality is so forcefully incorporated into both the formal composition and the fantastic character of the scene that, merely by its presence, it too becomes an element of the fantastic, something one believes in spite and because of itself. The drawing could well serve to illustrate Chagall's outburst in his memoirs: "Do not call me a fantasist! On the contrary, I am a realist. I love the earth."[16]

The many likenesses he drew of members of his family, among them one of a sister (plate 18), remained bound to the subject and, in manner of drawing, recall Matisse. It was as if he wished to recharge himself with all the reality of his surroundings and so reined in his fantasy as much as he could and took pains to keep the formal side under control.

Yet his familiar reality was disturbed by something new. War was unsettling daily life with new worries and anxieties. Soldiers marched through the streets to the railroad station. The first convoys bearing the wounded were arriving. Fathers and sons were called up for military duty, and their families remained behind in distress. The prevailing mood nonetheless stimulated Chagall's inventive powers, and again he became open to the legendary aspect of human woe. His sympathy was expressed in many drawings of soldiers and the wounded with their nurses. One of the finest of his war pictures shows peasants called up for duty and on their way to the reporting office accompanied by their weeping families (plate 19). Disposed as a frieze, three lamenting groups pass through the village by night. Not only the highly expressive scene in itself but the unreal light in the drawing conveys the feeling of something from an old legend. The lighting results from an unusual inversion of the technique of pen-and-ink drawing. Unlike the customary technique in which the black line lends energy to the white ground, here the energy comes from the way the white emerges, not without effort, out of the very heavily laid-on black. The idea was essentially technical in inspiration, since here drawing attempts to imitate the technique of line etching which Chagall had learned for his contributions to Walden's review, *Der Sturm*, in which his drawings were reproduced by a technique which, however simple, required from the artist himself a certain acquaintance with its principles. A number of Chagall's drawings conceived in this manner for

[16] Chagall, *Ma vie*, p. 155.

publication in *Der Sturm* are known. Even so, another line of thought takes us further. Paul Klee at much the same time was experimenting in his own way with this energetic emergence of white out of black. Working on a glass disk covered with lamp black, Klee drew with a needle on the black ground. The result was an inversion of the usual roles of black and white in defining objects and, what is more, an astonishing intensification of the hallucinatory quality of the white line and an expressive transformation of the light which, through the shift from negative to positive, acquired a unique expressive significance and a representational capacity all its own. Certainly Chagall never knew anything of Klee's experiments, but in attempting to find an equivalent in drawing to the line-etching technique he came on the same path and turned a technical device into a very special means of expression. Like Klee's, Chagall's white line took on a hallucinatory quality, and he was able to put to expressive use the light-energy which developed out of the black. In the particular drawing seen here, this combined perfectly with the attempt to transform the frieze-like lamenting figures into something legendary.

It was not only unusual events and feelings, however, that turned Chagall back to his own domain of meta-phorical reinterpretation. Home again, and back in the Jewish community, he once again fell under the spell of the Hasidim with their ecstatic religiosity in which the most ordinary things of reality are illumined by a shimmer of the mystical. This was the time of his picture of wandering Jewish beggars who, to his hallucinated gaze, appeared as the wonder-working rabbis of Hasidic legend. Among the images that came to him at this time was that of the legendary mythical Wandering Jew with sack on back striding across the sky of Vitebsk and making the familiar cityscape a theater of mystical goings-on. Chagall's personal bent to Hasidic religiosity had its counterpart in a general concern with reviving a Jewish art which was very much in the air in Petrograd during 1916–17, when Chagall spent most of his time there, and which involved even artists like El Lissitzky. This renewed emphasis on Jewish religious themes stirred his fantasy, and once again he turned to gouache.

Typical is a gouache of the *Feast of Tabernacles* done in 1916–17 (plate 20). Conceived as a sketch for a small mural in a Jewish school in Petrograd, it fits very well into Chagall's familiar theme of the cycle of religious holidays. The focus is on the chief personages: father and son at their meal under the hut of green boughs traditionally raised for that holiday; the housewife bringing the pot to the table; the neighbor with his palm frond on the way to the synagogue; and above his solemn figure, the abbreviated notation of a small domed church as an attribute of piety. The narrative is laid out in a frieze, kept simple in form and naive in feeling, and the artless way drawing is used to define shapes goes perfectly with this (and is strikingly different from the skilled and sophisticated manner used in the portrait of the artist's sister). The similarities to the flat disposition of planes in the Paris gouaches are evident. Cubism still has its effect in the way the roof of the hut of greenery is laid out. Yet in the spatial elements, the color, and the individual descriptive details, one senses the same innate feeling for real things that was characteristic of Chagall's first Russian years. With these gouaches he seems to have been finding his way back to his original thematic repertory though, thanks to enhanced observation of the world around him, on a broader plane. Political events, however, sent him on another path.

In October, 1917, the revolution broke out. Chagall returned to Vitebsk. Caught up in the general enthusiasm, he sought to have his part in the great change as it affected his own field and drew up a plan for an art school in Vitebsk. Approved by the People's Commissar for Culture Lunacharsky (who had visited him in Paris), the school was set up. Chagall took on the direction and called in a choice selection of Russian avant-garde artists including Malevich, El Lissitzky, and Ivan Puni (who would later become Jean Pougny in Paris). But it was inevitable that Malevich would make trouble. Chagall was soon accused of pseudo-revolutionary romanticism, and Malevich called for orienting the teaching toward his own Suprematism and Constructivism. In 1920 Chagall was forced out and moved to Moscow. Already in Petrograd he had developed an interest in the theater, so he busied himself thenceforth almost exclusively with wall paintings, costumes, and stage decoration for the State Jewish Theatre in the capital.

Chagall had taken the organization of his school very seriously and sacrificed to it much of his time and energy. Depressed by the eternal bickering of Malevich and his supporters, he had taken such pains to come to terms with

those problems, in his own thinking as well, that it is no exaggeration to speak of a recognizable caesura in his life and work in this period which is summed up in a few drawings and gouaches (plates 21–23). These make up a quite uniform group and must have been produced between 1918 and 1921, though Chagall himself afterwards dated some of them a little earlier. The drawing of *A Man Carrying the Street* (plate 21) attempts a synthesis between a rigorously constructive composition and the romantic notion of the painter in his city. Separated·by a diagonal, at the left is a constructivistically stylized stretch of a Vitebsk street, at the right a young man peers out from behind this barrier—evidently the artist himself. The succinct organization gives the drawing something of the character of a poster to which the lyrical theme of "Chagall and his town" lends a note of real feeling.

A gouache with a young man in an exaggerated goose-step (plate 22) has more than a touch of the theater about it. The figurine—which is the only word for it—indulges in a burlesque dance step, a kick so high that house and moon are knocked topsy-turvy but at the same time make an ornamental pattern on the surface which, for all the liveliness of the forms, conveys a decidedly constructivist feeling. Color contrasts—blue against orange, black against white—make the whole seem even more poster-like. A pen-and-ink drawing carries the same idea to a handsome perfection (plate 23), turning a dancer's pivoting whirl into a highly effective sign of abstract dance movement, whence the abstract title, *The Movement*, uncharacteristic of its author.

The influence of Russian Constructivism is obvious in these works. It is instructive, however, to observe how Chagall could incorporate it into his own poetic, balletic, burlesque conceptual vocabulary which, fired by the dream-world of the theater, could likewise assimilate the posterlike element so much a part of the theater and its activity. In the wall paintings and décors for the Moscow Jewish Theater Chagall found his way back to his own world of fantasy. Viewed in that context, those Russian years were very much an interlude dictated by the tricks that life plays and implemented by the improvisations it demanded from the painter. This was no longer his way, and during the entire period he yearned to escape from this chance turn in his fortune, to return to the city that had, in the final reckoning, given his art so much more than had his native town.

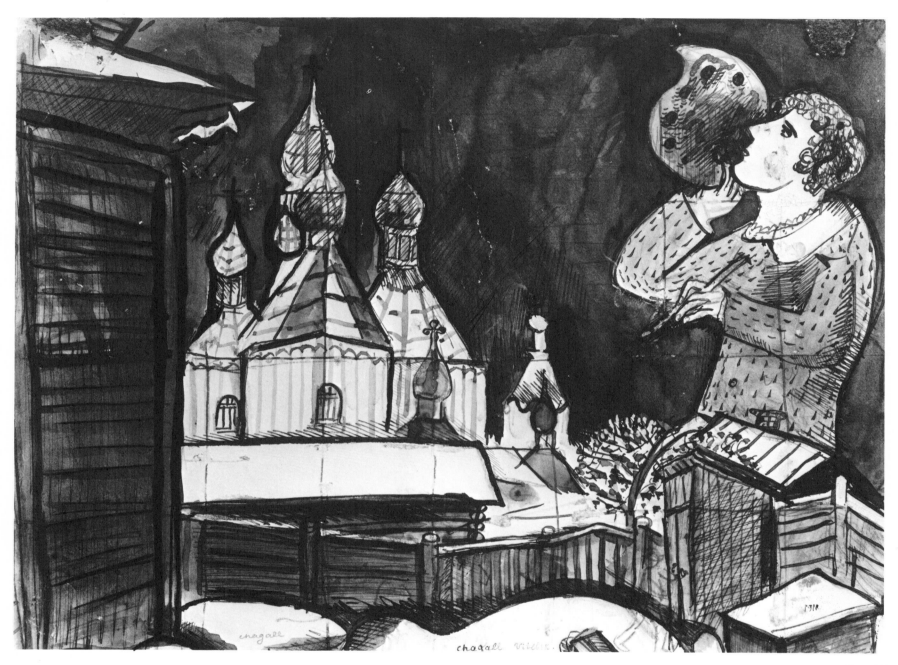

Plate 17

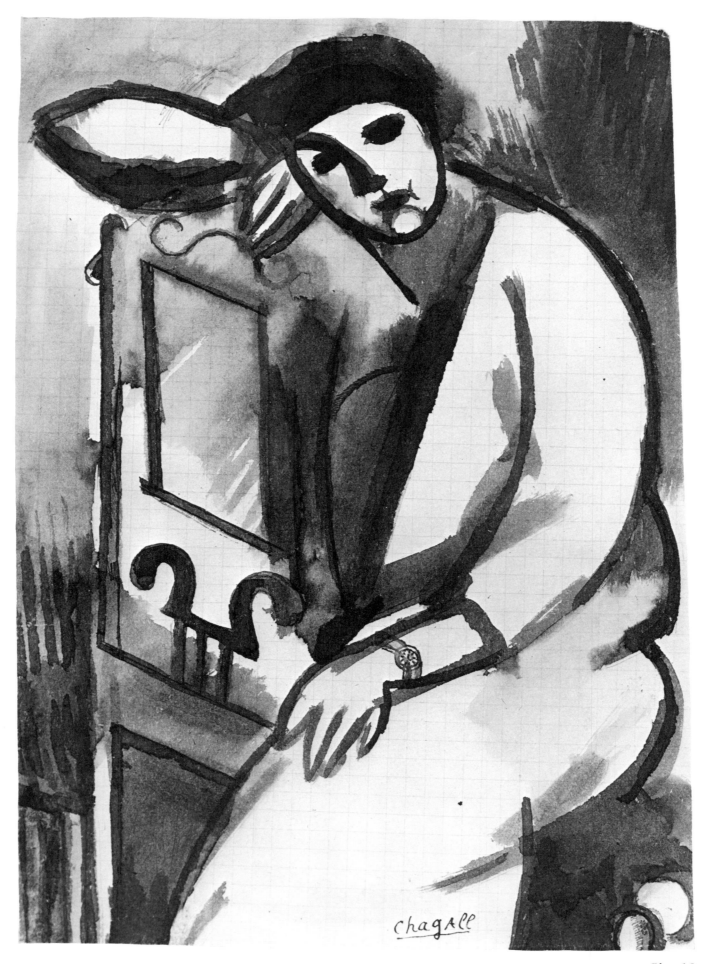

Plate 18

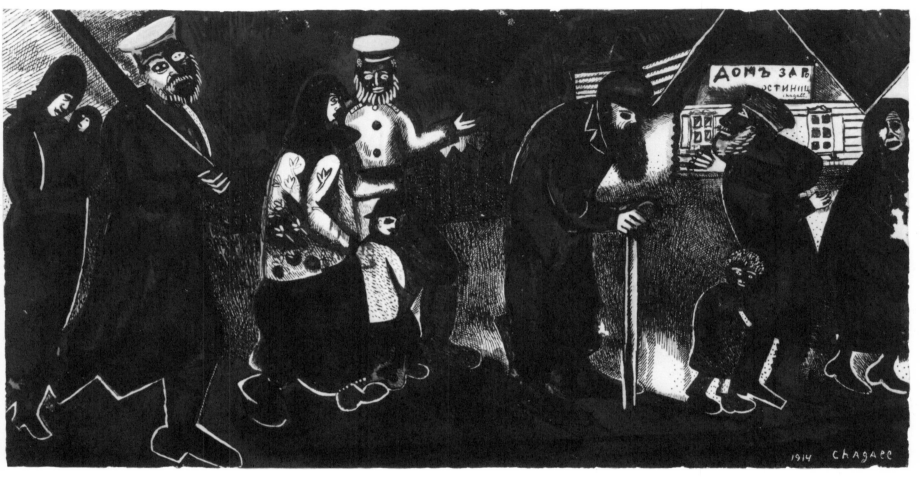

Plate 19

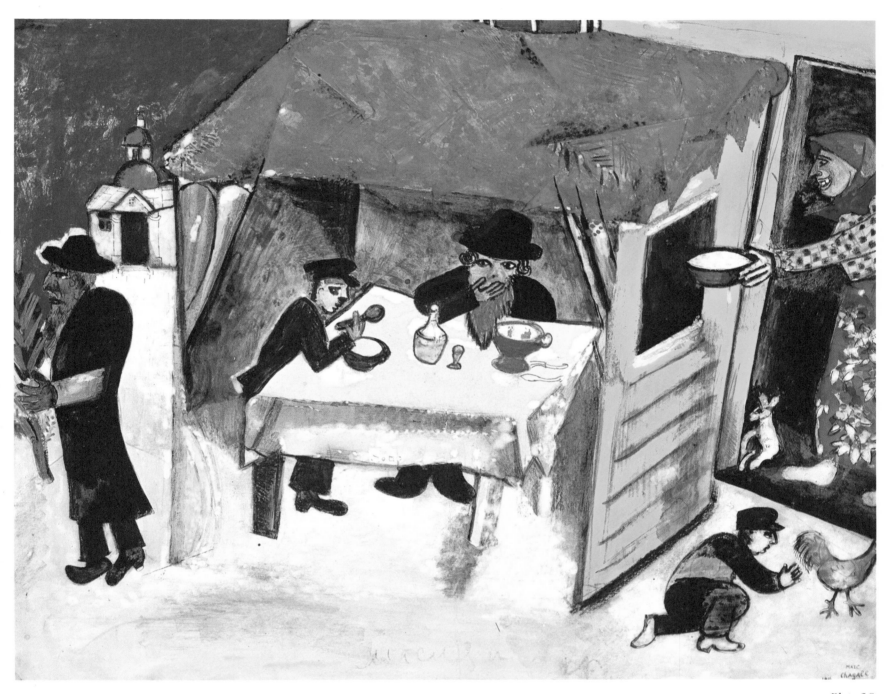

Plate 20

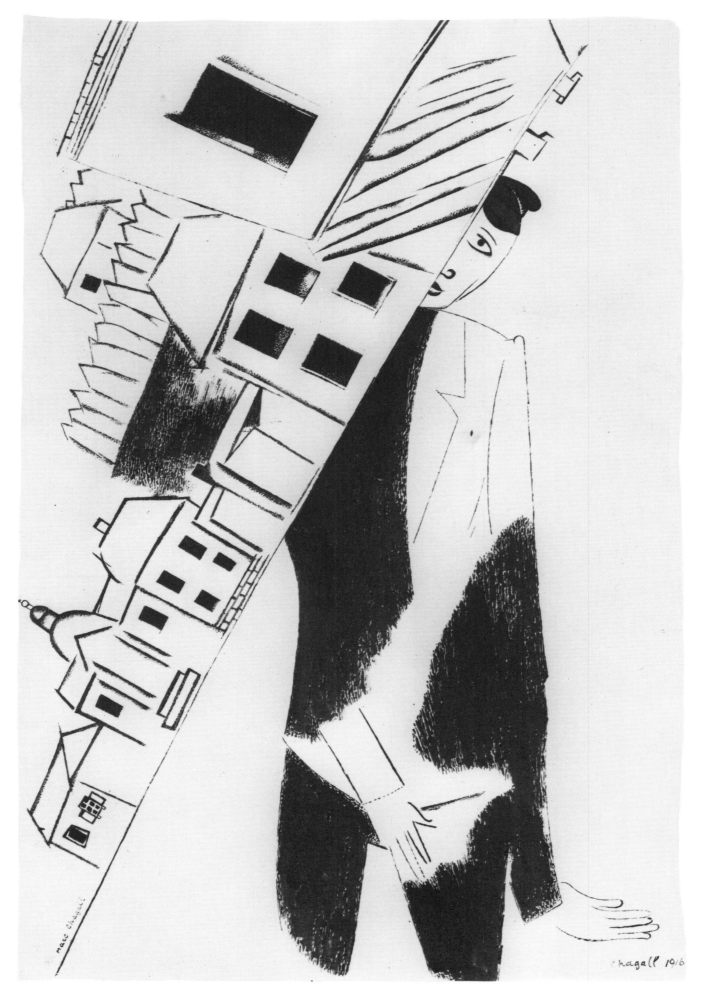

Plate 21

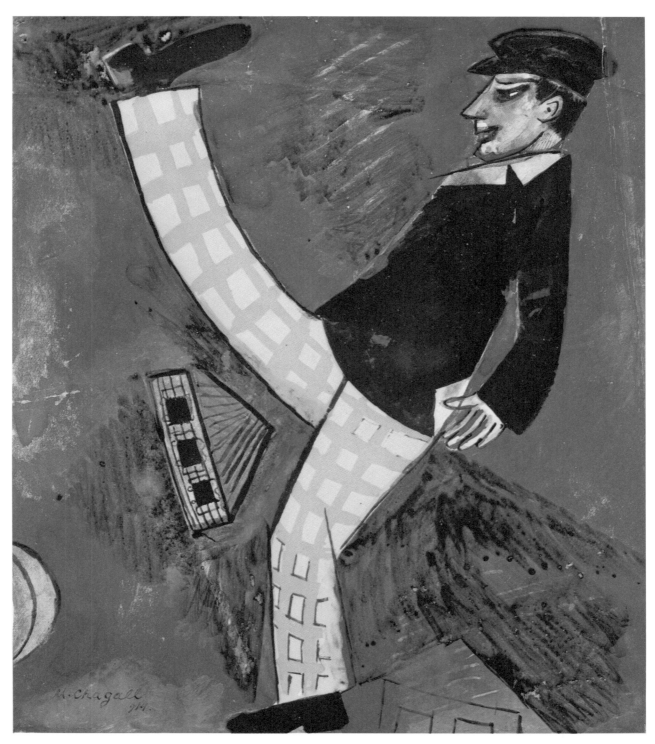

Plate 22

1921

Marc Chagall

53 Moscou Marc Chagall

Plate 23

V

After many unsuccessful tries, Chagall finally managed to leave Russia in the summer of 1922. His first stop was Berlin, where he had left with Herwarth Walden almost everything he had produced in Paris and which he now expected to recover. This proved difficult, and what he was able to salvage was only at the cost of a long legal conflict. Trapped in Berlin for over a year, he used the time to write his memoirs, *Ma Vie*, which he had sketched out in Russia and which Cassirer now proposed to publish in German translation. Although the translation did not go through, Cassirer did commission a portfolio of etchings to illustrate *Ma Vie*, and these the artist finally brought out on his own. These were his first works conceived entirely for printing and included also a few lithographs and woodcuts. Although in little else, the Berlin year did have this positive result.

What Chagall learned from it helped him make a fresh start in Paris, to which he was finally able to return in the first days of September, 1923. Blaise Cendrars had arranged a first contact with Ambrose Vollard, and that celebrated art dealer readily accepted to publish, on Chagall's proposal, some one hundred large etchings illustrating Gogol's *Dead Souls*. The work was begun with no delay, and 107 plates were ready by autumn of 1925.

Delighted to be back in Paris, Chagall was eager to take up his work at the point at which he had left it in 1914. The efforts to track down his dispersed pictures in Berlin had familiarized him again with what he had accomplished in those first years. Work on his autobiography likewise had kept fresh the memories of that time, while the *Dead Souls* illustrations confined him still to his accustomed Russian themes. Thus everything was ready for him to resume the life of the Parisian atelier again. In order to renew acquaintance with his old fantasies, he repeated or varied a number of his early pictures, and in this attempt to work himself back into the past, gouache again proved a useful medium.

Absorbed as he was in the world of *Dead Souls*, images from the legendary domain of his childhood inevitably came back to mind. A large gouache, *My Village* (plate 24), conjures up the prospect of a Russian village in which the droshky of the crafty dealer in souls, Chichikov, might clatter down the main street at any moment. In iconographical content, however, this gouache goes back

almost literally to one from 1910–11, so narrowly did he at first attempt to pick up the strands of his first Parisian sojourn. A comparison of the two shows the later one to have a more careful treatment of color as against the hectic colorfulness of the earlier version. The individual color voices are more closely unified with an overall tone—the blue that permeates the picture—which conveys the effect of a general atmosphere.

This is true also of *The Pinch of Snuff* (plate 26), which likewise goes back to a motif Chagall had already used in an oil painting of 1912. Compared with the studies for that painting, this watercolor shows a comparable pervasive lighting and the same sort of damping of the Expressionist brilliance of the color. Chagall's general mood in his exploration of pre-war memories is well conveyed by a fine drawing in lithograph crayon which may have been done shortly after his return to Paris (plate 25). It shows a young man—surely the painter himself—caught up in a dream while looking at two elderly people on a bench in the distance who, no less surely, must be the painter's parents.

This new approach to color and its atmospheric quality speaks eloquently of the effect that the new-old environment—France and its light—was having on the painter. In his first sojourn he had known only Paris. Now he was discovering the French countryside and the way people lived in it. Repeatedly he left Paris for country places. In 1924 he spent the summer in Brittany; in 1925 he was frequently in Montchauvet. Spring of 1926 was spent in Mourillon near Toulon on the Mediterranean, summer in Chambon-sur-Lac in the Auvergne. He was making the landscape, light, and life of France intimately his own.

A drawing of his little daughter Ida on a window seat looking out at a Brittany landscape was done in 1924 (plate 27) and reveals his delight in French light, which now seemed to him more important to pin down than the pensive play of fantasy. Yet even where memory still dictated content, as in a large gouache of *My Father at Table* of 1925 (plate 28), this light that lends its special coloristic tinge to French painting in general makes its way into the otherwise entirely unrelated picture of his dead father painted from memory. True, there are the familiar furnishings of a Russian peasant dwelling—the oil lamp, wall clock, simple tableware—in the room where the father sits at the table chanting his prayer. Yet an atmosphere

tuned to the light of France permeates all the colors, and the vision of memory becomes fraught with the feel of reality. The handsome yellow of the tablecloth is richly modulated and introduces delicate contrasts of light and shade in the things on the table (where a plate of fruit certainly recalls Cézanne). The father's coat is in a heavy fine bottle green and has its answer in the complementary red of the richly modulated ground. One thinks of Bonnard or Matisse, both of whom in the same years were working at a similarly finely woven film of color. Likewise Chagall's growing feeling for nature corresponds to the development those two great French painters were undergoing at the same time. Thus, for all that this beautifully painted work is still bound up with memories of a Russian past, in it the Russian repertory of images is beginning, however slowly, to fade.

Its place was being taken by the French countryside. In the summer of 1926, in the Auvergne, Chagall drew much from nature outdoors. Among the results was a fresh drawing with peasants binding grain (plate 29) that he would use afterward as an illustration for Gustave Coquiot's *Suite provinciale*. In its bright light and flickering line it conveys very well the heat and light of a summer landscape. Its spontaneous manner of drawing, free of all stylistic compulsions, suggests that it was done from direct observation on the spot.

The comic, burlesque element has always had a characteristic appeal to Chagall's sly humor. The village of Chambon-sur-Lac with the sharp spire of its Romanesque church struck him as charmingly ludicrous enough to be pictured (plate 30). The splendid gouache, most likely painted from memory immediately after observation, shows the rather droll way the houses fit together, with angles every which way. Chagall populated the town with amusing figures: a citified-looking little girl gawking at the chickens, peasant women with grotesque hats, peasants unloading hay. If many details still recall the scenes from Russian village life, Chagall nonetheless captured the real look and feel of an old French village beneath a luminous gray late-afternoon sky when the houses begin to take on a glow of their own. Further, his color modulated over gray and earth colors and the finely tuned harmony of his colors truly evoke the French earth.

Chagall was much taken with the poetic quality of rural France and sought to render it in his own way, which for him involved pictorial metaphor and fable. He had come on the *Fables* of La Fontaine, and those simple tales with their homely moral lessons were thoroughly in tune with what his eyes were seeing about him and the poetic reflexes such sights aroused in him. He was finished with the illustrations to *Dead Souls*. They had occupied his fantasy long enough with pictures of Russian life and compelled him to think in the purely graphic terms of shades of gray. This new theme, inspired by the world immediately around him, appealed to him especially because it involved color. He promptly proposed to Vollard to bring out another set of illustrations to the La Fontaine fables, but this time in full color. Vollard, whose keen eye may have noted how gouache brought out a new coloristic poetic in Chagall, was in full agreement. It was settled that the illustrations would be done in colored gouache and then translated into color engravings by skilled graphic technicians. For Chagall the agreement was the welcome signal to turn his unconstrained imagination to a theme perfectly attuned to what he had himself been seeing in the French countryside and to his personal response to it. In an almost explosive outpouring in 1926–27, he produced well over a hundred gouaches, many during that first summer in the village in the Auvergne.

La Fontaine's fables provided only the pretext. The rest was pure fancy and pure Chagall. Using his favorite inventive medium of gouache and a small format—the sheets average about nineteen by fifteen inches—nothing disturbed the free play of his fantasy. It readily followed the suggestions of the spontaneously laid-on color and the new inventions that they brought to mind. The images emerged in a contemplative interplay of thought and act, of spontaneous gesture and, where called for, control. The painter could look on, as if at a remove, at what was taking form on his paper. If he was astonished at the figurative world which, as if on its own, was pushing its way into images, there was a metaphorical counterpart in the astonishment he was himself experiencing before the delights of rural nature. His general theme aside, he never knew at the start what he was going to end up with. Much like Klee, he began with no specific content in mind and, in a relatively passive state, let the picture grow out of whatever the forms and colors he happened on might suggest.

The picture arose in the painting of it. It was the pictorial response to the moment's mood. It reproduced no image worked out in the mind in advance but, instead, with the help of the autonomous power of speech of the pictorial means, evoked a counterimage that matched the poetic stimulus. Easily and merely by improvising, the medium of gouache let a suggestive shape of literally fabulous unreality take shape, and in that unreal atmosphere the fable took on visual reality and poetic probability.

Thus, in the illustration to the fable of *The Miller, His Son, and the Donkey* (plate 31) we find an entirely unrealistic violet color spread across the surface. Only when a few elementary signs are inserted that allude to a church and houses does that spread of violet become a landscape, one whose fairytale prospect shot through with light offers an apt field of play for the color. And it is precisely this trans-illuminated picture surface that sets a mood for the tale which, because it is in contrast to the grotesque figures and the *gaucherie* with which they are rendered, arouses in us both sympathy and laughter.

How such pictorial configurations grew can be traced back in the fantastic *Peacock Complaining to Juno* (plate 32). The painter began by laying down a dark, mysterious, glowing, evocative ground which he then shot through with light by making tiny dots or splashes of color. Out of this magical ground he let a peacock emerge. Then, as he more and more defined the shape, he embroidered it with a lavish decoration of other stippled and sprinkled dots until the proud bird began to look like an emanation of the starry ground itself. Finally he painted the goddess in pure opaque white and in a position within the composition which strikes one as the natural and inevitable culmination of the upward diagonal set by the peacock's shape but, equally, of the oblique ascent of the stippled colors. Through the contrast of light and dark the goddess's light-bathed figure imparts a sense of space to the darkly glowing color fluorescences of the ground and at the same time also marks the focus of all the color and light energies. In this way, though confined to an upper corner she becomes the central element, exactly as in the fable itself. One can say, then, that the picture grew into its final configuration with no predetermined plan. It was only in the active realization of the pictorial suggestions arising out of the color and its treatment that the poetic metaphor assumed a shape which

permits it to stand, independent yet related, alongside the seventeenth-century poet's fable.

In the gouache with the peacock, the paint is laid on very thickly in order to capture the phosphorescent noctural mood of this summer night's dream. In others, however, like *The Woodcutter and Mercury* (plate 33), the paint is flowing, light-toned, strongly colored, and applied with a baroquely energetic panache. The dominant blue contrasting with the flat white of the young god plunging downward (looking much like a baroque plaster putto) evokes the mood of a hot workday under the glaring sharpness of a summer sky. The color acts as a serene decorative background for the ornamental arabesque of the divine youth in flight.

Wholly different and virtually Expressionistic in its flickering treatment of color is *The Old Woman and the Two Serving Girls* (plate 34). The old woman pops up in the lower left with her lamp to catch her lazy domestics still abed at cockcrow. The lamp shoots out its beam like an exploding fiery fountain of yellow and red. Agitated flashing brushstrokes splash red and yellow as if in fits and starts across the work, illuminating the bed with the two girls which, in the flaring light, looks like a magic carpet in flight. A dense texture of color interweaves with the burst of light breaking up the surface for an apparition compounded of sleep and fright. La Fontaine's sobersided moralistic fable has been converted into a witches' sabbath out of the East. No wonder the French critics reproached Vollard for surrendering a sacrosanct classic of French literature and its reputedly inborn sense of *mesure* to the wild fantasy of an "Oriental." In fact, the illustrations really are pure Chagall, metaphors of his fantasy for the moralizing metaphors of La Fontaine, and therefore fantastic twice over. Each receives its own and fitting guise.

The work with the old woman belongs at the end of this extensive series of gouaches, since in its development over the months the painter's fantasy became ever more untrammeled. Vollard, who was merely amused by the outcry of the champions of *le Classicisme français*, himself took pleasure in Chagall's excesses and goaded him to further flights. Even before the La Fontaine gouaches were completed, he invited Chagall to turn his hand to a circus series. He did not have to ask twice. Whenever possible the pair of them went off to the *cirque* to marvel at the acrobats,

lady bareback riders, and clowns. While still engaged on the La Fontaine series, Chagall produced the burlesque sequence he still refers to as his *Cirque Vollard*. In the circus the world is transformed into utter fantasy: what counts is the improbable and illogical, and even gravity is defied. With that as point of departure, Chagall let his circus world be utterly absurd. Cavorting in his ring are to be found the Eiffel Tower riding a donkey, many-headed monsters goaded by clowns and leaping about, animal acrobats mocking at gravity. And all of it depicted with a fulminating line that seems to come from the flick of a wrist and in colors that catch the magical artificial light of the circus and then, by art, make it even more artful.

Alongside these cycles there were a great many gouaches born out of the freest improvisations. These are all painted with utterly spontaneous nonchalance, and their freshness reflects the sheer pleasure Chagall took in his sudden inspirations. Inevitably the old Russian motifs crop up again, but now treated facetiously and burlesqued. Here again is the *Fiddler* (plate 36), but now he is a frisky young fellow who dashes off a cheerful dance tune to the amazement of a peasant woman behind a fence. This happy rhythm carries over to another splendidly colored work where one sees only the dancing legs of a blue-trousered peasant lad (plate 37). A rain of flowers from a bouquet he carries accompanies the unheard music. The color is exceptionally inspired: below, the basic beat of the stamping blue legs against a luminous white ground; above, an iridescent play of color accents which, like a tinkling glockenspiel, makes variations over the basic blue and white chord and adds to it all the most delicate ornamental patterning of vibrant counter-rhythms. With colors bursting into bloom at the top and making a colored equivalent to the lyrical dancing impulse, there was no need to complete the figure. This evocative fragment suffices to express a musical inspiration entirely through the metaphor of color. The coloring has little of the motley vividness associated with Russian folk art because, as Chagall said, France had cast her colorful luminosity over everything he did. Comparison with Bonnard, for instance, would show how much Chagall was reacting to the sensitive gradations of the Frenchman's palette, yet how much also his color continued to burn with his own mysterious Eastern fire. It is this simultaneity, this inter-weaving of two very different traditions, that makes Chagall's color so entirely his own.

It was his personal color likewise which enabled him to capture his hallucinated, picture-puzzle, somnambulistic dreams. In the gouache of *The Goat in Front of the Church* (plate 38), an undulating abstract white form overlies a grayish blue surface. A crescent hanging from delicate strands of beads is all that tells us this is meant as the sky. The astral light illuminates a remarkable scene. Before a cold emerald green church stands a goat on which golden moonlight falls. It must be a celestial goat, and obviously a gigantic one since at its udders sucks the head of a sleeping man. It is a mythical beast, like the cow in the painting of *Russia, the Donkeys, and the Others* of 1911, and, like it, also a symbol for the warmth of earthly things as opposed to the remoteness of the cosmos. Then suddenly the dream turns—and with it the sheet—to show a childhood scene in a Russian village under warm golden light. Like a picture-puzzle or a proverb remembered, this is Chagall's answer to the intricate meanderings of a dream called forth into the light of day. The pictorial realization moves within the categories Chagall strove to master from his earliest days in Paris: it is utterly original, rhythmic, ornamental.

For Chagall, the years between 1926 and 1928 were just right for gouaches. His response to nature along with an overwhelming joy in life had so liberated his fantasy that an incessant flood of images pressed to be set down—an ideal situation for gouache. At that point he learned that it was not feasible to translate his gouaches, dependent as they were on a virtual excess of color, into colored engravings. What the printers foresaw as results were so disappointing that Chagall had to resign himself to reworking his colored gouaches into black-and-white etchings. Work on the hundred La Fontaine plates went on from the end of 1928 to the beginning of 1931 and took so much of his time that his creative imagination was blocked and consequently there were few gouaches in those years. Likewise the times had turned more serious and were offering fewer incentives for the comic and burlesque antics that had previously succeeded so well in that medium. France was in the grip of financial depression; the political climate grew gloomy. Totalitarian ideas were spreading through Europe and assuming menacing forms in a Germany still reeling from its defeat in 1918. A wave of anti-Semitism grew

The Sick Child (Ida). 1918

alarmingly. News of the first pogroms was being heard. The threat of a new war was taking shape. Chagall was highly sensitive to the changing times. The burlesque element disappeared from his oil paintings of 1929–30; his painting style became more careful, more delicate; Jewish religious motifs haunted his imagination.

It was in this frame of mind that, in 1930, he began to discuss with Vollard a grand project, nothing less than illustrations to the Old Testament. Vollard agreed, and Chagall approached this huge project with utmost seriousness. To prepare himself inwardly, in February, 1931, he began a visit of more than two months to Palestine. Just as rural France had prepared him to cope with the fables of La Fontaine, so too first-hand acquaintance with the Holy Land seemed a prerequisite for his biblical cycle. In April he returned to Paris and set to work. Even though, after the disappointing experiment with the fables, the Bible illustrations were planned from the start as black-and-white etchings, once again the artist turned first to gouache as his favorite medium for self-expression, and most of the definitive etchings were based on preliminary gouaches. This great task occupied most of his working time in the next years. By the time the out-break of war in 1939 put a stop to the project for over a decade, sixty-six etching plates were finished and another thirty-nine under way.

The first were done in 1931, and among them is the scene in which Noah receives God's command to build the ark (plate 40). In both use of paint and manner of depiction, the style has changed, has become more painterly. The coloring is restrained, the drawing less agitated, the whole has a delicate inwardness of feeling and reposes on a profound religiosity. Unexpectedly there are recollections of Rembrandt's religious paintings, among which Chagall had always especially admired the *Supper at Emmaus* in the Louvre. The figure of the praying Noah emerging in a spiritual light in the warm brown ground is a reverential homage to the Dutch artist, who found the inspiration and models for his Old Testament paintings in the Jewish quarter of Amsterdam and in the religious feeling so vital there. The creative process in which gouache had always proved so vital continued to be as meditative as ever, but the religious inwardness of the subject restrained Chagall's usual extravagant fantasy. More than color, it is spiritual light that guides the painter's hand here and produces a unified continuum of space and color. The warm brown of the man in prayer breaks down to the cool night-black of the background which, strewn with points of light,

becomes a starry sky on which, like a guiding star, the invocation to the Lord shimmers forth in Hebrew letters. Out of the night emerges an angel in the form of a creature of light. With a hand which itself glows like a star in the still night, the angel points prophetically at the apparition of the sign of God. One senses that it was only by contemplatively feeling himself into the spiritual significance of the episode that the painter could bring such a vision to view.

It would be an error to consider such expressive coloring, based entirely on modulation of light, as an attempted approximation of the black-and-white of the etchings for which the gouaches were trial essays. It seems certain that Chagall did not work with that prospect in mind. If nowhere else, this should be evident from the intimate link between the muted coloring of this gouache and its poetic content, whence the inwardness of its feeling. Even in those biblical episodes whose themes might allow greater contrast, in *The Sacrifice of Noah* (plate 41) for instance, we find the same muting of tone and the same effort to ensure that the entire pictorial space is permeated with a single continuum of luminous color. Out of the green ground that mantles the figure of Noah in deep prayer, the altar of burnt offerings with the sacrificial lambs arises like an aureole blazing out of the prostrate figure itself. Its fiery light is intense, yet it blends into the overall modulation of light in the ground color. The brilliant effect of color contrasts, to whose expressive force Chagall has always been partial, gives way here to a gradation of tonal values which brings out the luminous quality of the color in carefully prepared steps. Here that quality takes on resonance and grows into a light-permeated, delicate, vaporous unified medium, with the result that even the flat planes, which previously Chagall had preferred to set off sharply one from the other, are absorbed here into a single spatial continuum. Chagall's favorite medium of gouache has undergone a striking change here, and along with it his own hallucinatory energy likewise was transformed into a repose turned inward on itself.

The new phase that the Bible illustrations initiated in Chagall's work would develop further and prepare the way for the incomparable creations of his old age. It was elicited by a change in his own inner life and feelings. The Hasidic religious ecstasy, which had room for even clownery and the grotesque, was transformed into something more meditative by a deepening of its essential mystic core. The change in Chagall was furthered by the cultural level of his French environment but also by contact with the Old Masters: with the work of Rembrandt on a trip to Holland in 1932, with that of El Greco, which he came to really know in 1934 when visiting Spain, with the coloristic sumptuousness of Titian which struck him full force on a 1937 visit to Italy. Nature and the Louvre: that wise French concept which neither Matisse nor even Picasso disregarded was now adopted by Chagall to control his often overexuberant fantasy. It should not be forgotten that work went on for years on the biblical cycle until interrupted by the war and, that pause notwithstanding, was resumed afterwards, thus making a link with his late work and in particular the paintings of the *Message biblique* cycle which he began in 1950, just when he was completing the remaining etchings for the Bible illustrations. It is this long incubation that gives the late work its spiritual depth.

This irradiance, if we can use the term, touched even those pictorial conceptions unconnected with religious themes. In his drawings the subtle plaiting of the pen strokes now took the upper voice, and he cultivated a broadly spanned melodious line coming to rest in ornamental clusters (plates 42, 44). A lyrical mood took over and revealed itself in the delicate gesture and caressing movements of the line which brought the white of the ground into something luminous.

There is a deepened feeling in the gouaches of those years as well. *The Large Tree* (plate 43) returns to a theme Chagall had already explored in his early years in Paris. Then, however, the tree was the pretext for an eruption of color in which the branches and foliage seemed more like a blazing growth all their own. Now its green shot through with yellow light becomes the focal point of a sun-drenched luminosity and, in content, a sign of nature as beneficent protectress. The realistic aspects likewise come more clearly to the fore. The painter obviously had in mind one of those quiet Parisian squares that so unexpectedly interject the look and smell of the countryside into the life of the great city, one of those places where the elderly and retired can take their ease. Here, though, the man sitting in the shade of the tree has a quirky loneliness about him, and with his characteristic cane somehow brings to mind Charlie Chaplin, and somehow too there is an air of melancholy about it all.

Chagall's beloved circus theme likewise changed. In the

Cirque Vollard the wildest inventions had tumbled over each other and color was heightened almost to zaniness, but the mood in the *Female Clown with Violin* (plate 45), datable, in my opinion, to 1937–38, is of astounding lyrical delicacy. On a transparent ground a female clown is delineated in the finest, most musical line. Even the diminutive comics following her seem less boisterously crude clowns than satyrs in a lyrical comedy. As for the glimpse of a naked woman riding a cow—with a subtly drawn curtain pulled aside behind her to give even more the suggestion of something theatrical—all this belongs entirely to a world of dreamlike lyricism. But what claims our attention here is not only the enhanced lyrical quality but also a change in the very manner of presentation. The jokey acrobatics of the circus fade out before the sweetness of a *commedia in musica* or, better, *A Midsummer Night's Dream*, which had become Chagall's great model. Thenceforth that comedy and Mozart's *The Magic Flute* would remain key elements in his fantasy. If one turns from this gouache to an India ink pen drawing (plate 46) done in Gordes in 1940 when the painter was already fleeing from the war, this subliminal link with Shakespeare's lyrical fantasy world is striking, though one would be hard put to find a specific scene to attach it to.

From this period there is a wonderful large gouache which displays a kind of apotheosis as if on a stage curtain (plate 47). Here, raised to the heavens, is Charlie Chaplin, who invented the figure of the simple little man whose good and happy and compassionate heart takes him safely through the hurly-burly of real life. Chagall particularly admired that invention and the way its inventor made use of it. Perhaps he sensed in it the incarnation of that special Jewish humor, open to every absurdity yet tinged with melancholy, which his own sorely tried people bear as a shield against suffering. His hand outstretched in greeting to a pair of dancing comedians, Chaplin straddles a small green goat which wears on its forehead the orthodox Jew's tiny box containing prayers on parchment, the *tefillin*. To Chaplin's other side, however, a simple woman, bent with misery, her child in her arms, bends low before the great comic. An angelic musician soars down from above, plucking its fiddle as accompaniment for the dancing couple. Below, in the lower left corner, an angel flies away. A great blue cloudbank which seems to float in the wake of the departing angel casts its undulating shadow across the

entire picture. Dance and grief and wit transposed into the Beyond: almost unintentionally a parable takes shape which touches on not only the figure of Chaplin but also, in a metaphorical image, on the painter's own state of mind in difficult times; he has become more serious, more mentally and spiritually attuned to the human and humanistic element of life.

The war had begun. Chagall was out of the way, in Gordes in the south of France, in an empty schoolhouse. He felt alone and persecuted and may well have felt too that he was not likely to escape the wandering fate of Jewry he had brushed aside and forgotten in the successes of Paris. An image oppressed him, that of a fiddler in the night who wanders, still fiddling, across a broad field gone fallow with only a few abandoned and rickety huts, and still with his theatrical crew of dancing girls and freakish animals.[17] A sad but appropriate metaphor for his current condition. A drawing (plate 48) shows an improvisation on this poetic motif. It is sketched in with the slender lyrical line he had developed in the thirties as means for a more feeling description of images from the inner reaches of his mind. The fiddler is defined out of the luminosity of the ground, yet with lines repeatedly broken to leave empty spaces into which light can pour. Here Chagall does not so much describe as set up evocative signs: the large hands which do not properly belong to the violinist but, like something from outside him, make his fiddle sing; the imaginary goat appearing in the light; the nude girl at the fiddler's back whose hair intertwines with his, which itself surrounds his face like a tremulous aura and which fades away above in the melodious arc of flickering points of light and in the silence of the white ground which reclaims as its own the apparition that glowed out of it. Each and every graphic sign strikes a poetic key which unleashes a chain of associations in the fantasy: words to music, as it were, that sing of a mood of lyricism and melancholy.

In these and all the years that followed, the gouache was Chagall's most sensitive medium, and it became more frequent in all contexts. In *The Village in the Snow* (plate 49), which may have been done in the winter of 1940–41, a few months before the flight to New York, the paint is applied in numerous superimposed coatings to produce a translucent, enamel-like solidity in the film of color. That density matches a particular way of seeing: each object, gone over

[17] Haftmann, commentary to plate 37.

and over again by the painter's hand, hardens in fact as in image into a heraldic sign. A celestial body looms gigantic in an apocalyptic sky above a village laid out without rhyme or reason and which, cowering in the cold, seeks to preserve a touch of warmth in its reddish brown tone. In the foreground a window flies open, and a fabulous bird with a sorrowing woman's head prepares to take wing. Where in this cold and beneath such a sun will its melancholy flight come to rest?

In April of 1941 Chagall himself had to flee. He went first to Marseilles and Lisbon, then to New York, where he arrived on June 23rd, just as the German armies were beginning to swarm over his Russia. It was the start of a seven-year exile. He was not happy in America. Not that there were not some good moments. In the summer of 1942, with Russian friends, for a Ballet Theatre production in Mexico City he designed scenery and costumes for the ballet *Aleko* based on a Tchaikowsky piano trio; in 1945 for the same group he did the designs for Stravinsky's *Firebird*. Again it was gouache that teased his fantasy into play. Yet the American years were very depressing. He did not know the language, was consumed with anxiety over his homeland and relatives, suffered over the grim fate of the Jewish community, and could not put his happy years in Paris out of mind. In September, 1944, just when with the liberation of Paris there was hope of returning home, his wife, Bella, died. With grief so great there could be no thought of painting for many months.

The distress of his life in those years shows itself in the dark mood of his pictures. In a steady series, like pages in a diary, gouaches recorded his responses to those circumstances. There were visions of burning villages, of people in flight, of martyred and crucified Jews, but also of fantastically apocalyptic themes. These, painted in the thick manner of *The Village in the Snow*, reveal a similar treatment of the main subject and are steeped in the same dark grieving. There would be little point in singling out a few from this long series of pictures, and in any case they would need a book on their own since all are so closely bound up with Chagall's own life. To exemplify the years of exile one very fine gouache may serve, *The Purple Angel* (plate 51).

Here again there is deep anxiety, yet illumined by a certain heartstick hope of salvation. The evocative ground is in a golden yellow that has the mystical radiance of a gold-ground icon. It spreads out from the figure of the Crucified, of which only half is seen, as if only one part of the salvation shines through the All and what happens on earth can never be more than an edge of the whole. In 1937 the figure of the Crucified returned to Chagall's iconography as symbol of suffering mankind. In the American years it became an emotional formula for the hope that still glimmered in the midst of affliction and humiliation. Christ, the Jew, had prophetically testified to the believer's need to submit to God's will. For the Jews as well, He became the metaphor for the man who bows without questioning to divine decrees that elude human comprehension. In this gouache the golden light of the crucified Christ is refracted in the cosmic bodies of sun and moon, and it illumines the otherworldly landscape into which earthly nature has been metamorphosed under that light. Huge, with gleaming wings, soaring as in a dance, the purple celestial messenger makes his appearance and, in embracing the crucified Christ, brings the angelic salutation of the Lord into our lowly world. A woman's pensive face identifies that earthly zone; an innocent blue horse with peasant trappings traverses it. Certain abstract signs that defy objective explanation— the strange shape near Christ's leg, for one—are mysterious voices whispering further the tidings to man. And those tidings are sounded through the solemn resonance of yellow and purple. In the unfolding of meditative perception of everything that color can suggest in the way of poetic content, a visual poem is materialized out of abstract rhythm and objective meaning.

In this painterly efflorescence of well-tuned color one can sense something else as well: a greeting to faraway France, to the land that had really awakened Chagall as painter. The thought of France never left him during his American exile. Homesickness and a longing to return were always great driving forces in Chagall's human makeup. In Paris it was Russia; in America, it was Paris that was the luminous source to which all his strength and poetry aspired.

Plate 24

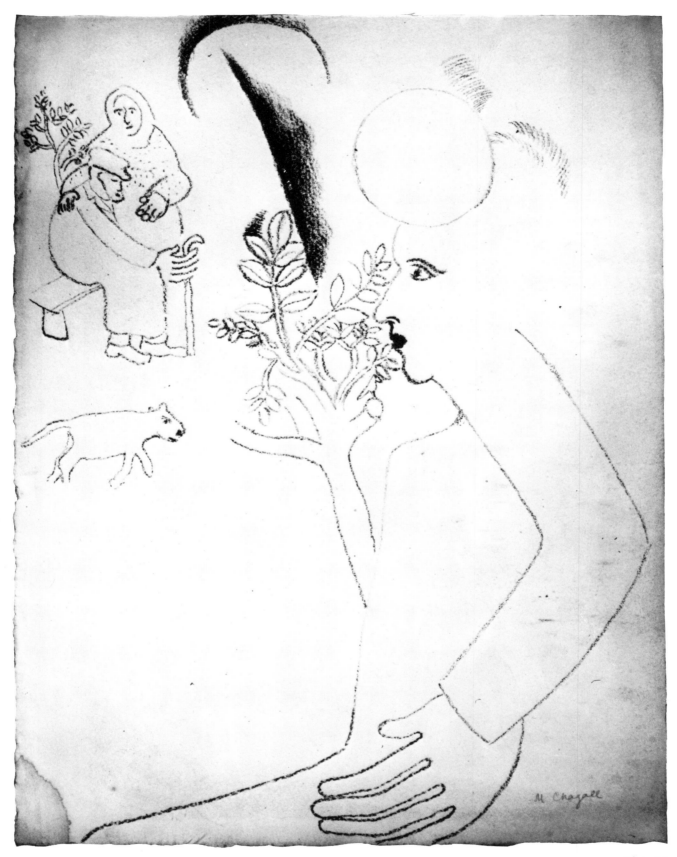

Plate 25

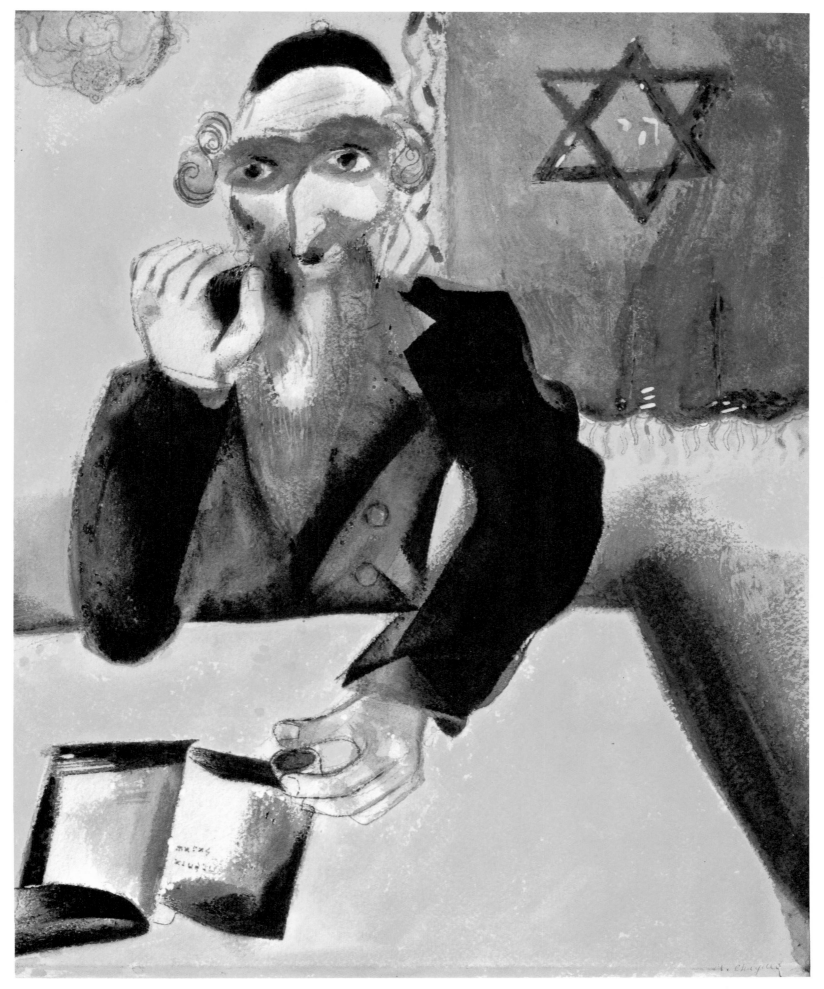

Plate 26

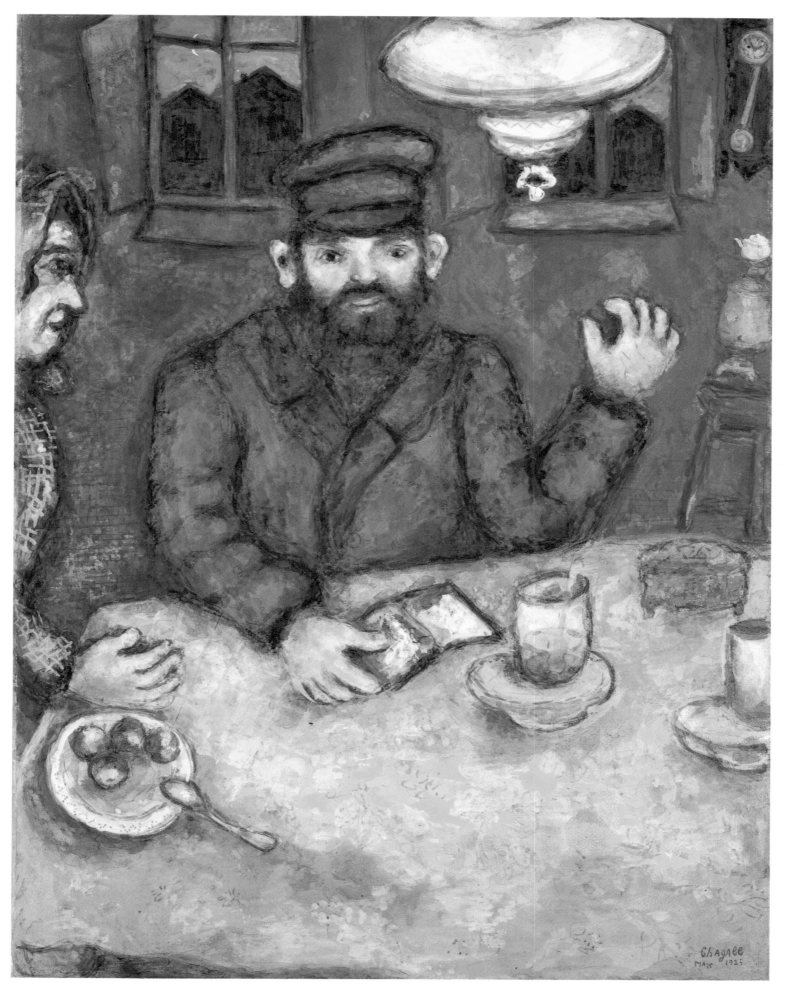

Plate 28

Plate 29

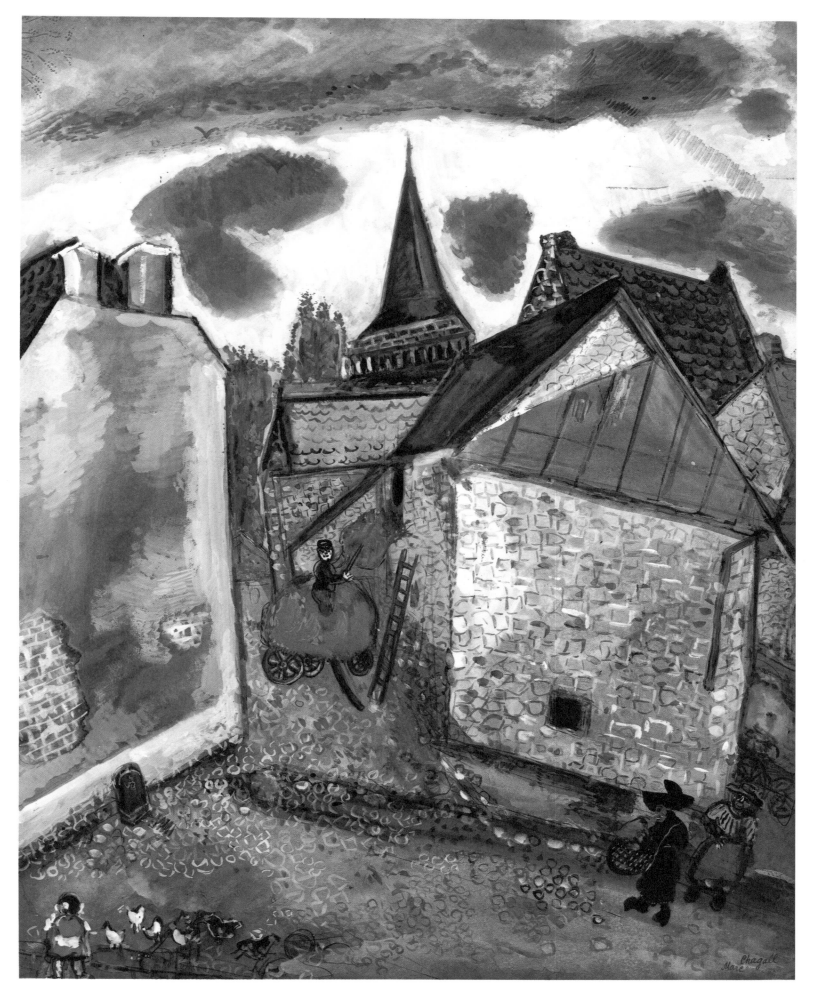

Plate 30

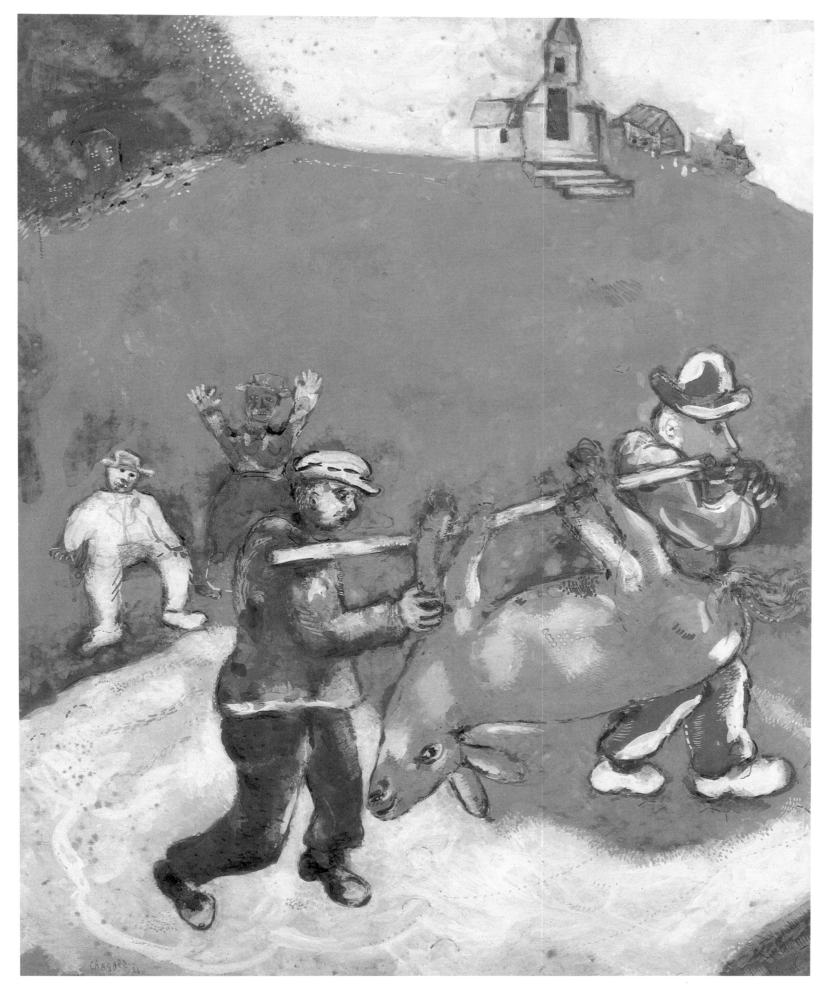

Plate 31

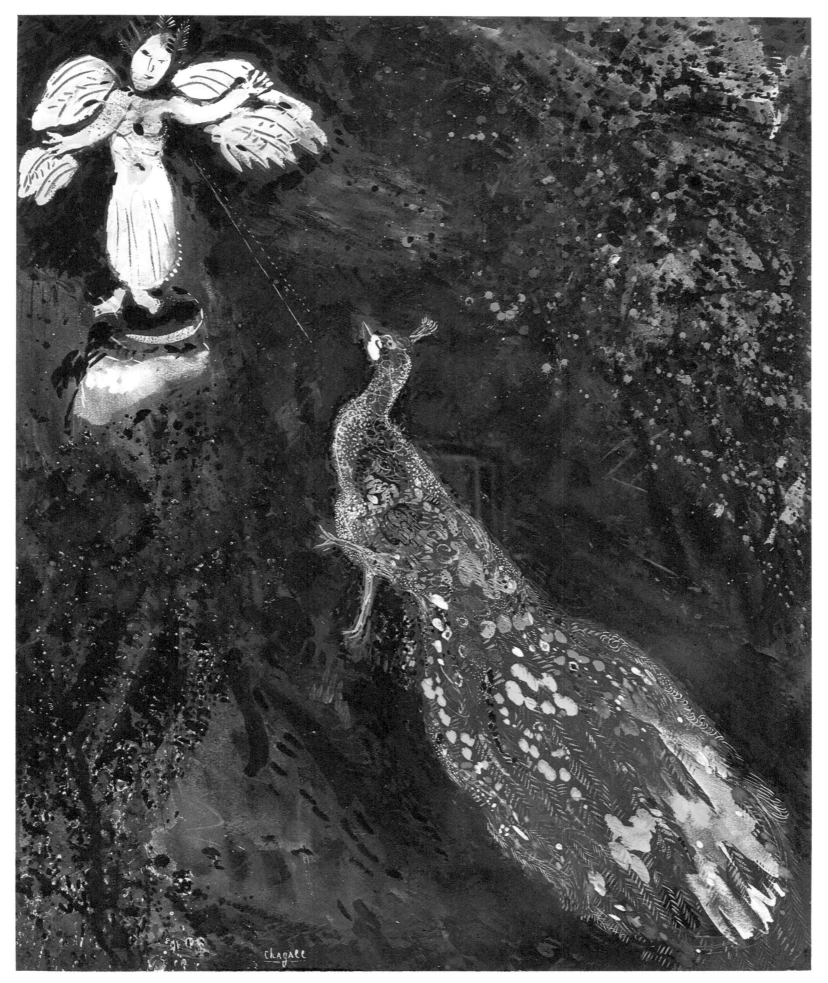

Plate 32

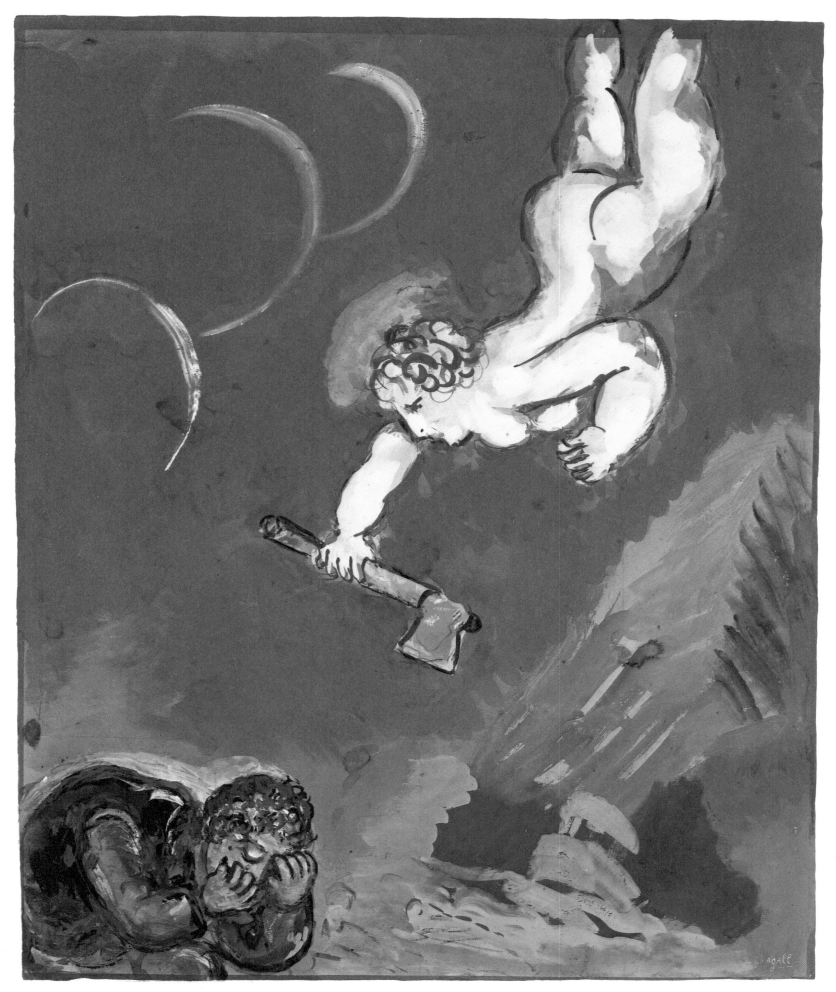

Plate 33

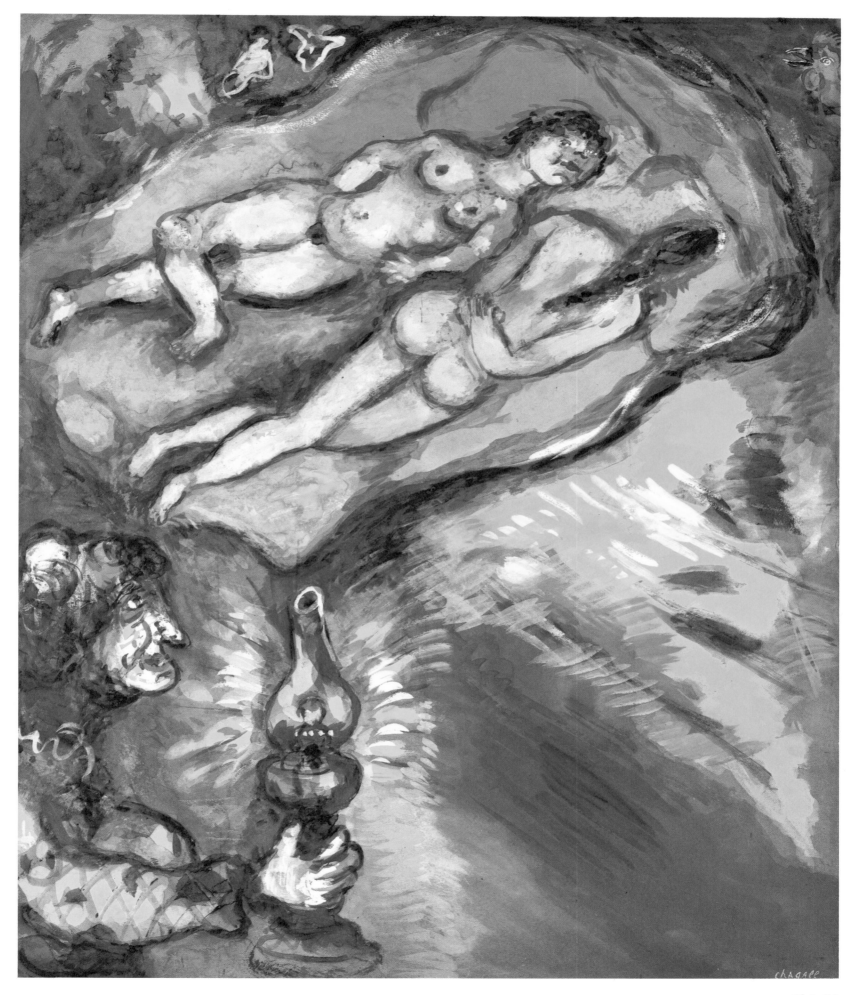

Plate 34

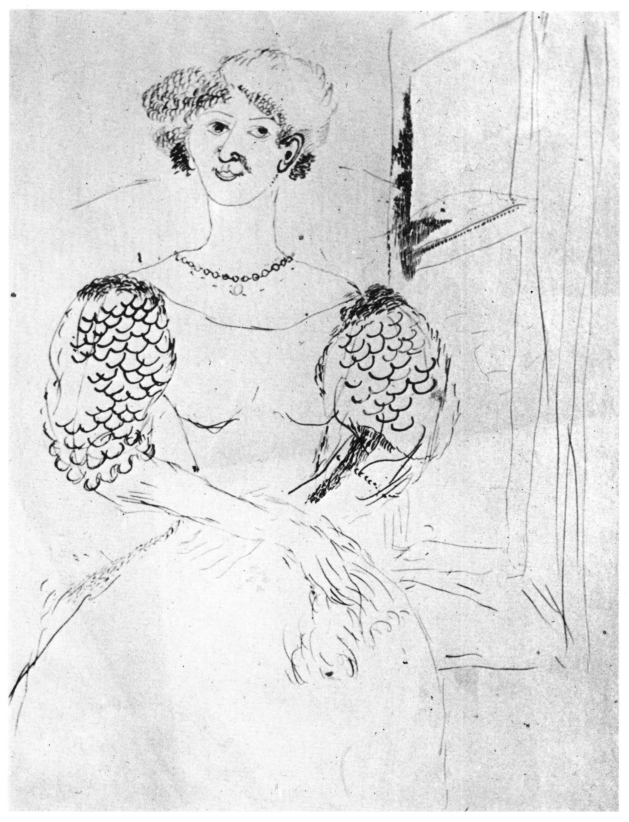

Plate 35

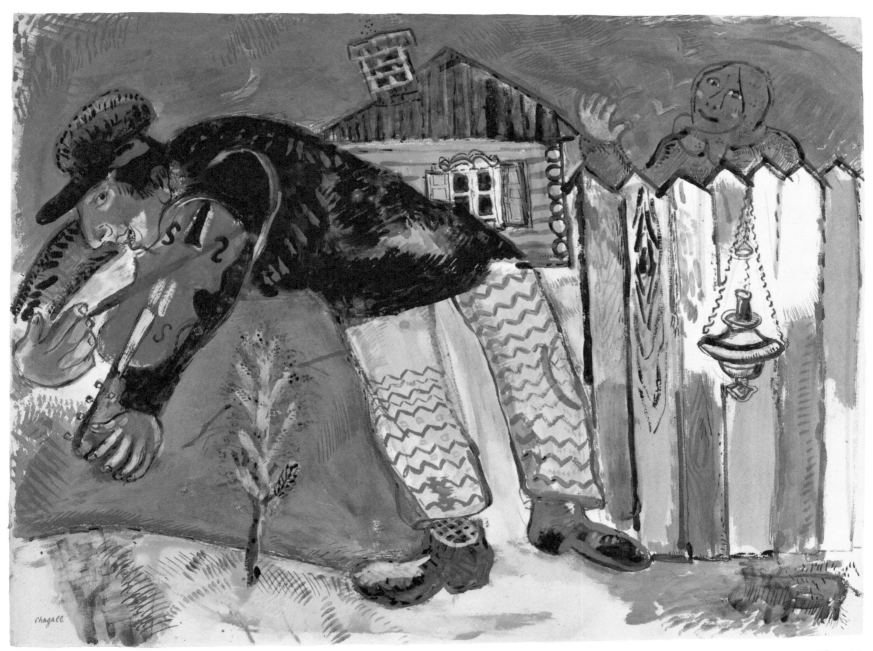

Plate 36

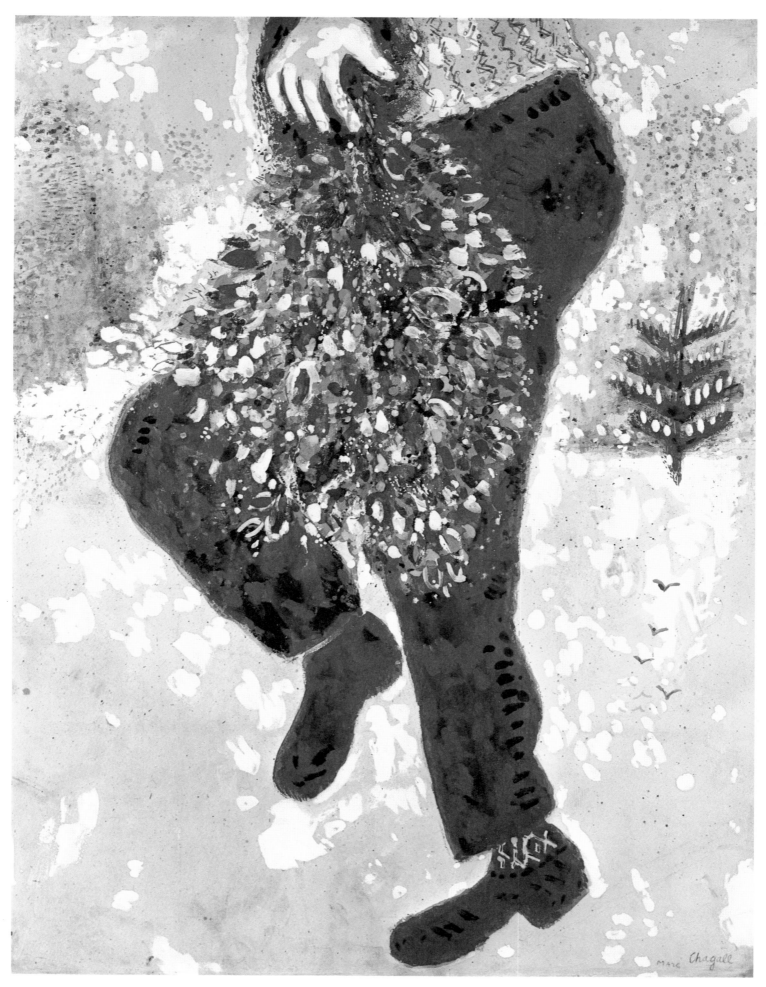

Plate 37

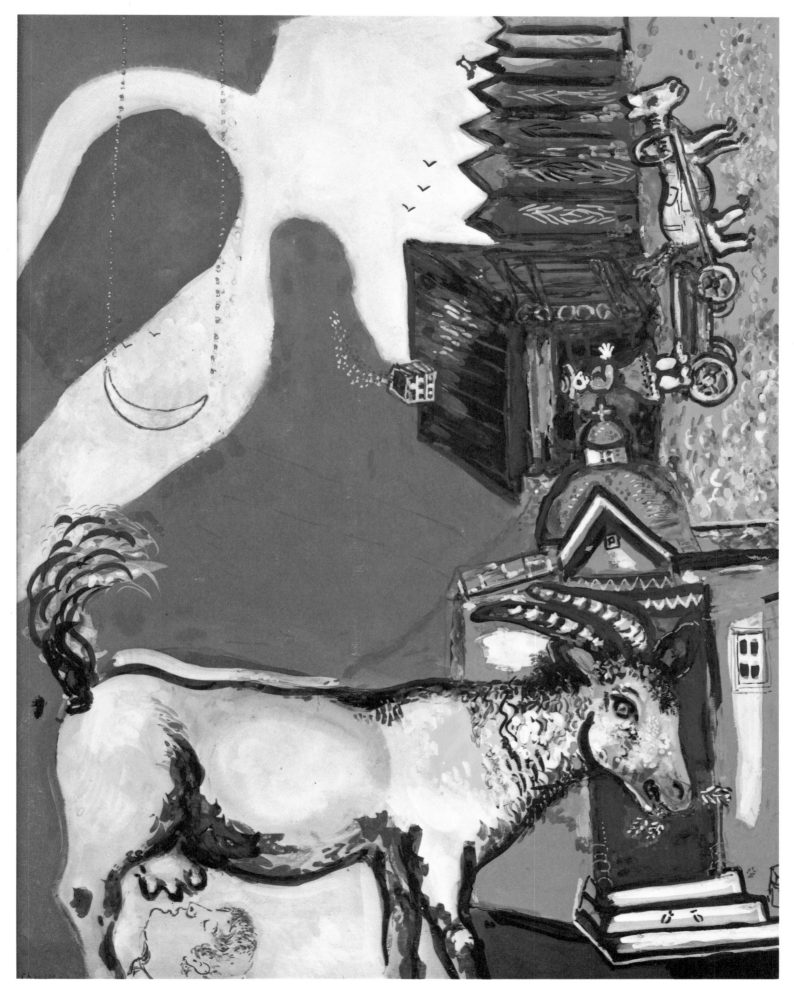

Plate 38

Plate 39

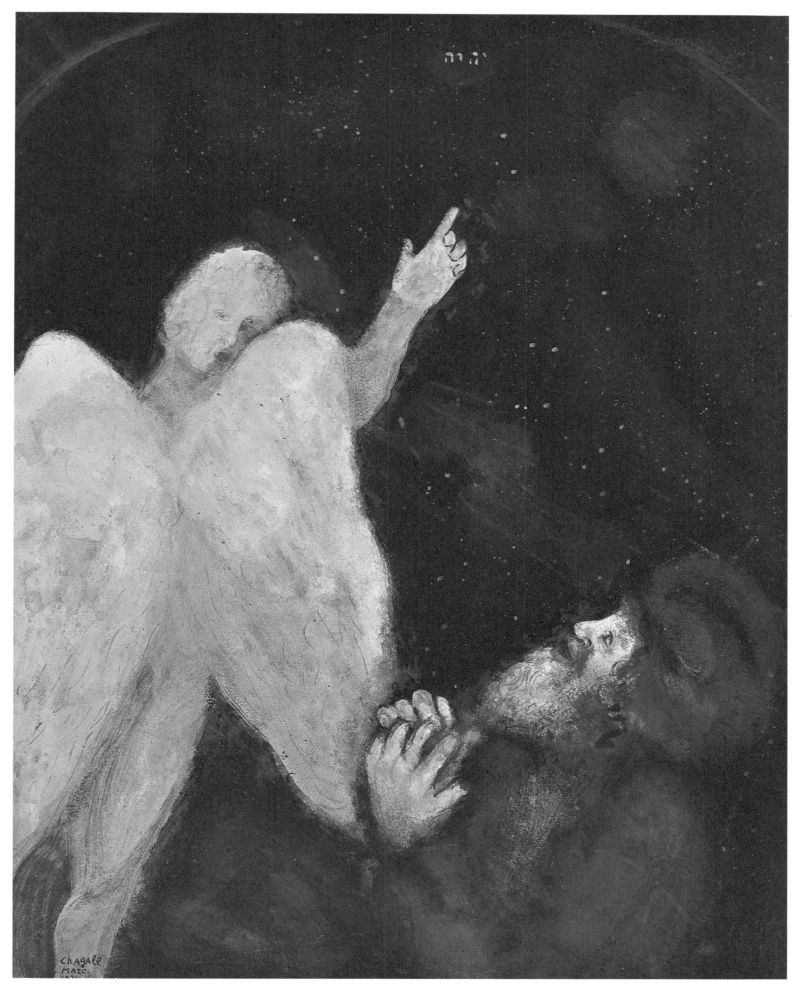

Plate 40

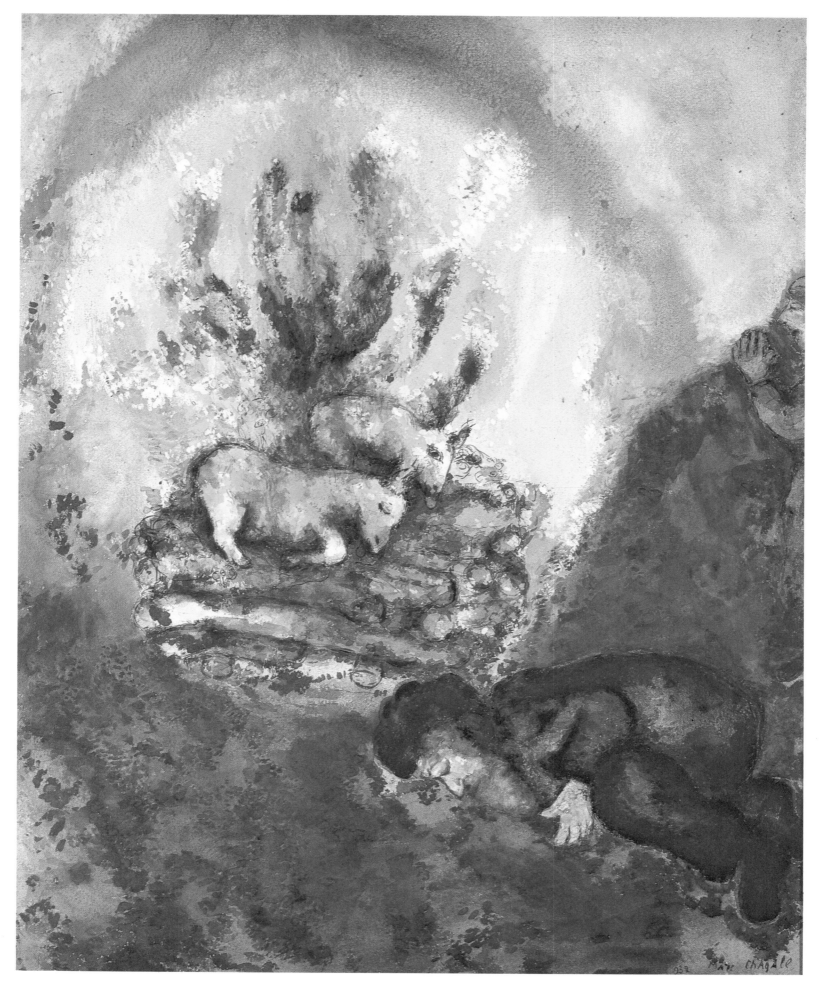

Plate 41

Marc Chagall

Plate 42

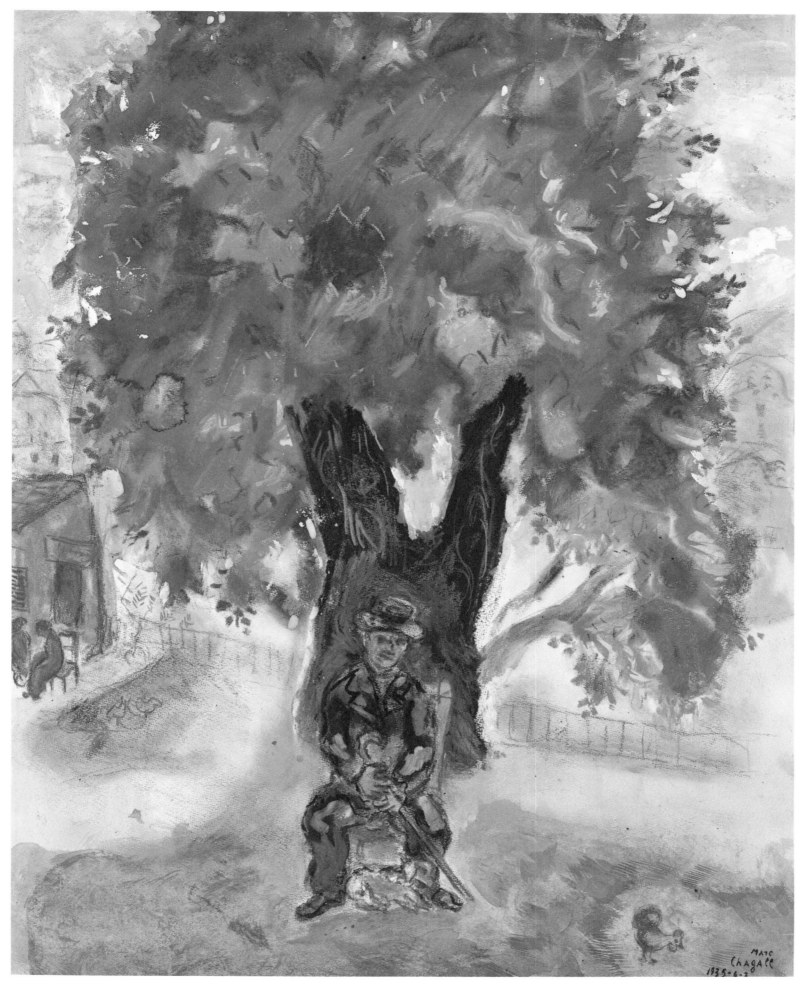

Plate 43

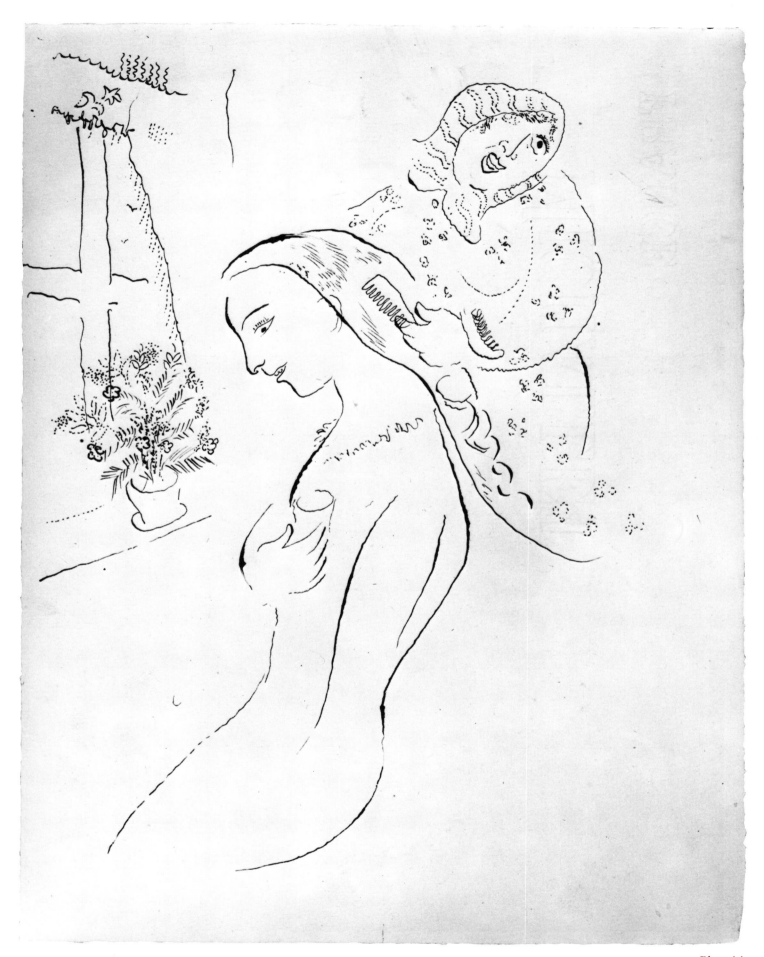

Plate 44

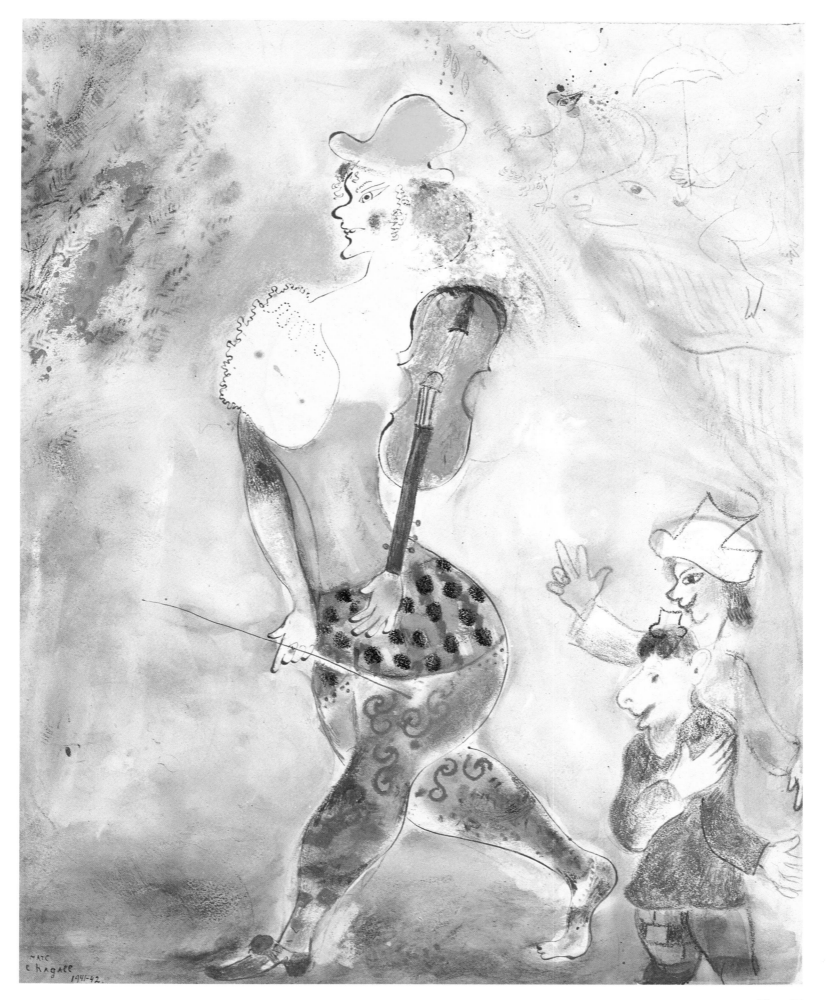

Plate 45

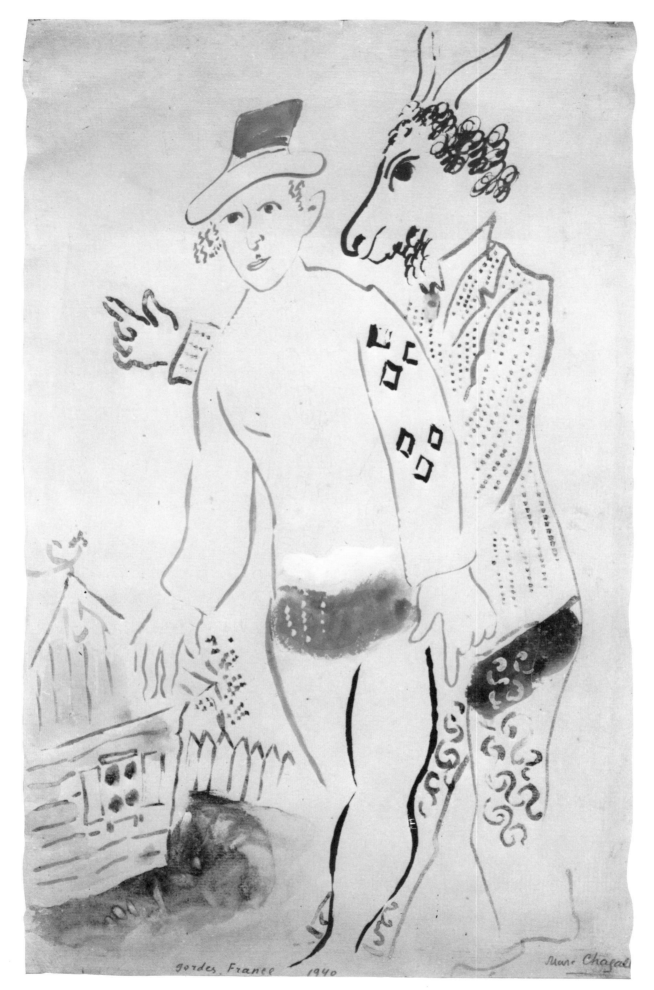

Gordes, France 1940 Marc Chagall

Plate 46

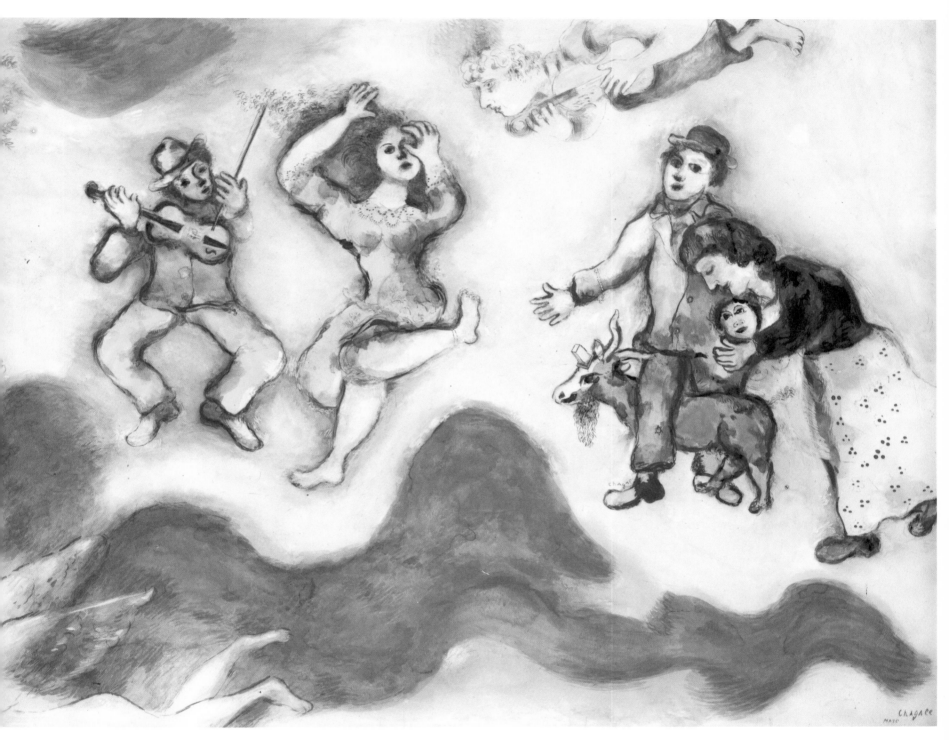

Plate 47

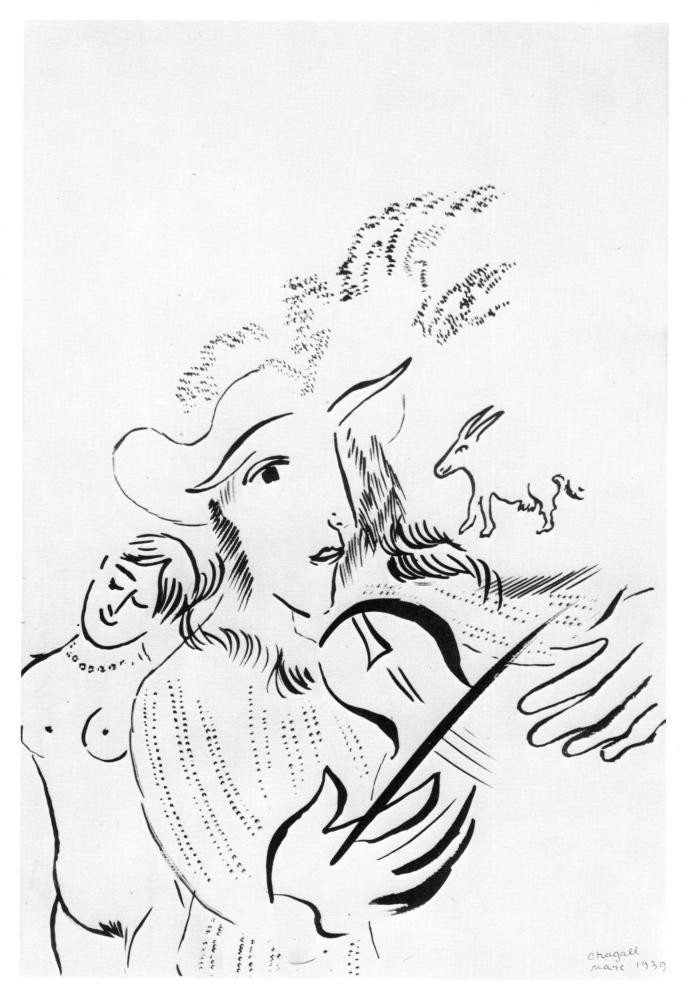

Plate 48

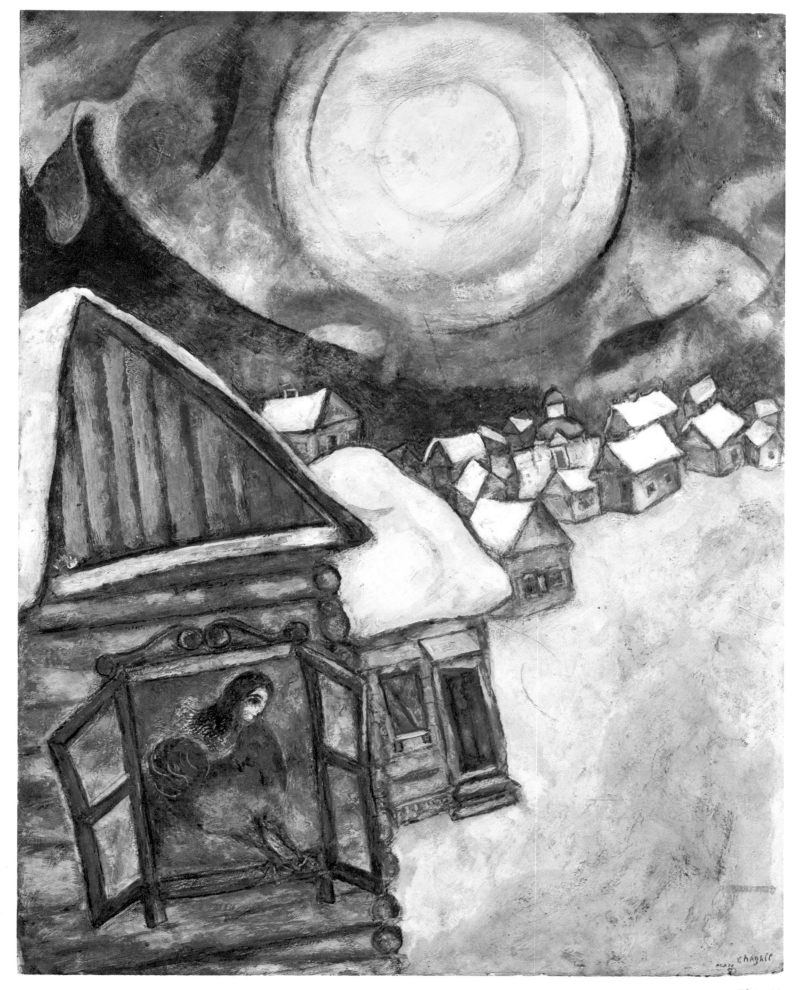

Plate 49

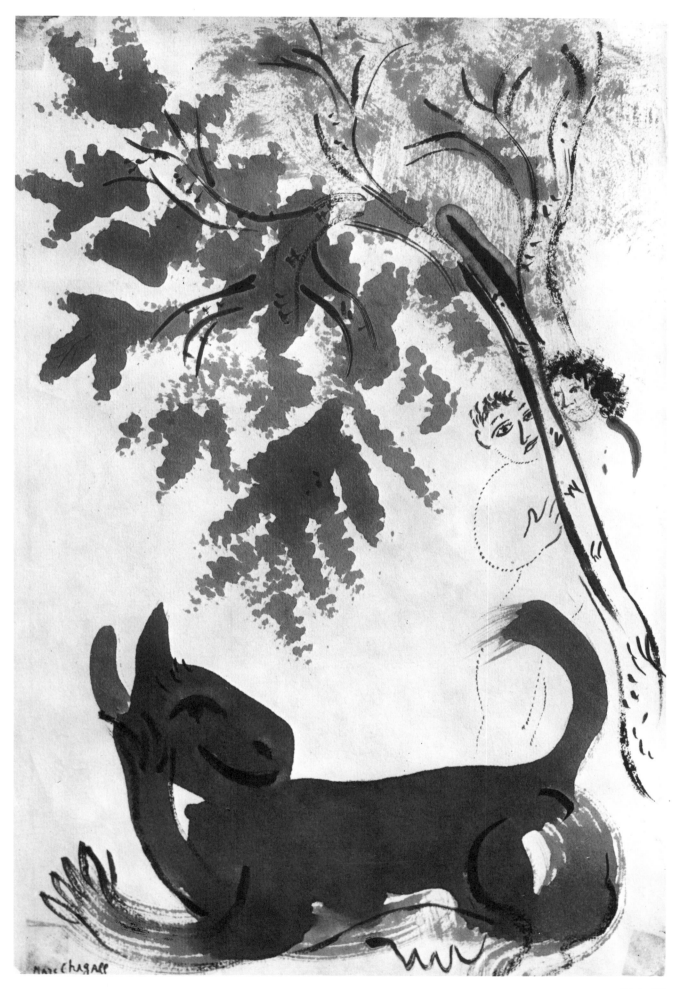

Plate 50

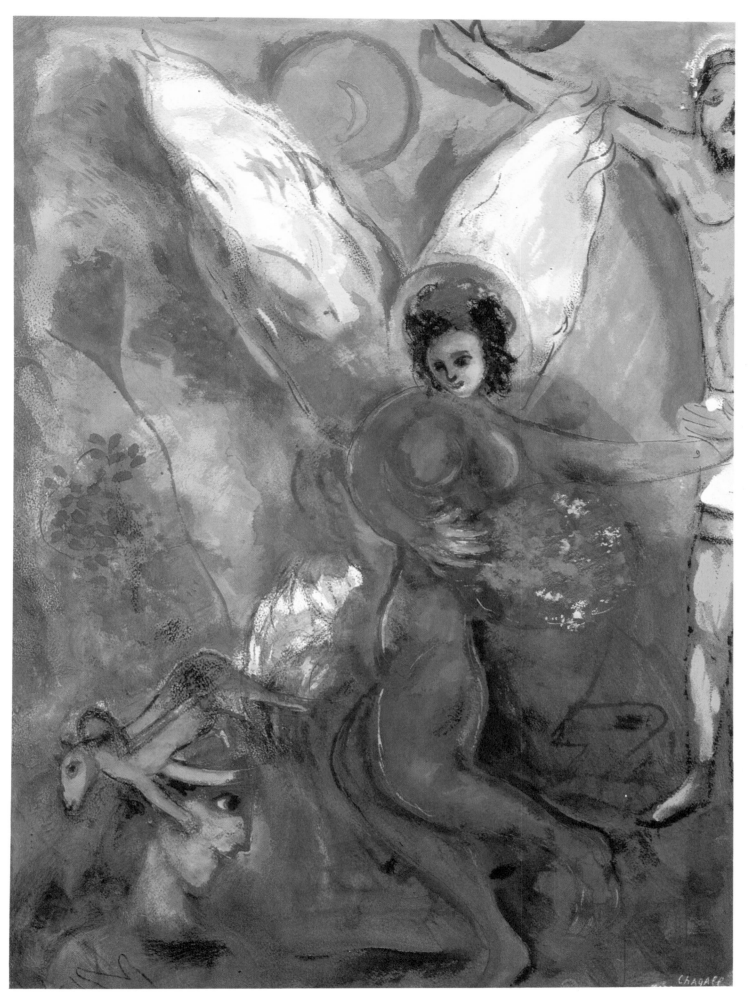

Plate 51

VI

In spring of 1946 Chagall was able to spend three months in Paris, in autumn of the next year a little less, but the definitive return to France took place only in August, 1948. In America he had avoided the big cities and found a small farmhouse where he could continue his work in peace. So too in France now. First he lived briefly at Orgeval near St.-German-en-Laye in the outskirts of Paris, but the winter months were spent near Nice, at St.-Jean-Cap-Ferrat. In autumn of 1949 he went to Vence, where in the following spring he found the villa "Les Collines" hidden away in a stand of old trees. When the modern mania for building took over there too, he settled in a newly built house in the quiet of a wooded valley near St.-Paul-de-Vence.

His wandering years were over. In 1952 he took a second wife, Valentina (Vava) Brodsky, who became the friendly guardian of his household. He was rebuilding his snug little world. True, he had to go to Paris often, and in 1951 he visited Israel. In 1952 and 1954 there were visits to Greece with Vava and a brief sojourn on the island of Poros. Italy too was visited on occasion. Later there were major commissions which entailed traveling to Israel, European countries, and the United States, but all those journeys were embarked on with a deep sigh and gotten over with as quickly as possible because the heart of all of his artistic work continued to lie in the quiet atelier in the Midi. It was there that the work of his old age ripened, work in which gouache has continued to play an important part.

In the close to four decades since Chagall returned to France he has produced, among other things, two large cycles of paintings, notably the *Message biblique* and *Hommage à Paris*, and mastered the techniques of ceramic and stone sculpture. In 1951 he began to turn out colored lithographs in considerable numbers, but there was also, for the first time, a turn toward the monumental in the stained-glass windows he created after 1956, in the ceiling painting for the Opéra in 1964, and in the tapestries and mosaics he turned his hand to in the sixties.

Gouaches nonetheless continued to hold their place. They gave shape to the insights that had been won during the preceding decades and kept them meaningful in form and scope. In content they drew on the sum of Chagall's old iconography: the dream-memories of his Vitebsk childhood which continued to nourish his work, the biblical scenes as the mythic undercurrent of his religious feeling, his mid-summer nights' dreams, and the nature-myths of his inexhaustible fantasy. Two new elements, however, came to the fore and altered the mood of his work: the elegiac and the arcadian. If it came to mean so much to him to be out of Paris and, by preference, in the Mediterranean coastlands, it may well be that it was out of inner need, a yearning for the serenity of the Classical feeling for life. Over all the new works lies the shimmer of the Mediterranean, even something Greek. No one could have predicted that, as exemplum for young students, Chagall would have chosen deliberately (we have his word for it) the ancient hero Ulysses, a man both bold and patient, as he did in 1968 in a thirty-six-foot-wide mosaic for the university in Nice!

His art more than ever before took to mirroring experiences of nature in poetic transformations and summoned up figures of a self-made nature mythology in which, in a strange manner, he mingled reminiscences of the pan-erotic personages of the ancient Classical mythologies. Already in the many gouaches turned out in that spring of 1949 at St.-Jean-Cap-Ferrat, when he returned for the first time in years to his beloved Mediterranean, such mythical metamorphoses constituted a response to the Greek feeling of the marine landscape around him. In a large India-ink drawing (plate 52) he sketched the quiet bay of Cap Ferrat and, above it, a young horned Pan carrying a dreaming fish-tailed siren while one of Pan's strange company holds a cluster of flowers in readiness for the bridal bed. A vision of utter grace with its ancient Classical reminiscences, it arises out of the fragrance of the Mediterranean bordering the quiet inlet and out of the light that bathes it.

For a technique apt to convey the feel of fragrance and light and the pictorial mood they elicited, Chagall now turned to wash drawing in which the flow of India ink casts infinite modulations on the white ground. Although he had already used it on occasion, after 1949–50 it became his almost exclusive drawing medium, and this was because it best captures the evocative play of light which was his central experience in his new Mediterranean environment.

Color, in that light, takes on a more resonant body. Chagall no longer treated it in terms of contrast, laying it over a constructivist frame, but allowed it to spread in modulations, as if from waves of light across the surface.

The colored luminosity itself carries the inspiration. In a gouache, *Basket of Fruit and Bouquet* (plate 53), we again see the bay at Cap Ferrat at evening, traversed by a small dream-boat. The fragrance of flowers and fruit wafts over the bay and, for the painter, evokes images of a bouquet and basket of fruit. Like a green cloud patterned through with blossoms, a mass of flowers grows out of the blue of sky and sea. The complementary golden yellow color is used to limn the details but also casts a flickering glow of light across the entire work. Then, to complete the metaphor, there appears the golden bird of fable, and on its back rides a pair of lovers who have blossomed out of the golden pollen. From the simultaneous experience of a Mediterranean bay and the fruitful, fragrant land Chagall created a unified lyrical visual poem whose words and meter are the stuff of color.

Wherever the painter's eye turned in this picturesquely lavish nature which is gentle yet rich with flowers and fruit, the nature-motif was transfigured into a lyrical apotheosis of light. Flowers and a basket of fruit on the window ledge of his atelier (plate 54) were the incentive to conjure up a play of light out of the contrast of black and white and which itself dissolved that contrast into a moment's mood. Or color—the dusky red of the ground in the gouache *The Red Flowers* (plate 55)—sets a basic poetic mood out of which flowers and fruit grow into an apparition that sends luminosity across the evocative ground. The tiny eros-motif of the lovers as well as the fairytale cow—the beast that had always embodied for Chagall everything good and gentle in nature—are present as fond allusions to the erotic element which always, in his experience of nature, pervades the things of the earth.

The gouache of *Evening at the Window* (plate 56) gives a clue to the painter's frame of mind at that time. A highly lyrical work, it is a variant on his old motif of the window. Indoors, in the twilit space of the studio, the lovers appear almost as a marginal allusion rife with memories: Chagall's sign for love and mutual protection. The window opens on a village, perhaps a Russian village and therefore Chagall's old sign for the warmth of the human community, though something about it suggests also the tiny medieval core of Vence. It is lonely, empty of human life under the night-blue sky through which the moon casts its yellow glow. A fable-bird wanders out of the open window into the bright night. And so what we see from the open window becomes

a metaphor for the imagination which can blossom unhindered in the ever-open spaces of dream.

A strain of loneliness, of melancholy and fate-fraught earnestness, is not to be overlooked. At the same time as these arcadian dreams there came into being visions of a darker, more religious character. Around 1949–50, in the atelier in Vence, Chagall began the legendary series of the "biblical message." Visions of dramatic force took shape, such as *Jacob Wrestling with the Angel* (plate 57) or, in another Inda-ink drawing, the terrified countenance of the prophet struck dumb by God's hand.

Sometimes in this context of fateful visions there were others which, though not biblical in content, carried something of the same dark metaphoric solemnity. These still have much in common with the scenes of terror in the gouaches that Chagall produced in America when the news of the war filled his imagination with images of fire and death. They dispense, however, with that anecdotal side and with any particular scenery or setting. Enigmatic emblems take the place of news from the front and translate it into a timeless pictorial script. In a gouache titled simply *Winter* (plate 58), as the sign of fate the gigantic fire-red head of a horse looms before the dark sky like an apocalyptic animal in flames above the wintry gray of a village landscape. A mighty cock, whose emerald green color glows with menace, strides solemnly out of the night and carries with it the tiny figure of a peasant woman. Below, a lonely, frightened peasant gesticulates, cracking his whip over his rustic sled which, however, no horse now pulls. Difficult as it may be to puzzle out in words the content of this work, the metaphorical power of its pictorial parable is nonetheless of stunning impact. What is asserted here is the plight of man abandoned in the domain of God's creatures. Man is driven from without by a force of destiny, but drawn as he is into the circle of nature, those non-human creatures that serve as signs for that force can also serve as signs of menace to man's own natural world.

Such ominous images of fate persisted in the succeeding years as *mene-tekel* for a threatened world. We find them in the *Flight* of 1960 (plate 70) or in the apocalyptic image of the *Setting Sun* of 1961 (plate 74). Such pictures are always disavowals of the arcadian world into which Chagall's fantasy, charmed by the easy beauty of Mediterranean nature, was forever tempted to retreat.

Daily walks in the vicinity of Vence turned the painter's

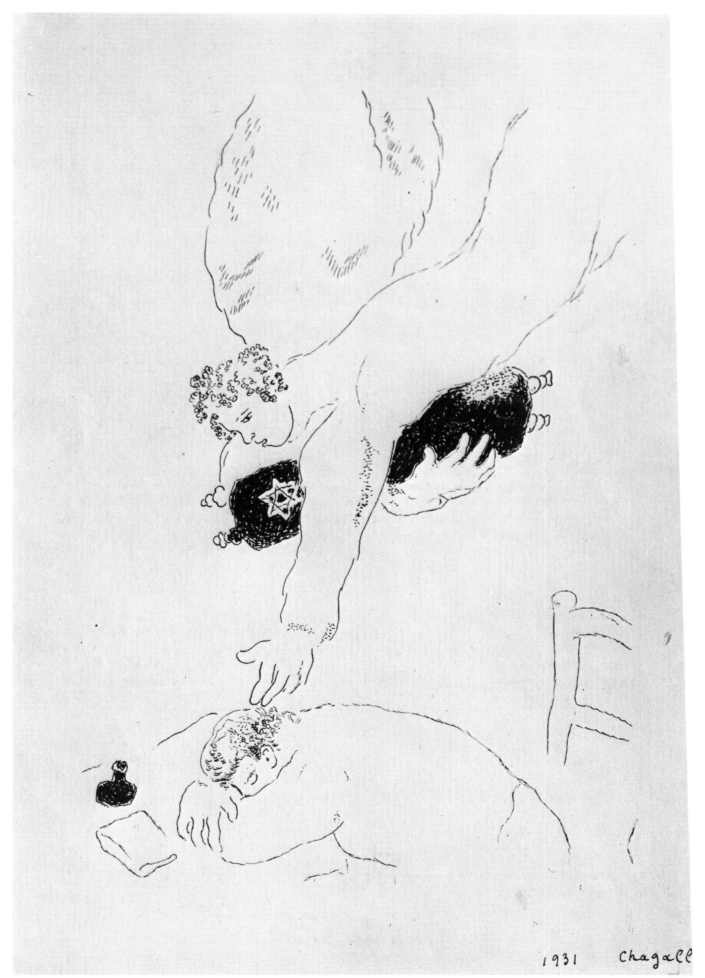

1931 Chagall

The Angel with the Torah. 1931

thoughts repeatedly to the arcadian motif. Once at twilight he encountered a woman reaper riding her donkey down the gentle slopes of those Mediterranean alps to her home in the village below. A pleasant motif, around which he did an entire series of gouaches. The one we see here (plate 60) is particularly characteristic since it shows how, spinning out in his imagination something actually observed, there remained always a tang of the Russian, an aftertone of memory.

From near the beginning of this arcadian-elegiac phase are gouaches done in Greece. Once he had made his way into the Mediterranean world, Chagall insisted on seeing its spiritual heartland with his own eyes. His friend, the publisher Tériade, himself a Greek from Lesbos, told him with Greek passion about his native land, had him read Longus's pastoral novel *Daphnis and Chloe*, which takes place on Lesbos, and spurred him to turn his hand to illustrating it. Tériade had a villa on the bay of Cap Ferrat whose garden Chagall commemorated in a number of fragrant pencil drawings (plate 61). There the two friends must have talked of the land of Homer and its islands, and the silvery shimmer of the drawings done in the garden already show a foretaste of the Greek world.

After Chagall's second marriage in the spring of 1952, the new couple's first trip together was to Greece in the following summer. Their way led from Athens to Delphi and finally the island of Poros. There, in the wonderful light of the Greek summer which captivated the artist, and in the poetic glow of the ancient love story of Daphnis and Chloe, he began his new life with his second wife, whose task was to ensure the aging artist the peace and calm which do in fact breathe through the large-scale works of his late years.

In autumn of 1954 the couple had another lengthy sojourn on the Greek island, and it was there that he produced the sketches for the colored lithograph illustrations to *Daphnis and Chloe* as well as a number of independent works. Among the latter is a *Blue Still Life* (plate 62) in which once again a window opens on the majesty of the simple but great Greek world of nature. The magical blue on which the moon casts its beams covers the entire sheet in a reciprocal mirroring of sky and harbor. A few graphic outlines suffice to define the simple items of the Greek island landscape, the inlet of the sea, the distant summits of the mountains, the little town between sea and mountains. A few isolated objects add a lyrical description, and in this gouache anyone who has ever known a Greek harbor at night will recognize the enchantment of the Greek islands.

The Greek element as nostalgic arcadian dream has remained always just below the threshold in Chagall's world of ideas. It accounts for the note of elegy in his reaction to landscapes, pervades also the landscape around the little medieval town of Vence which itself often appears in his backgrounds as a delicate abbreviation for the whole notion of "city." Bouquets, still lifes, landscapes dreaming under the moon all speak of his immersion in Mediterranean nature. Fabulous beasts are the protagonists of a loving nature-myth (plate 66). Lovers in bridal attire enveloped in flowers and landscape (plate 68) bring the pan-erotic element into play.

Certainly no one should expect to find naturalistic depictions of landscapes or figures. However steeped in the feeling of nature they are, not even these late works were painted "in" nature but only in the studio. They are responsive mirrorings of experiences and dreams which have assumed visual shape only in the course of the artist's daily commerce with colored forms. They are always and only pictorial metaphors for an inner psychological or spiritual state.

Certain themes reappear in ever new variations: the Russian village and its inhabitants, Old Testament figures, the crucified Christ who is Chagall's symbol for mankind taking on all the world's woe. If in gloomier hours memories return of war and persecution and the unhopeful prospect of our world of politics, as in a gouache called *Flight* (plate 70), the suffering world is symbolized by the Russian village and the tangle of its crooked streets stands for the labyrinth of the human escape routes whose every way out is marked No Exit. If Chagall depicts himself at work in his studio as in *Blue Interior* (plate 75), in the background we find the Beloved with a bouquet and the little kobold carrying the Sabbath lights. But on the easel stands a picture with Christ on the cross as mystical icon for the miraculous circumstance that the world's salvation comes out of the affliction of the prophet. In the gouache of *The Setting Sun* (plate 74), Chagall invented a picture of man's fate which draws the sum of his own life-experiences. Beneath a dark sky set aflame in the distance by the last

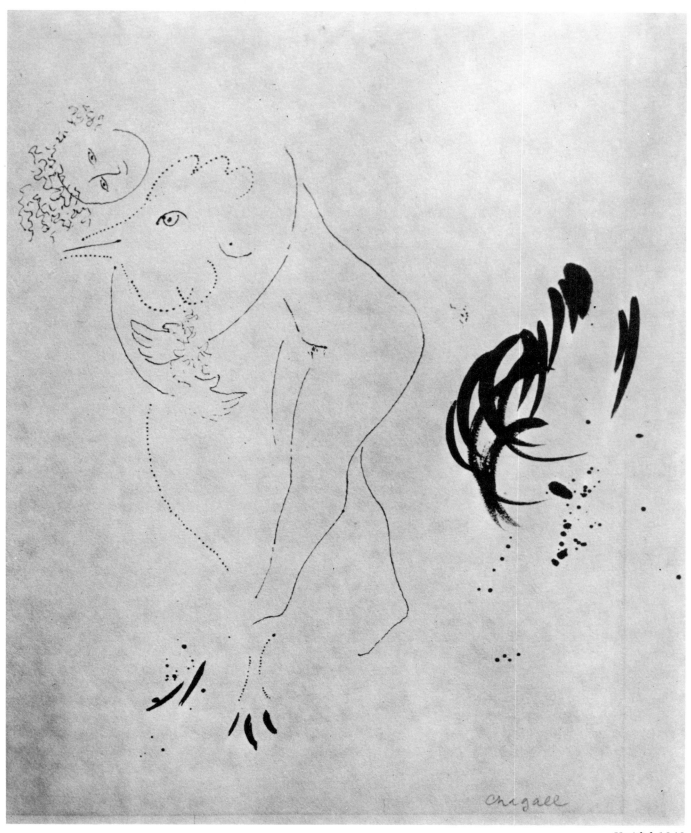

Untitled. 1940

rays of the setting sun, the gigantic apocalyptic head of a cow looks down on a wintry village benumbed by snow, crouching under the menace written in the sky, huddling in fear around its village church: the zone of human life. A pair of lovers stretch out in the village, seeking to bring a touch of warmth into a frozen world through their embrace. A fleeing Jew blows the ritual shofar over the lonely hovels, a fiddler plays his song in the snowy streets, while behind him, through a transparent wall, one sees a man at his pious Sabbath meal under the comforting golden glow of an oil lamp. In the midst of this vast and frozen loneliness, the tiny dots and dabs of gold around the Sabbath table bring to these minuscule scenes of a lost world the sign of a pious activity that holds its own against the world's despair. Then the axis shifts, and two figures appear upside down in the gloom-drenched sky: the tragic mask of a Jew crying his prayers aloud against the hostile darkness, the portrait of the painter himself who holds his icon of crucified Man like a shield against the stars.

In this latter context it should be noted that however much Chagall's conceptual world may be filled with figures from the Old Testament and the mystical side of Jewish religiosity, he declines to be thought of as a "Jewish" painter. Some years back he produced a major cycle of paintings he called his *Message biblique* and donated them to the city of Nice which built a community center worthy of housing them. Yet even these were dedicated to the ecumenical community and communion of all believers without regard for the particular creed. Chagall's concern is not with the Jews but with all mankind. Because they have taken so much pain and suffering on themselves, the Jewish people—like Christ the Jew—can serve as symbol for all humanity. Whence the gentle melancholy which lies over all the productions of this late long frieze of images.

One figure crops up repeatedly in the late work, as formerly the Jew with pack on back appeared over and over in the earlier compositions as symbol for the wandering existence. Now he takes the form of the Jew who embraces the sacred scrolls, the Torah (plate 64). One finds him not only in the sanctuary of the synagogue, as in the present gouache, but even more often wandering through dark places and burning villages. The figure is to some extent a self-portrait, or at least autobiographical. As regards the Torah, Chagall feels that his art likewise is wrapped up in

those scrolls, like the sacred texts in the case that contains them. Like the Jew carrying the Torah, so Chagall has borne his art with loving care through all the disasters of a time devastated by the heavy hand of politics, has preserved it faithfully from all perils. His art is his scroll of pictures which grow essentially out of a religious ground but also contain much that is pagan, though that too—still in the Hallotria of the superabundantly celebrated life and still in the simple thing and the most ordinary animal—bears a spark of the love of God in itself, according to the belief of the Eastern European Hasidim. When Chagall unrolls that scroll, as he has done in the multitude of his gouaches, then the maddest circus may at times emerge and the painter himself bow in as a clown, as the *saltimbanque* of a kindly God, the Lord's own juggler.

Chagall the man is entirely surrounded by the world of imagery of Chagall the artist. The recurring burlesque circus scenes (plate 77) find a place even in his deeply earnest late works, take on their reality only in his own inner vision thanks to his power of creating images. Once, in a very beautiful poem he wrote for the book *Cirque*, brought out in 1967 by the Éditions Verve, Paris,[18] he described the existence of those images immanent within the reality of his own imaginative faculty:

Dans la nuit, tu sursautes.
Tu sens en toi la présence de l'Éternité.
La nuit sans fin.
Le matin me fait rêver avec sa nouvelle clarté.
Je rêve que je suis dans un cirque.

J'ai imaginé mon cirque dans les heures nocturnes.
Il est au milieu de ma chambre.
On entend les rires et les cris.

Ces acrobates se balancent dans les hauteurs.
Ils passent d'une main vers d'autres mains,
Ils passent d'une jambe vers d'autres jambes,
Ils sont en bleu et en rose.

Mon cirque se joue dans le ciel.
Il se joue dans les nuages, parmi les chaises,
Se joue dans la fenêtre où se reflète la lune.

[18] The gouaches and wash drawings in that book were done in 1959 and 1961. The originals were shown in summer, 1972, at the Galerie Rosengart, Lucerne, which published a catalogue at that time.

(In the night, you start up. / You sense in yourself the presence of Eternity. / Night without end. / Morning with its new clear light makes me dream: / I dream that I am in a circus.

(I have imagined my circus in the hours of night. / Its place is right in my bedroom. / Laughter is heard, and shouts.

(These acrobats swing and poise in the heights. / They leap from one hand toward other hands, / They leap from one leg toward other legs, / They are costumed in blue and pink.

(My circus performs in the sky. / It performs in the clouds, amidst the chairs, / Performs in the window where the moon is reflected.)

It is this sublimated reality, filtered through the inner concept and translated into metaphor, that makes up the stuff of Chagall's gouaches.

Often his circus ring expands to become a metaphor for the world, with stars and moons and suns above it. Angel-like creatures burst in from on high; from below they are greeted by the animals of Chagall's menagerie and by his clowns. A world closed in itself, artistic and artful, takes shape, and anxiety is felt only as a vague unrest outside it, on its margins. Art: for Chagall it means also reshaping anxiety over the unsatisfactory nature of our world by means of images that reflect humanity and love. Again and again each of us finds in Chagall's multitudinous cast of characters some figure that touches us personally, that holds us spellbound, then awakes in us that tenderness our real world so often buries.

The late gouaches are painted thickly, laid on even like some precious stuff. They no longer have the motley expanse disposed in firm planes and kaleidoscopically splintered prisms, as in the early examples. The film of color is densely woven and is partial to the chromatic gradations between colors closely adjoining on the color scale. Out of the relatedness and contrast of his colors, the painter aims at developing a luminosity which, as a unified medium, can spread its light over the entire field of the picture. This use of color, in which the entire range of the spectrum is exploited, although everything is subjected to a unifying general tone of light steeped in color, is the ultimate professional achievement of Chagall the colorist. It owes something to Titian, El Greco, Rembrandt, and Goya, painters whose works Chagall studied to the core during his travels. But it also developed in the course of a long life as a painter and in gradual slow steps out of the bright spectrum of Orphic Cubism. From that development it has retained the treatment of color as something in itself which not so much describes the object in view as generates an expressive aura out of color and light in which the object—the subject matter—passes over into the dimension of visual poetry.

For that is, in sum, the true fame of Chagall, that he is the painter-poet of our century. From the time of Cézanne, and with Matisse and the Cubists, the purely evocative picture had been the central concern of art. It was Chagall who filled that essentially non-representational picture with far-reaching poetic content and who, as painter, was the first to initiate the kind of pictorial metaphorism which Paul Klee took up too and spun further into remote regions of the psyche and which then the Surrealists distributed into separate domains of existence. It was Chagall's own intuitive poetic capacity that made him one of the great image-makers of our century. It was not by chance that he turned most often to a medium like gouache in order to seize upon the salient features of that great flood of metaphorical images that welled up in him and to transport and transpose them into works of art to be shared with us.

Tavarnelle Val di Pesa (Florence)
early summer, 1975

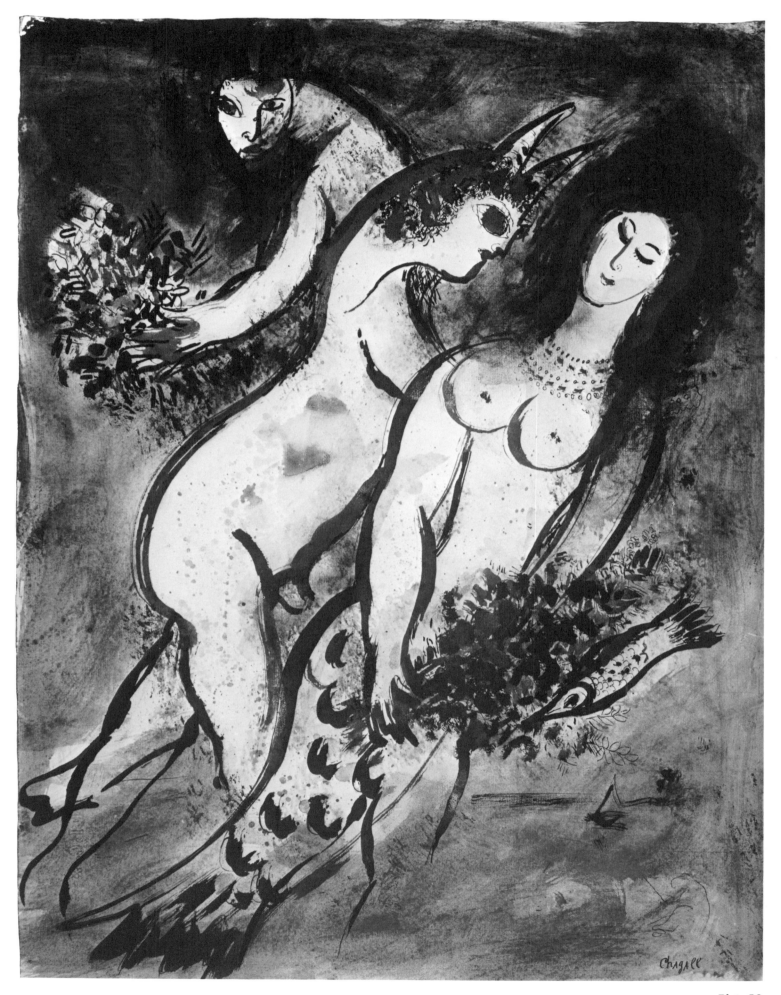

Plate 52

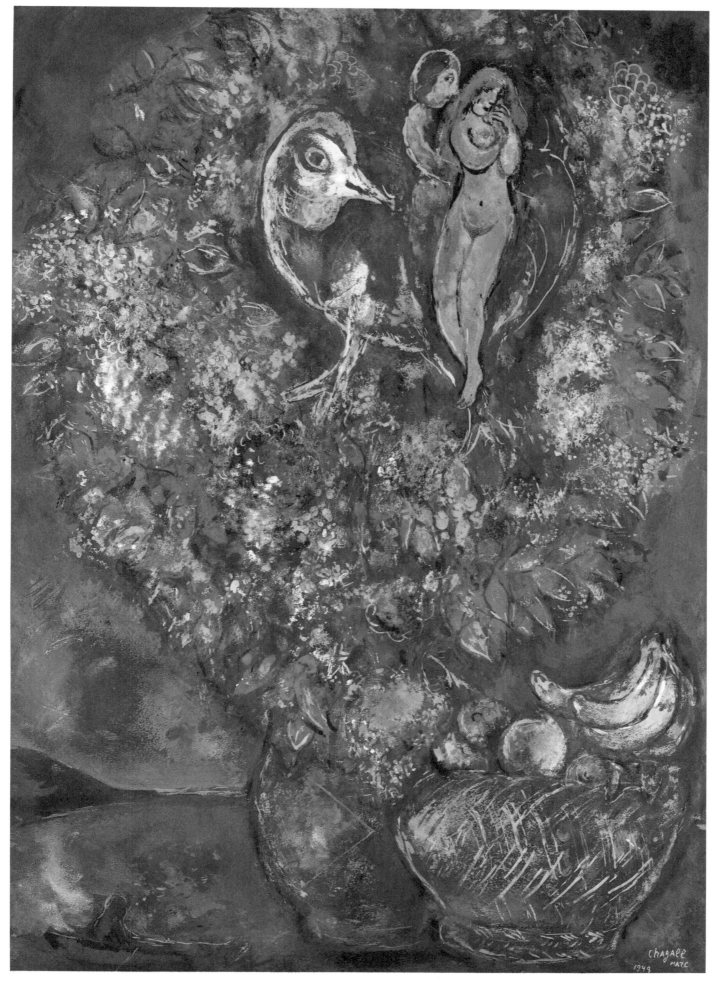

Plate 53

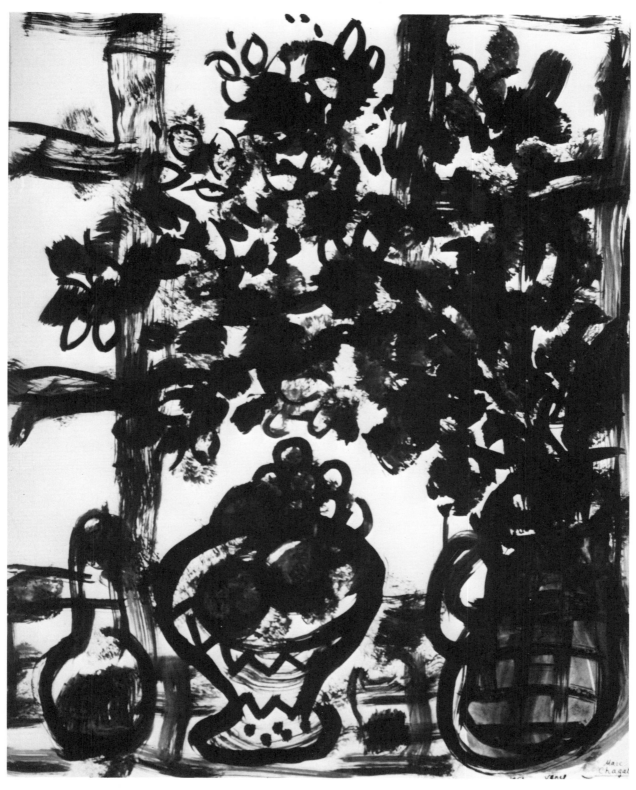

Plate 54

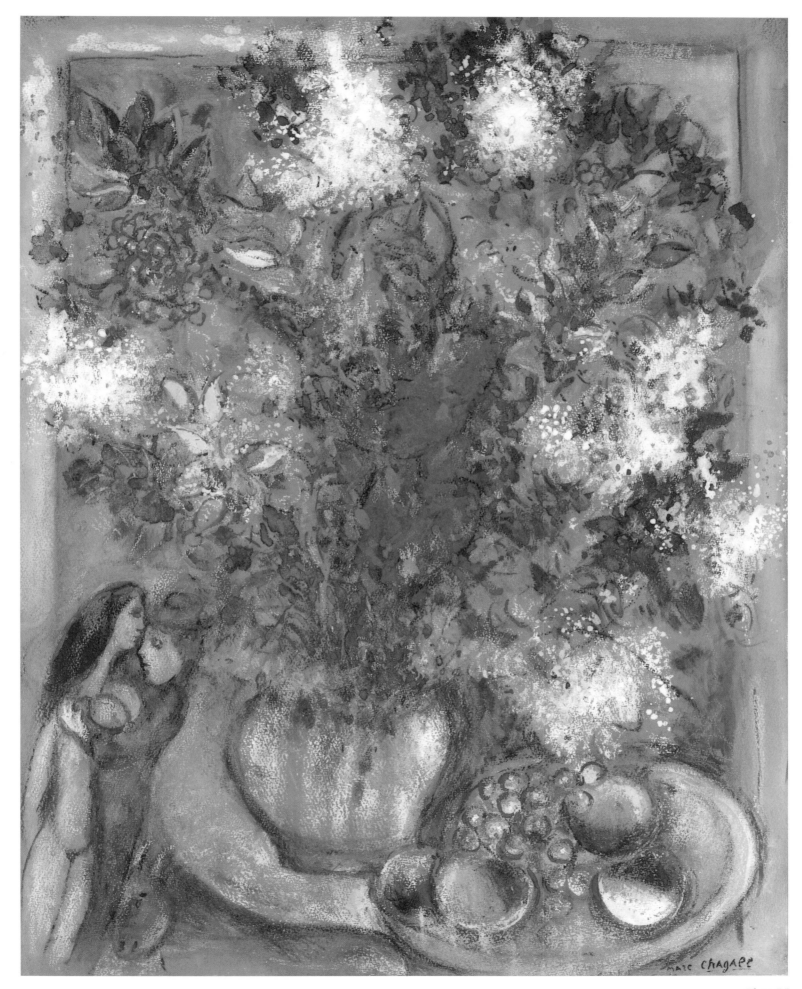

Plate 55

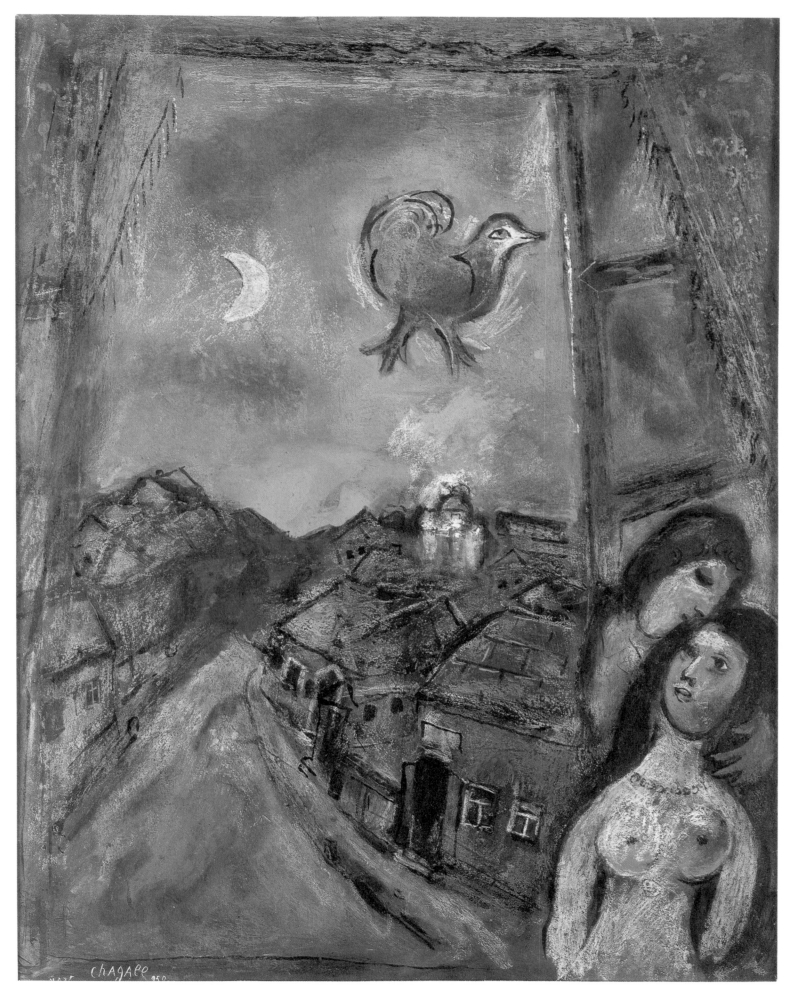

Plate 56

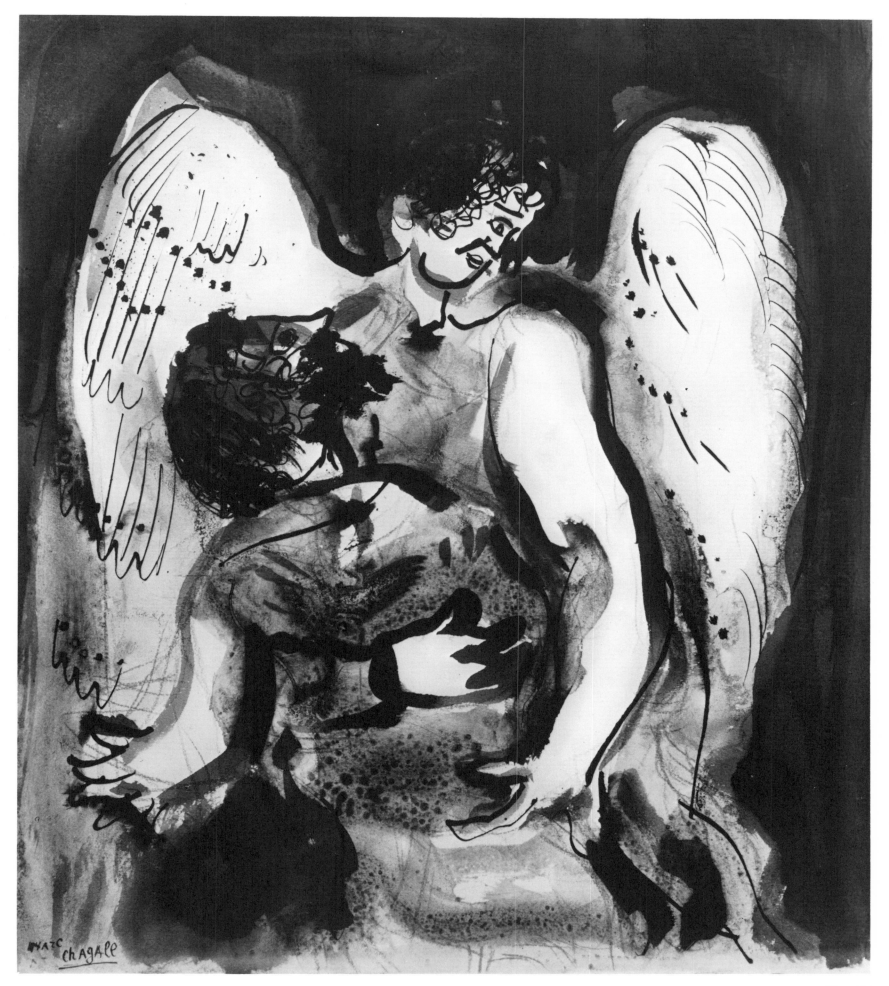

Plate 57

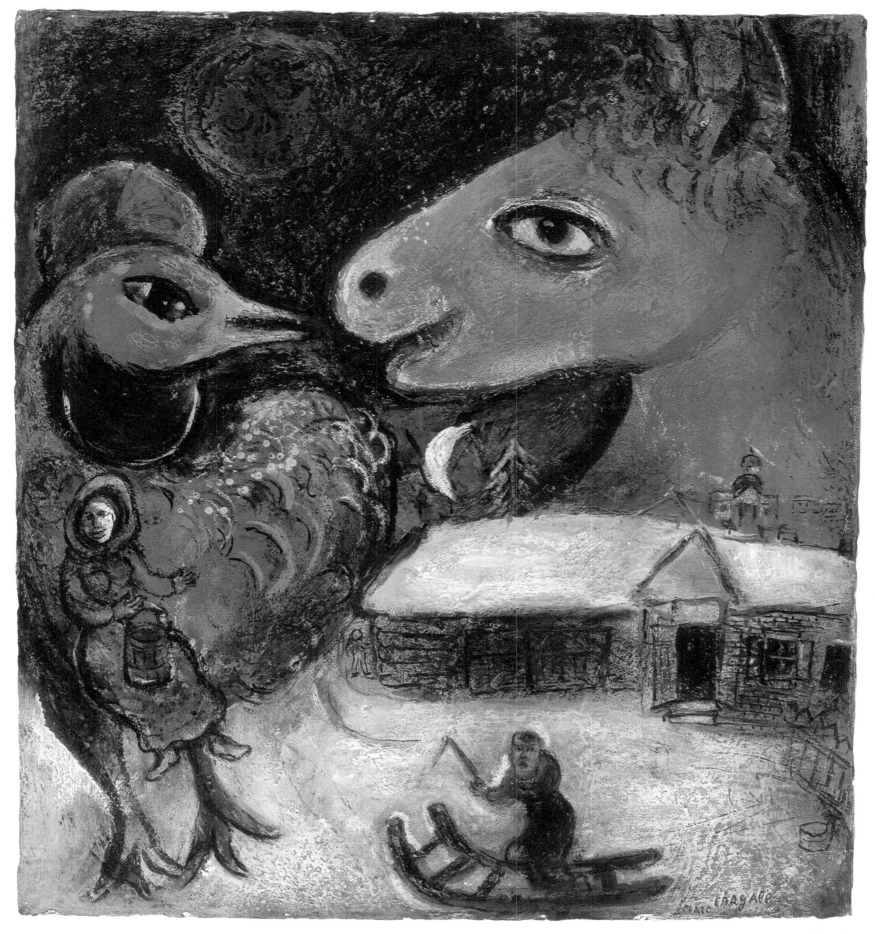

Plate 58

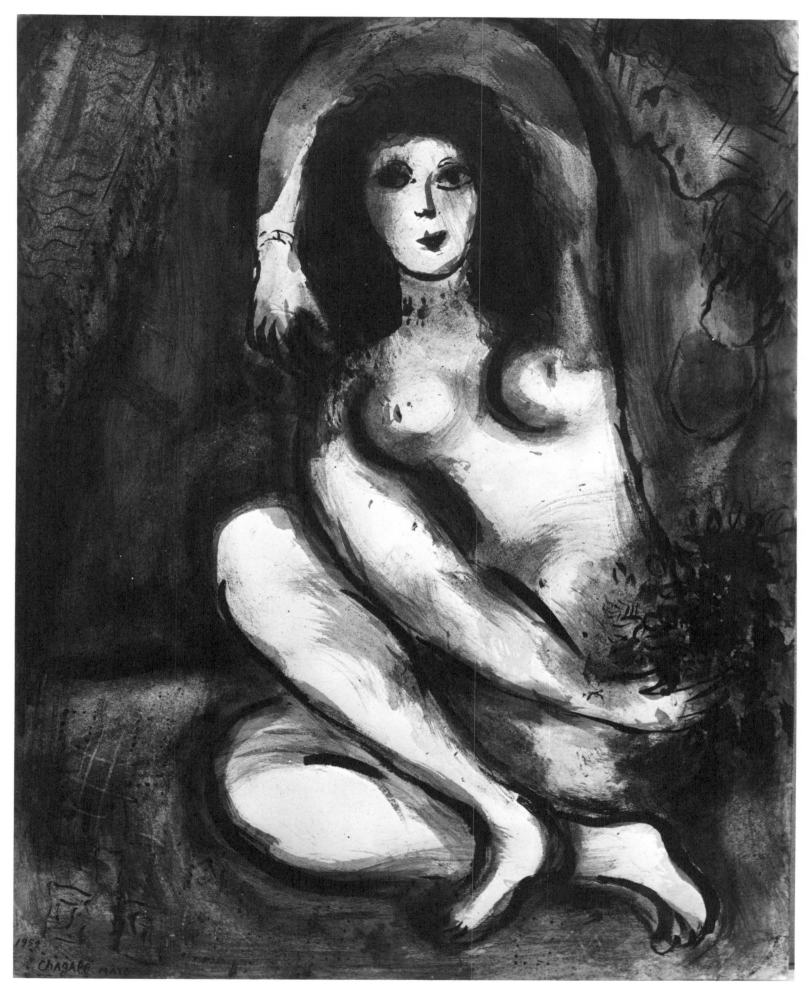

Plate 59

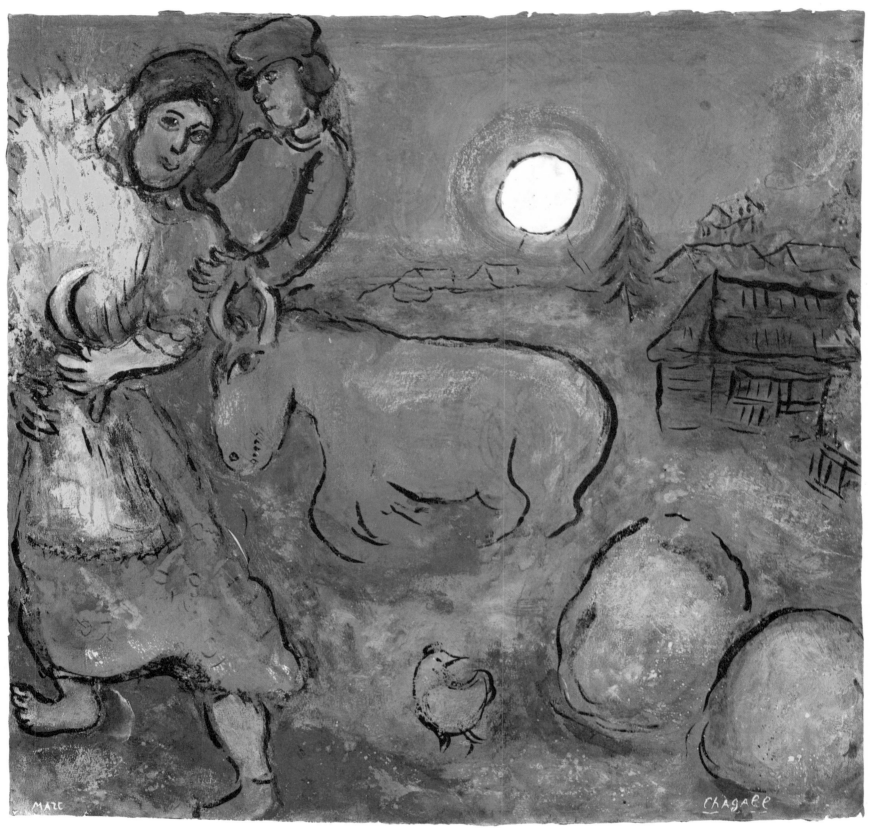

Plate 60

Plate 61

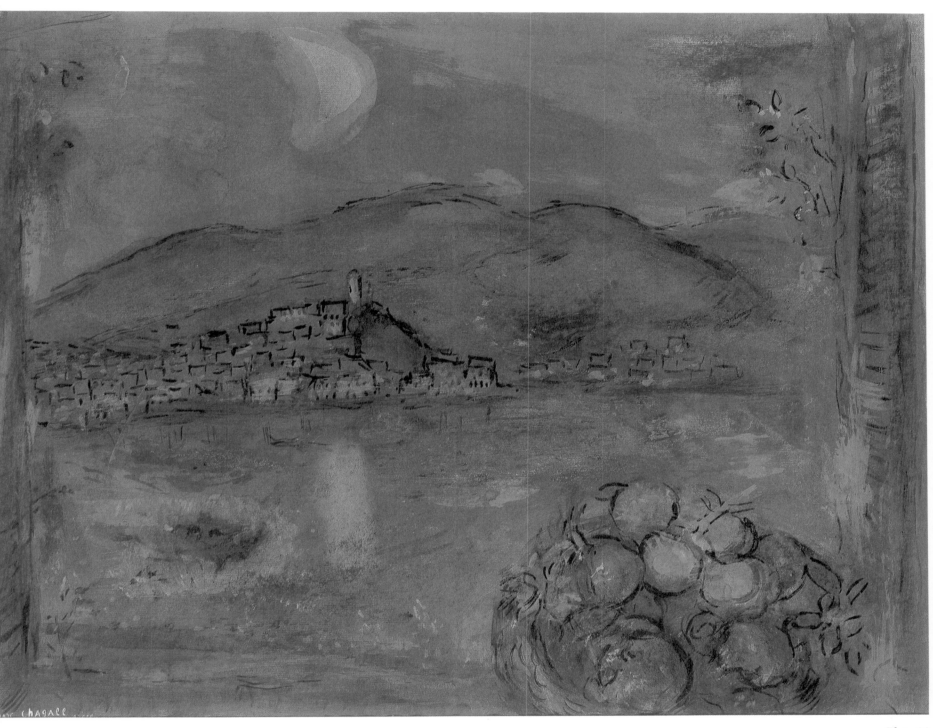

Plate 62

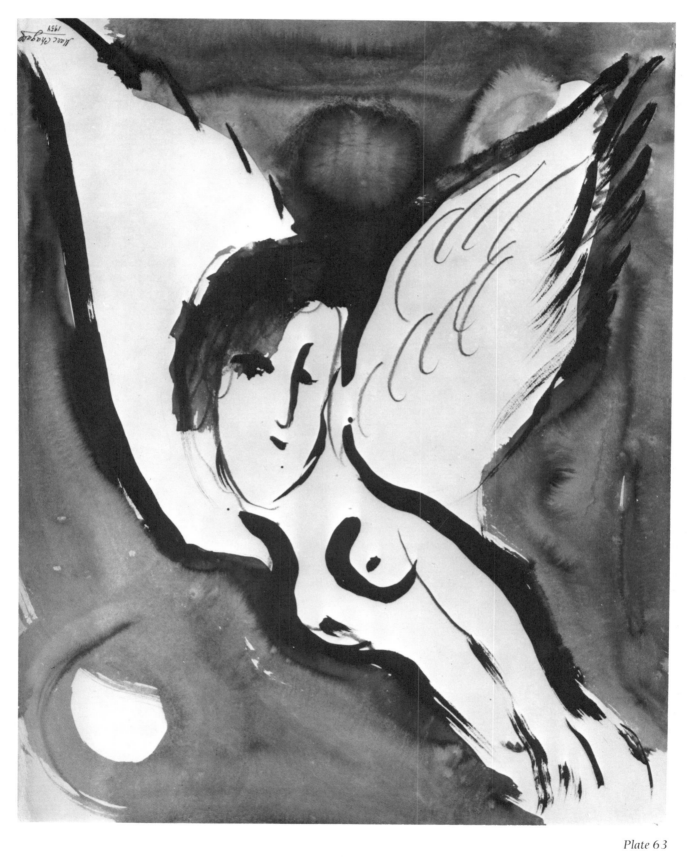

Plate 63

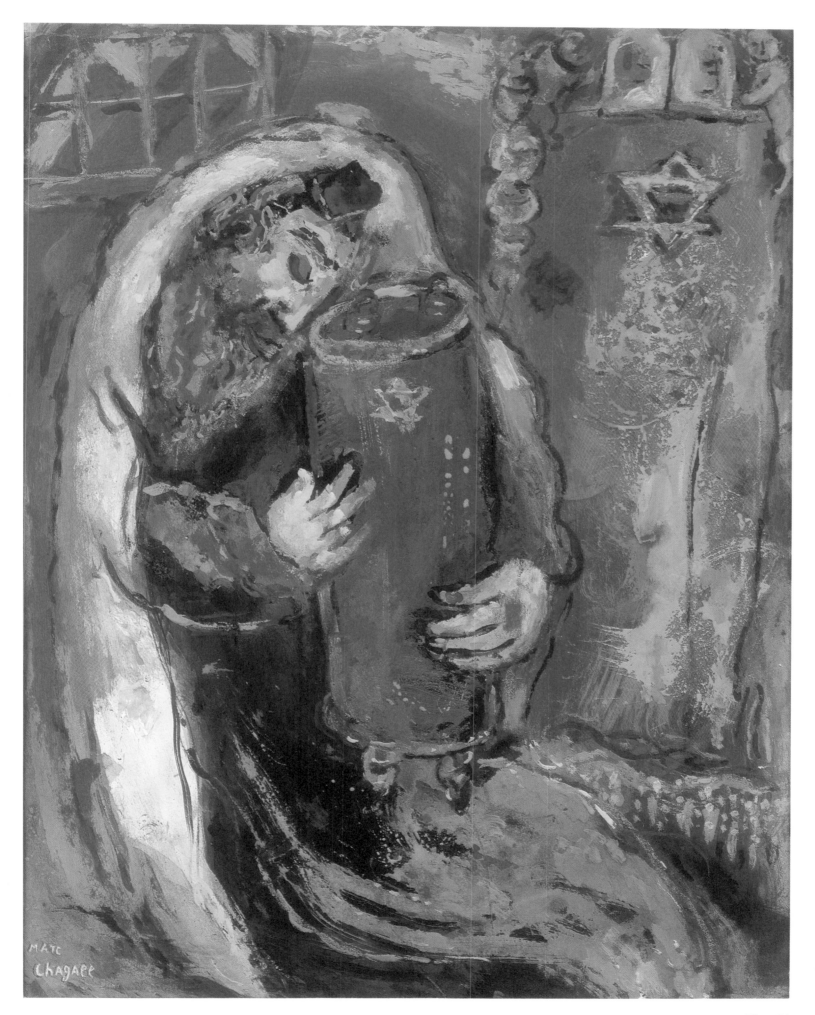

Plate 64

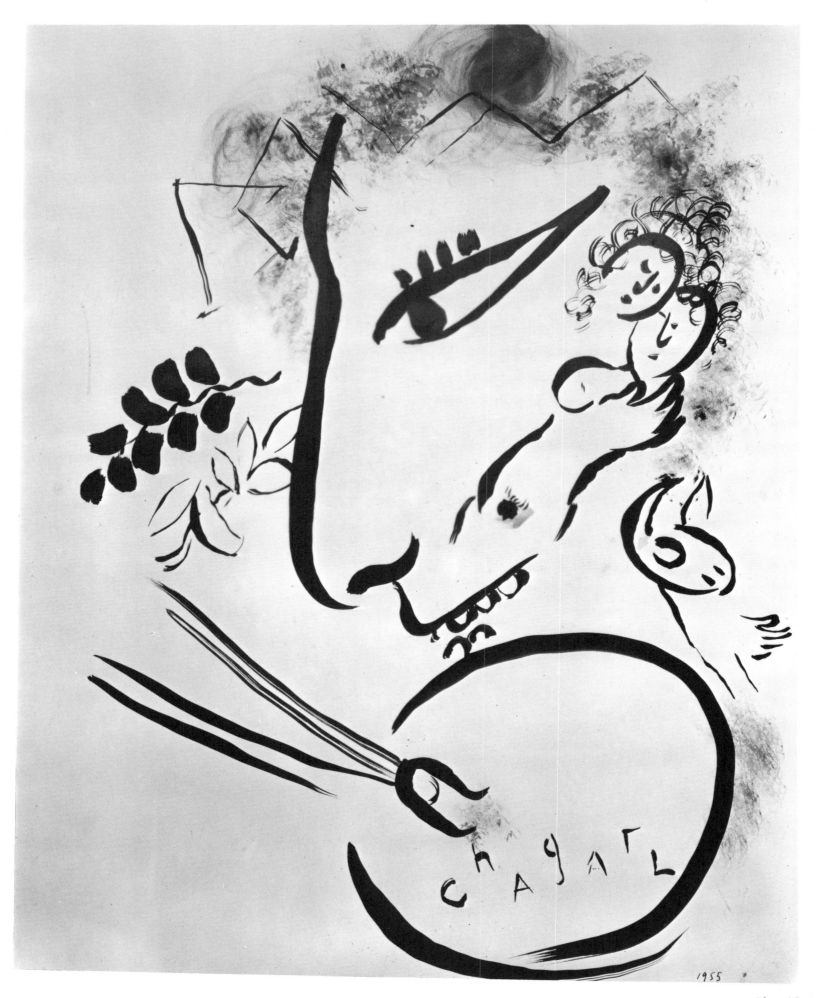

1955

Plate 65

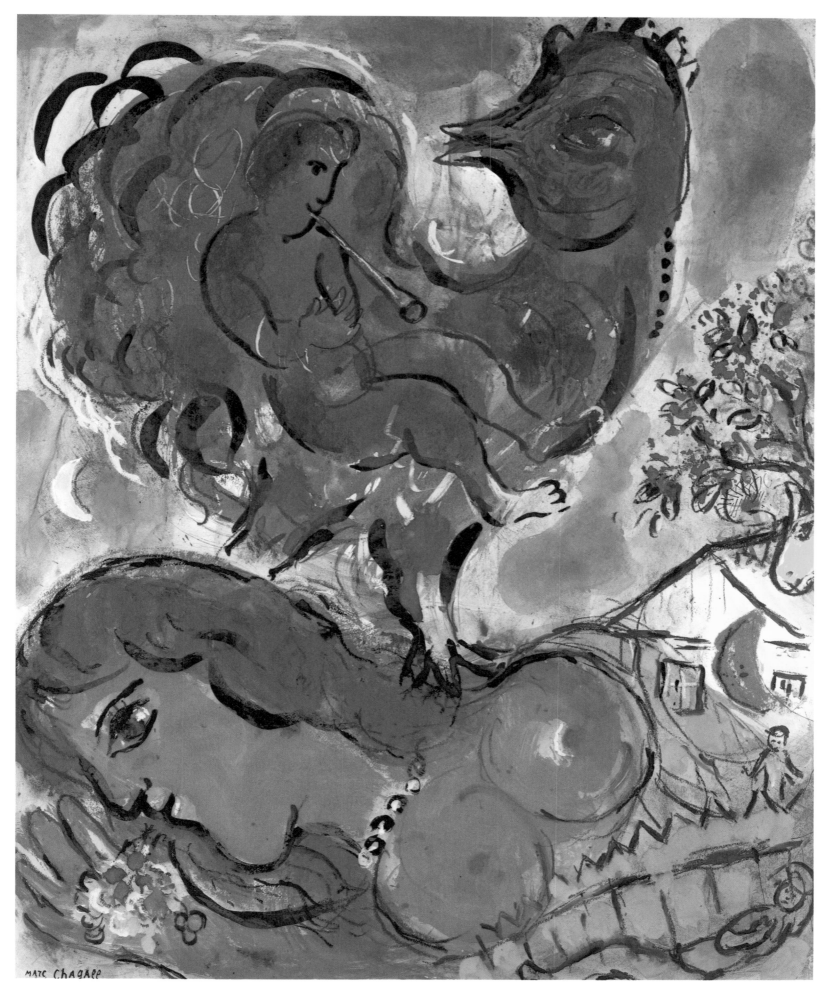

MARC CHAGALL

Plate 66

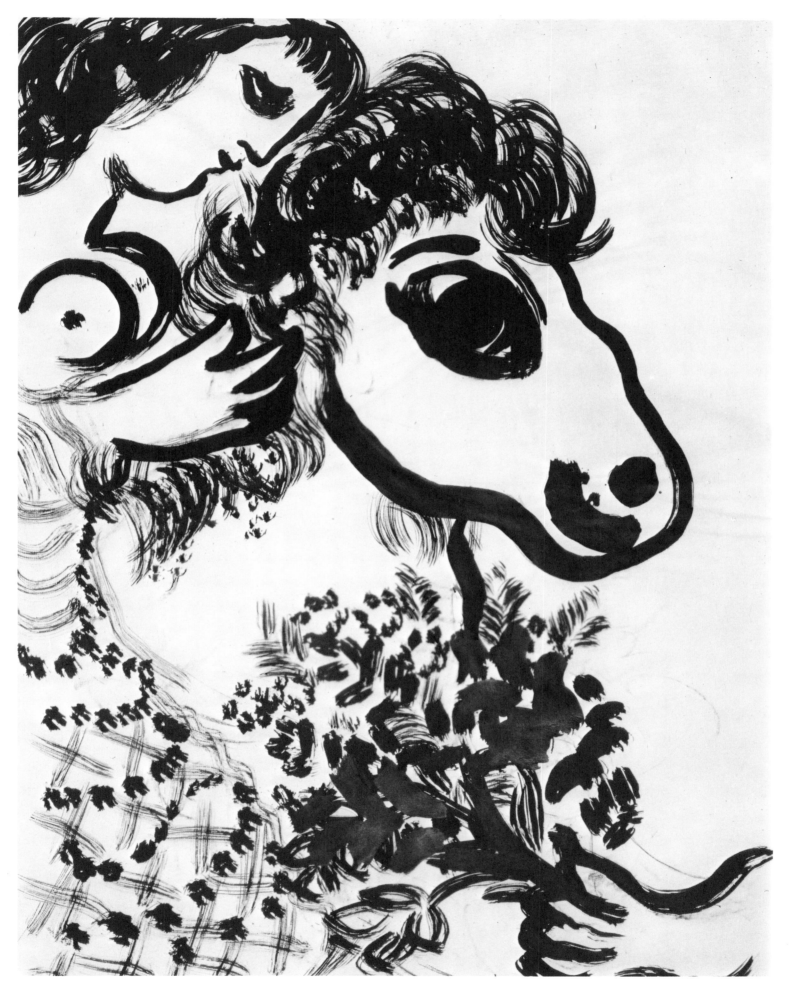

Plate 67

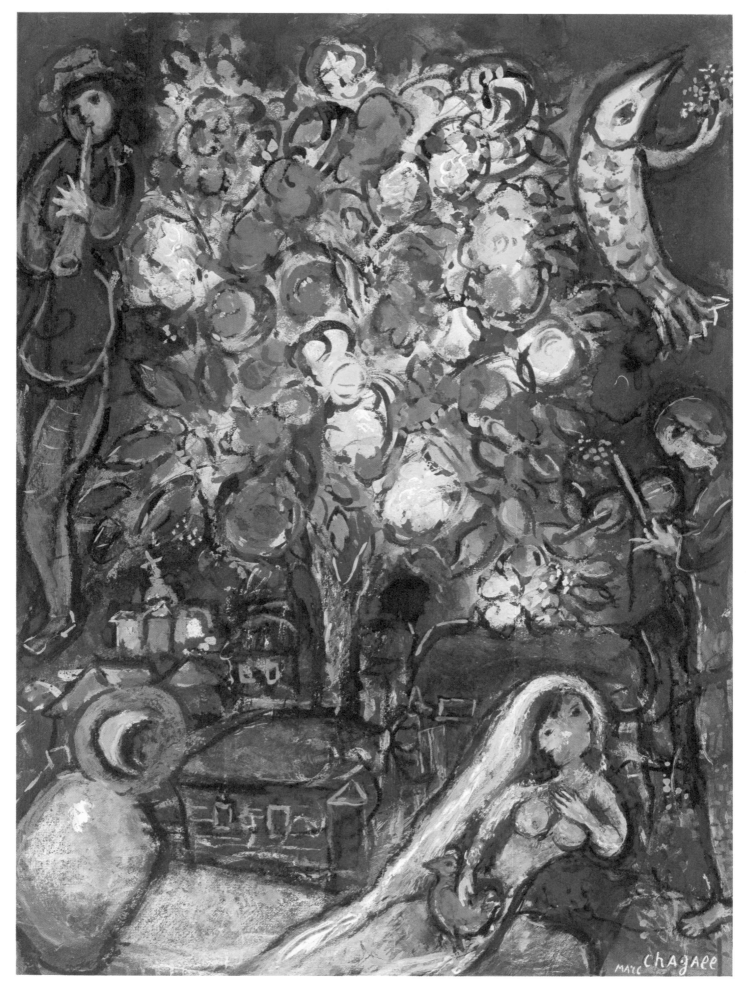

Plate 68

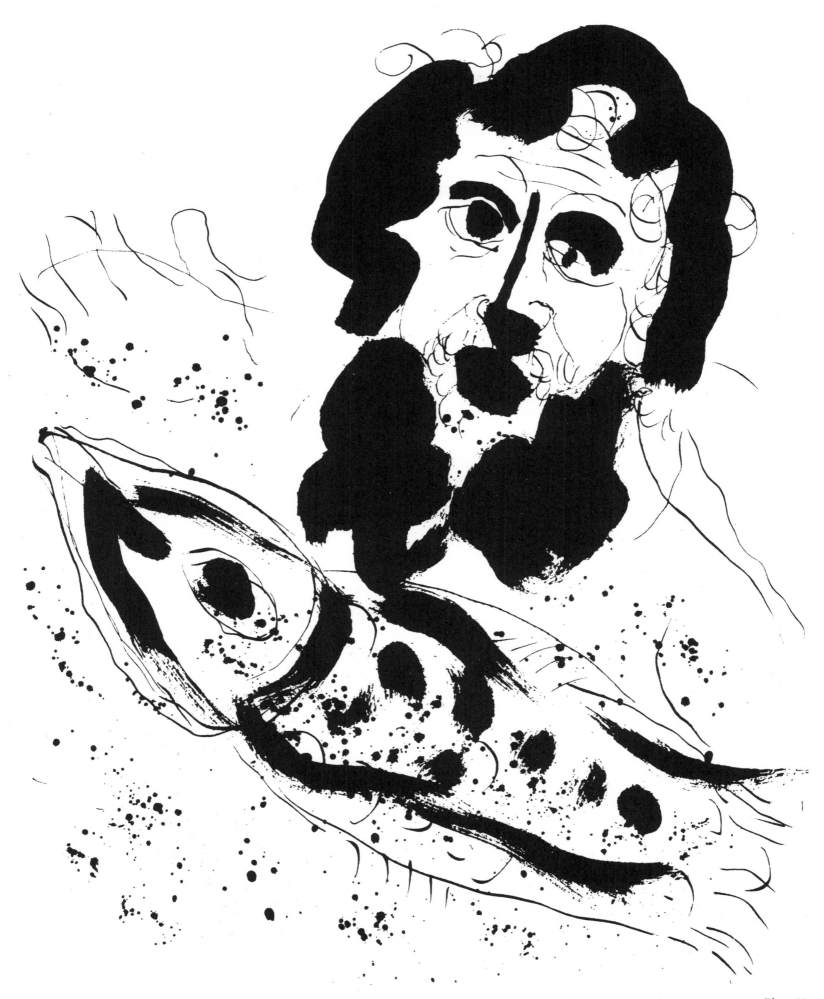

Plate 69

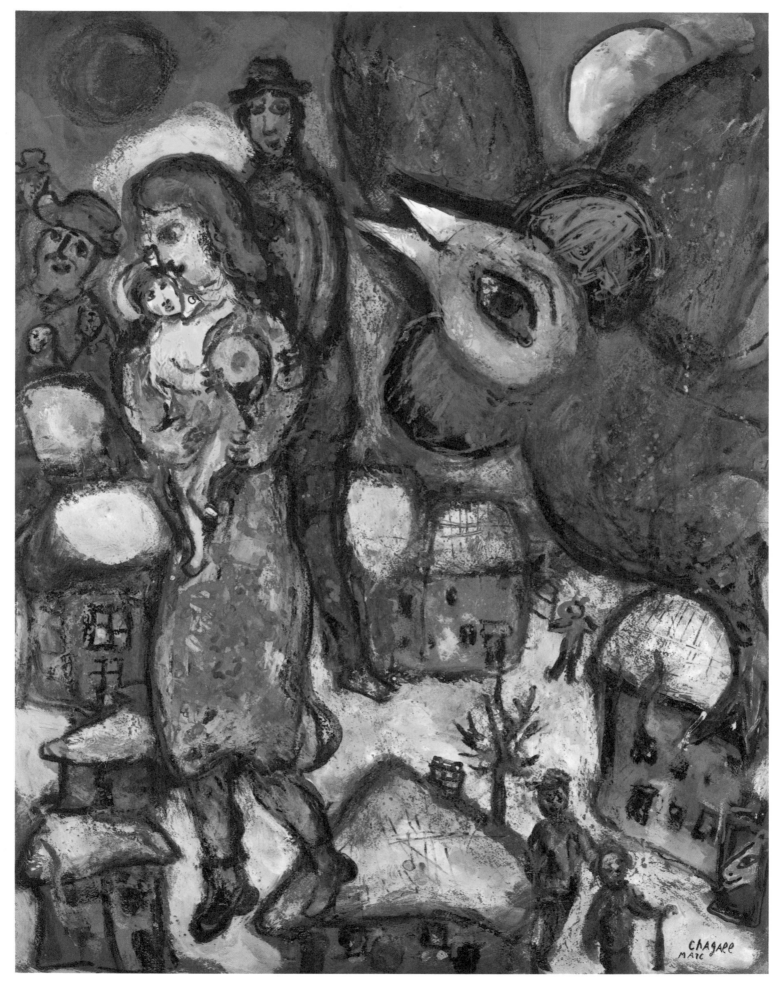

Plate 70

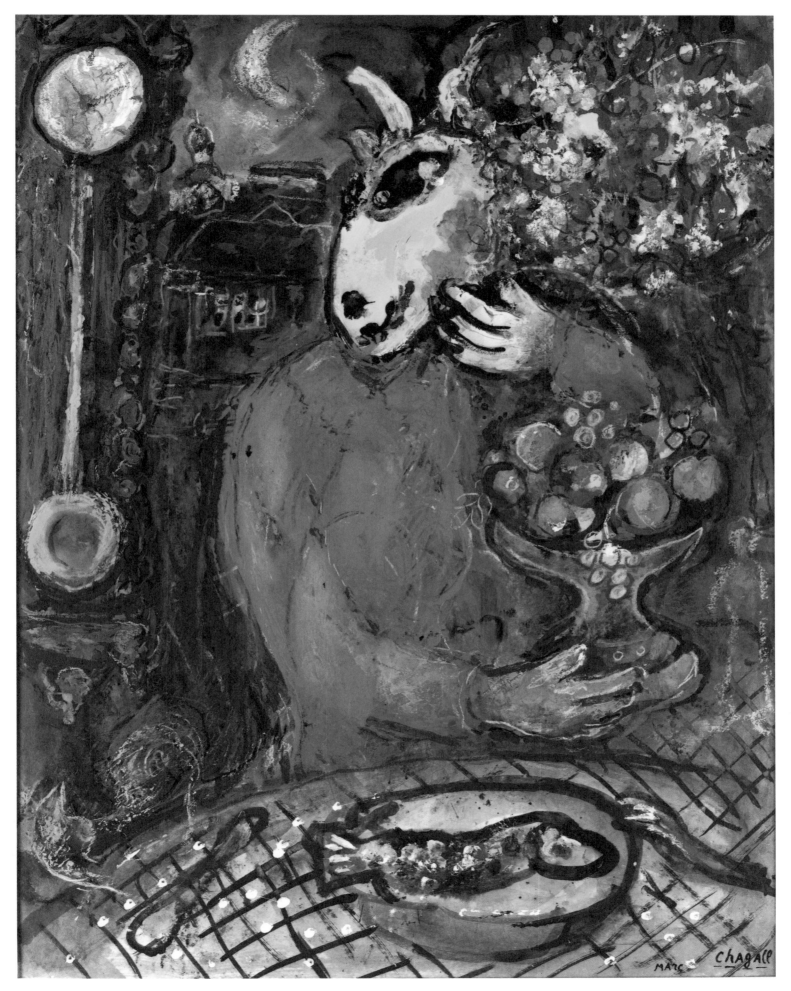

MARC Chagall

Plate 71

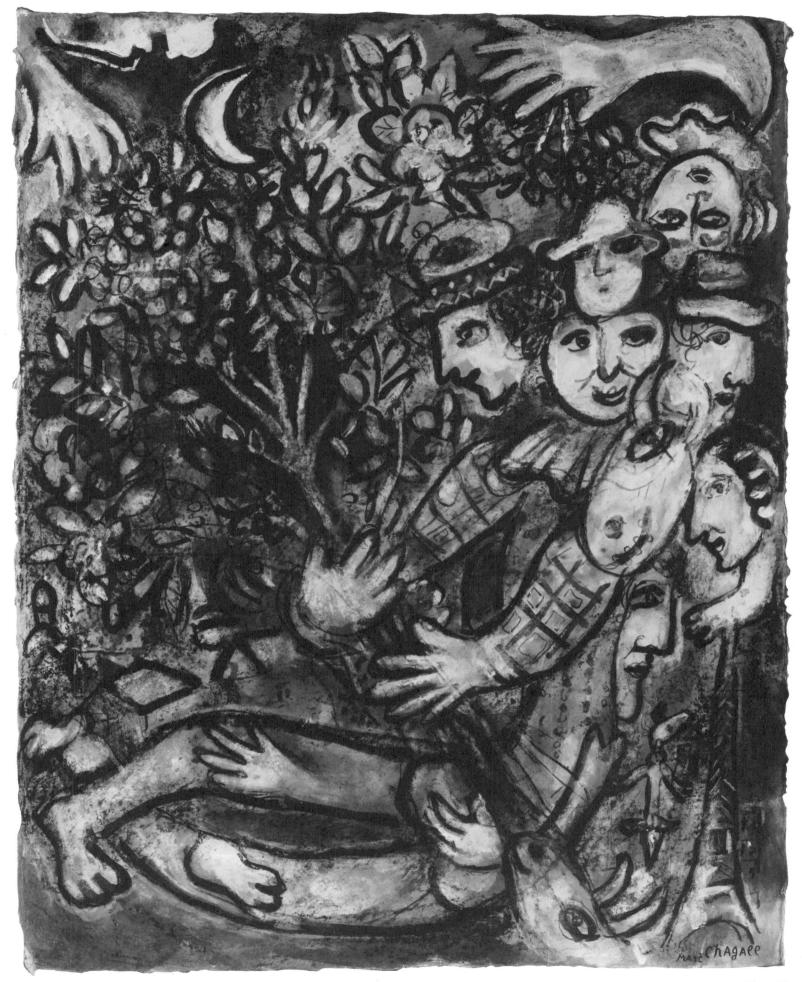

Plate 72

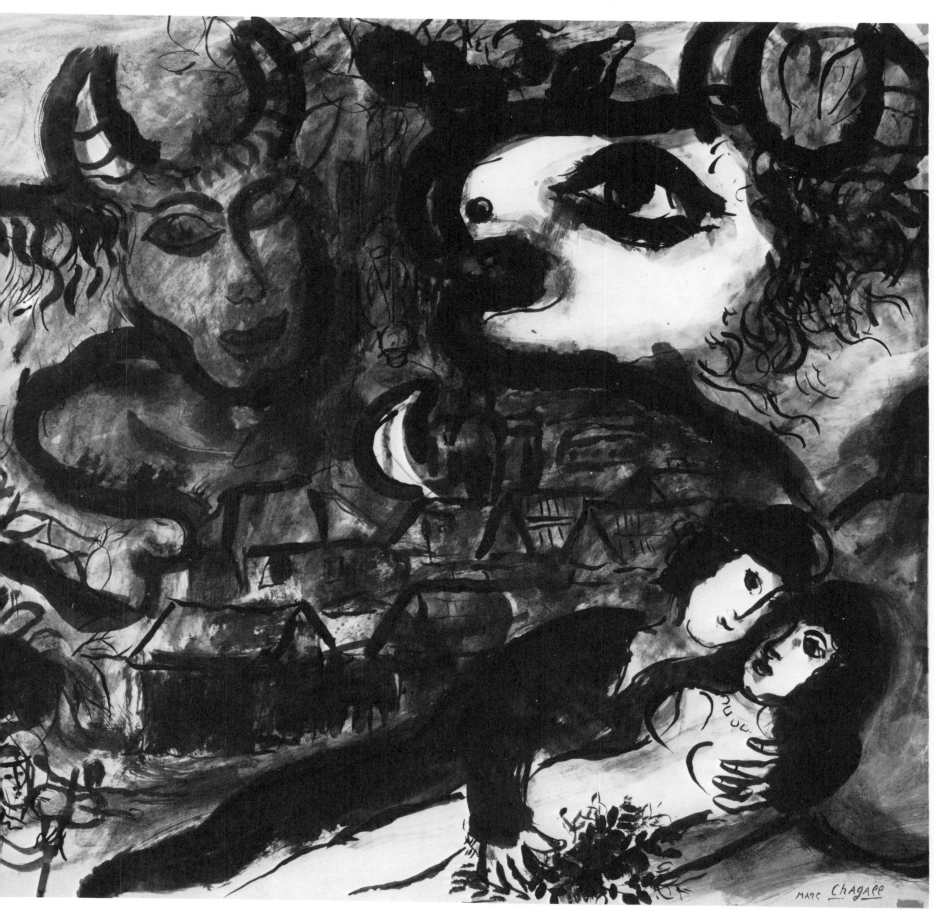

Plate 73

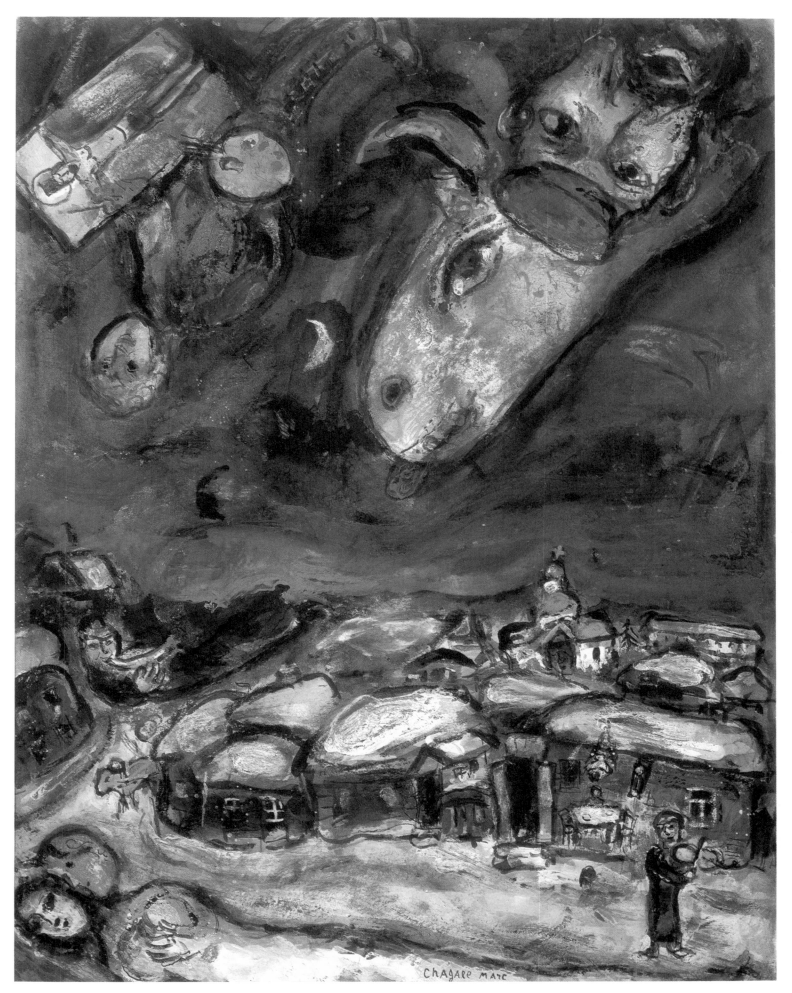

Plate 74

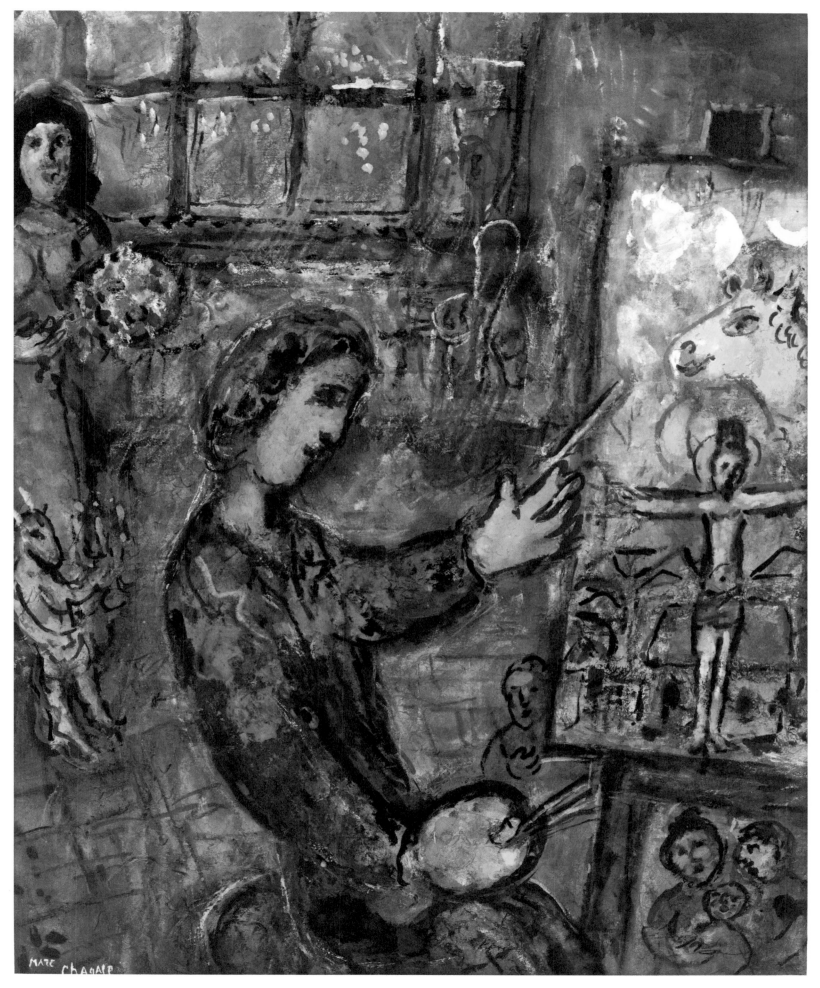

Plate 75

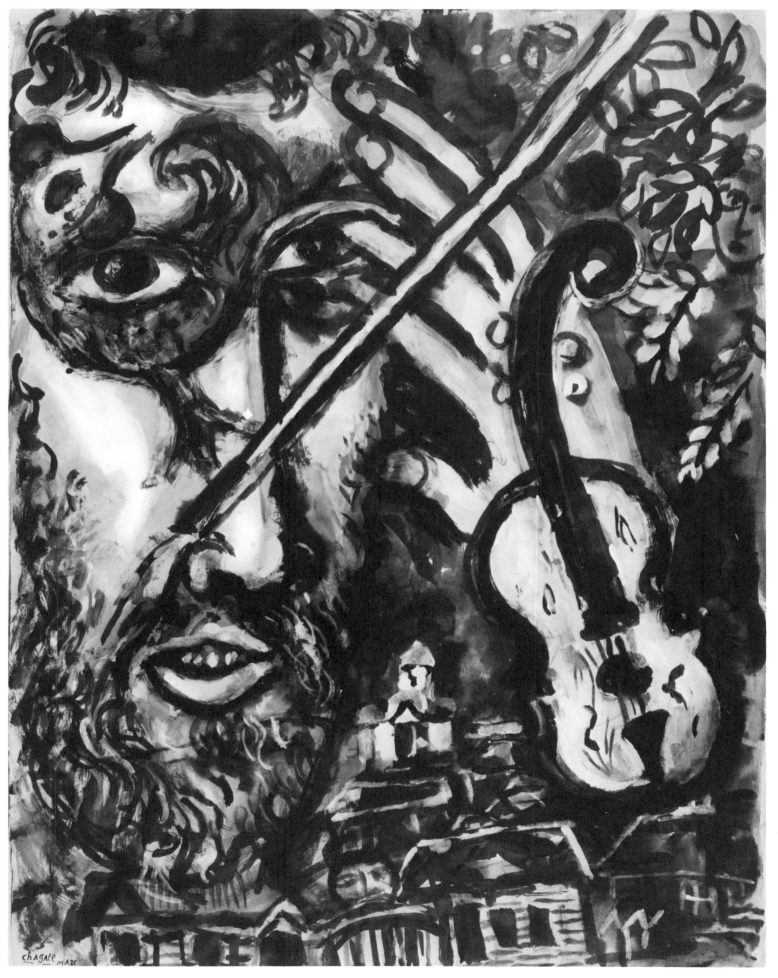

Plate 76

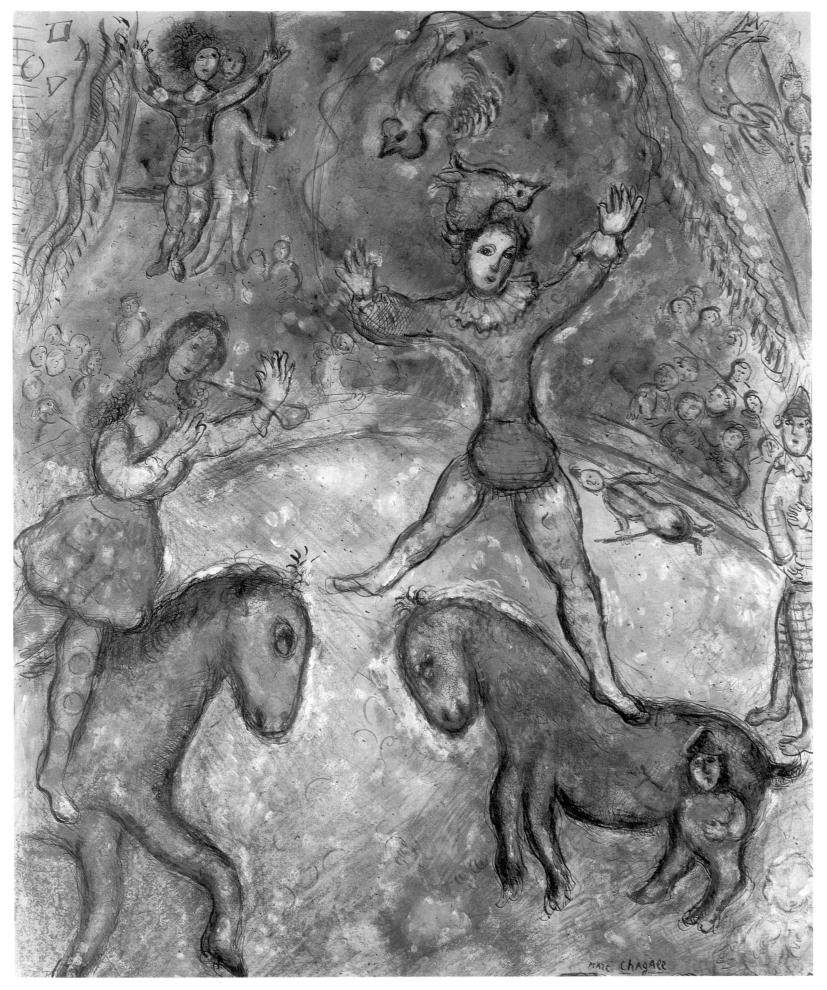

Plate 77

ILLUSTRATIONS

10 *The Procession.* 1911–12
India ink with brush on paper, 14 1/8 × 11 3/8"
Signed lower right: 1909 Marc Chagall
Collection the artist
(Photo: Kleinhempel, Hamburg)

11 *The Cattle Dealer.* 1912
Gouache on paper, 10 1/4 × 18 1/2"
Signed twice lower right: M. Chagall
Collection E.W. Kornfeld, Berne

12 *For Apollinaire.* 1911–12
Pencil on paper, 13 1/4 × 10 1/4"
Signed lower right: Pour Apollinaire Chagall 1911
Collection the artist

13 *Woman Carrying Water.* 1911
Gouache on paper, 8 3/8 × 10 3/4"
Signed lower left: 1911; lower right: Marc Chagall
Collection the artist
(Photo: J. Beyer, Saint-Louis)

14 *The Poet.* 1911–12
Pen and ink on paper, 9 7/8 × 6 7/8"
Signed lower right: Chagall
Collection the artist

15 *The Water Carrier on the Hill.* c. 1914
Gouache on paper, 12 5/8 × 17 3/8"
Signed lower right: Chagall
Private collection

16 *The Eve of the Day of Atonement.* 1912
Gouache on paper, 12 5/8 × 10 5/8"
Signed lower left: Chagall
Private collection
(Photo: Marlborough Fine Arts)

17 *The Painter in Front of the Church.* 1914
India ink with pen on paper, 6 3/4 × 9"
Signed lower middle: Chagall Vitebsk; lower right:
1914
Collection the artist
(Photo: Colin, Vence)

18 *A Sister of the Artist.* 1914
India ink with brush on paper, 10 × 7 1/8"
Signed lower middle: Chagall
Private collection
(Photo: Kurt Blum, Berne)

19 *Street at Evening.* 1914
India ink with pen on paper, 7 1/4 × 14"
Signed lower right: 1914 Chagall
Private collection

20 *Feast of Tabernacles.* 1916–17
Gouache on paper, 12 5/8 × 15 3/4"
Signed lower middle: Marc Chagall (Russian script);
lower right: 1916 Marc Chagall
Private collection
(Photo: Galerie Rosengart, Lucerne)

21 *A Man Carrying the Street.* 1918–20
India ink with pen on paper, 12 5/8 × 8 5/8"
Signed lower left: Marc Chagall; lower right: Chagall
1916
Private collection

22 *L'Homme qui marche (Marching Man).* 1918–20
Gouache on paper, 7 3/4 × 6 3/4"
Signed lower left: M. Chagall 914
Private collection

23 *The Movement.* 1921
India ink with pen on paper, 18 1/2 × 13 3/8"
Signed lower left: 1921; lower right: 53 Moscou Marc
Chagall (twice)
Private collection, France

24 *My Village.* 1923–24
Gouache on paper, 19 1/8 × 24 3/8"
Signed lower right: Marc Chagall
Private collection
(Photo: Galerie Rosengart, Lucerne)

25 *The Young Man.* 1923
Lithograph crayon
Signed lower right: M. Chagall
Private collection
(Photo: Albert Winkler, Berne)

26 *The Pinch of Snuff.* 1923–24
Watercolor on cardboard, 16 3/4 × 13 3/4"
Signed lower right: M. Chagall
Galerie Rosengart, Lucerne
(Photo: Galerie Rosengart, Lucerne)

27 Sketch for *Ida at the Window.* 1924
Pencil on paper, 12 1/4 × 8 1/4"
Signed lower left: Esquisse de Portr. de Ida a
Bretagne; lower right: M. Chagall 1924
Collection Ida Chagall, Paris
(Photo: Kurt Blum, Berne)

28 *My Father at Table.* 1925
Gouache on paper, 25 1/4 × 19 1/8"
Signed lower right: Marc Chagall 1925
Private collection
(Photo: J. Beyer, Saint-Louis)

29 *The Peasant.* 1926
Pen and ink on paper
Private collection
(Photo: Albert Winkler, Berne)

30 *The Church in Chambon-sur-Lac (Auvergne).* 1926
Gouache on paper, 25 5/8 × 20 1/8"
Signed lower right: Marc Chagall
Museum Boymans–van Beuningen, Rotterdam

31 *The Miller, His Son, and the Donkey.* 1926
Gouache on paper, 19 5/8 × 15 3/4"
Signed lower left: Chagall 26
Galerie Beyeler, Basel
(Photo: J. Beyer, Saint-Louis)

32 *The Peacock Complaining to Juno (Juno and the Peacock).*
1926–27
Gouache on paper, 20 × 16"

Signed lower left: Chagall
Collection Mr. and Mrs. Albert A. List, New York
(Photo: U.E. Nelson)

33 *The Woodcutter and Mercury.* 1926–27
Gouache on paper, 20 1/8 × 16 1/4″
Signed lower right: Chagall
Collection the artist
(Photo: J. Beyer, Saint-Louis)

34 *The Old Woman and the Two Serving Girls.* 1927
Gouache on paper, 20 × 16 3/8″
Signed lower right: 927 Chagall
Collection the artist
(Photo: J. Beyer, Saint-Louis)

35 *Woman at Window.* 1927
Pen and ink on paper, 10 5/8 × 8 1/8″
Signed lower right: Chagall
Collection the artist

36 *The Fiddler.* 1926–27
Gouache on paper, 19 1/4 × 25 1/4″
Signed lower left: Chagall
Collection Louis Franck, London

37 *The Legs.* 1925
Gouache on paper, 24 3/4 × 19 1/4″
Signed lower right: Marc Chagall
Collection G. Charensol, Paris

38 *The Goat in Front of the Church.* 1926–27
Gouache on paper, 25 1/4 × 19 1/4″
Signed lower left: Marc Chagall
Collection Mr. and Mrs. Leigh B. Block, Chicago

39 *Lovers.* 1926
India ink with brush on paper, 9 3/16 × 7 1/4″
Collection the artist

40 *Noah Receives God's Command to Build the Ark.* 1931
Gouache on paper, 24 3/8 × 19 1/4″
Signed lower left: Marc Chagall 1931
Musée National Message Biblique Marc Chagall, Nice
(Photo: Service de Documentation photographique
de la Réunion des Musées Nationaux, Paris)

41 *The Sacrifice of Noah.* 1932
Gouache on paper, 24 3/8 × 19 1/2″
Signed lower right: 932 Marc Chagall
Musée National Message Biblique Marc Chagall, Nice
(Photo: Service de Documentation photographique
de la Réunion des Musées Nationaux, Paris)

42 *Lovers.* 1938
Pen and ink on paper
Signed lower right: Marc Chagall
Private collection
(Photo: Marc Vaux, Paris)

43 *The Large Tree.* 1937
Gouache and pastel on paper, 24 × 18 7/8″
Signed lower right: Marc Chagall 1935–6–7
Private collection
(Photo: J. Beyer, Saint-Louis)

44 *The Toilette.* 1940
Pen and ink on paper
Private collection

45 *Female Clown with Violin.* 1937–38
Gouache on paper, 25 1/4 × 19 1/4″
Signed lower left: Marc Chagall 1941–42
Private collection
(Photo: Bert Koch, Cologne)

46 *Two Figures.* 1940
India ink with brush on paper, 17 1/2 × 11″
Signed lower middle: Gordes, France 1940;
lower right: Marc Chagall
Costakis Collection, Moscow

47 *Chaplin and Company.* 1937–39
Gouache on paper, 18 7/8 × 24 3/4″
Signed lower right: Marc Chagall
Private collection

48 *Fiddler in the Night.* 1939
Pen and ink on paper, 17 × 11″
Signed lower right: Chagall Marc 1939
Collection Mr. and Mrs. Morton G. Neumann,
Chicago

49 *The Village in the Snow.* 1940–41
Gouache on paper, 22 3/4 × 17 1/4″
Signed lower right: Marc Chagall
Private collection, New York
(Photo: Bert Koch, Cologne)

50 *The Green Donkey.* 1940
Green india ink on paper, 18 × 11 5/8″
Signed lower left: Marc Chagall
Collection the artist
(Photo: Marc Vaux, Paris)

51 *The Purple Angel.* 1941
Gouache on paper, 29 1/8 × 21 1/4″
Signed lower right: Marc Chagall
Collection Mrs. Paepcke, Chicago
(Photo: Bert Koch, Cologne)

52 *Pan and Siren.* 1949
India ink with brush on paper, 24 × 18 1/2″
Signed lower right: Chagall
Maeght Collection, Paris

53 *Basket of Fruit and Bouquet.* 1949
Gouache on paper, 29 3/4 × 20 7/8″
Signed lower right: 1949 Marc Chagall
Private collection
(Photo: Walter Steinkopf, Berlin)

54 *Flowers and Basket of Fruit.* 1952
India ink with brush on paper, 25 5/8 × 19 5/8″
Signed lower right: 1952 Vence Marc Chagall
Collection the artist
(Photo: Kurt Blum, Berne)

55 *The Red Flowers.* 1950
Gouache and pastel on paper, 25 5/8 × 19 5/8″
Signed lower right: Marc Chagall

Collection Ida Chagall, Paris
(Photo: Walter Steinkopf, Berlin)

56 *Evening at the Window.* 1950
Gouache and pastel on paper, 25 5/8 × 19 5/8″
Signed lower left: Marc Chagall 950
Collection S. Rosengart, Lucerne
(Photo: Walter Steinkopf, Berlin)

57 *Jacob Wrestling with the Angel.* 1950–51
India ink with brush on paper
Signed lower left: Marc Chagall
Private collection
(Photo: Marc Vaux, Paris)

58 *Winter.* 1950
Gouache and pastel on paper, 22 × 20 1/8″
Signed lower right: Marc Chagall
Collection Alfred Scherz, Berne
(Photo: Bert Koch, Cologne)

59 *Crouching Nude.* 1952
India ink with brush on paper, 25 5/8 × 19 5/8″
Signed lower left: 1952 Chagall Marc
Galerie Maeght, Paris
(Photo: M. Routhier, Paris)

60 *Woman Reaping.* c. 1951
Gouache and pastel on paper, 18 1/4 × 19″
Signed lower left: Marc; lower right: Chagall
Collection the artist
(Photo: J. Beyer, Saint-Louis)

61 *Tériade's Garden.* 1952
Pencil on paper, 16 1/2 × 12 5/8″
Collection the artist
(Photo: Colin, Vence)

62 *Blue Still Life (Greece).* 1952
Gouache and pastel on paper, 18 3/4 × 24 1/4″
Signed lower left: 1952 Marc Chagall Grèce
Collection the artist
(Photo: Walter Steinkopf, Berlin)

63 *Angel.* 1954
India ink with brush on paper, 24 3/4 × 19 5/8″
Signed upper left (upside down): Marc Chagall
1954
Private collection, France
(Photo: Kurt Blum, Berne)

64 *Jew with Torah.* c. 1955
Gouache on paper, 25 5/8 × 19 7/8″
Signed lower left: Marc Chagall
Private collection
(Photo: Walter Steinkopf, Berlin)

65 *Self-Portrait.* 1955
India ink with brush on paper
Signed lower right: Chagall 1955
Private collection
(Photo: Colin, Vence)

66 *The Blue Cock.* 1955–60
Gouache on paper, 32 1/4 × 25 3/4″
Signed lower left: Marc Chagall

Private collection
(Photo: Walter Steinkopf, Berlin)

67 *Woman and Animal.* 1952
India ink with brush on paper, 25 1/4 × 19 1/4″
Collection the artist
(Photo: Colin, Vence)

68 *Blossoming Tree.* c. 1960
Gouache, pastel, and collage on paper,
21 1/4 × 15 3/8″
Signed lower right: Marc Chagall
Private collection
(Photo: Walter Steinkopf, Berlin)

69 *Jonah.* 1960
India ink with brush on paper, 13 3/4 × 10 5/8″
Collection the artist
(Photo: Hesse, Berne)

70 *Flight.* 1960
Gouache on paper, 26 × 19 5/8″
Signed lower right: Marc Chagall
Private collection
(Photo: Walter Steinkopf, Berlin)

71 *The Red Coat.* 1961
Gouache and pastel on paper, 26 × 20 1/8″
Signed lower right: Marc Chagall
Collection Victor Loeb, Muri-Berne
(Photo: Walter Steinkopf, Berlin)

72 *Harlequin's Family.* 1961
India ink with brush and gouache on paper,
26 × 19 7/8″
Signed lower right: Marc Chagall
Collection the artist
(Photo: Walter Steinkopf, Berlin)

73 *Pan.* 1964
India ink with brush on paper, 26 3/4 × 27 5/8″
Signed lower right: Marc Chagall
Collection Werner and Maya Allenbach, Berne

74 *The Setting Sun.* 1961
Gouache and pastel on paper, 26 1/8 × 20″
Signed lower middle: Chagall Marc
Private collection
(Photo: Walter Steinkopf, Berlin)

75 *Blue Interior.* 1969
Gouache on paper, 22 1/2 × 18 1/4″
Signed lower left: Marc Chagall
Collection Folco Giuglielmi, Trieste
(Photo: Walter Steinkopf, Berlin)

76 *The Fiddler.* c. 1970
India ink with brush on paper, 33 1/8 × 25 5/8″
Signed lower left: Chagall Marc
Galerie Maeght, Paris

77 *Circus with Jugglers.* 1971
Gouache and pastel on paper, 29 7/8 × 24 3/8″
Signed lower right: Marc Chagall
Private collection
(Photo: Walter Steinkopf, Berlin)